This belongs to
Virginia Laurena

NEW YORK
IN THE FORTIES

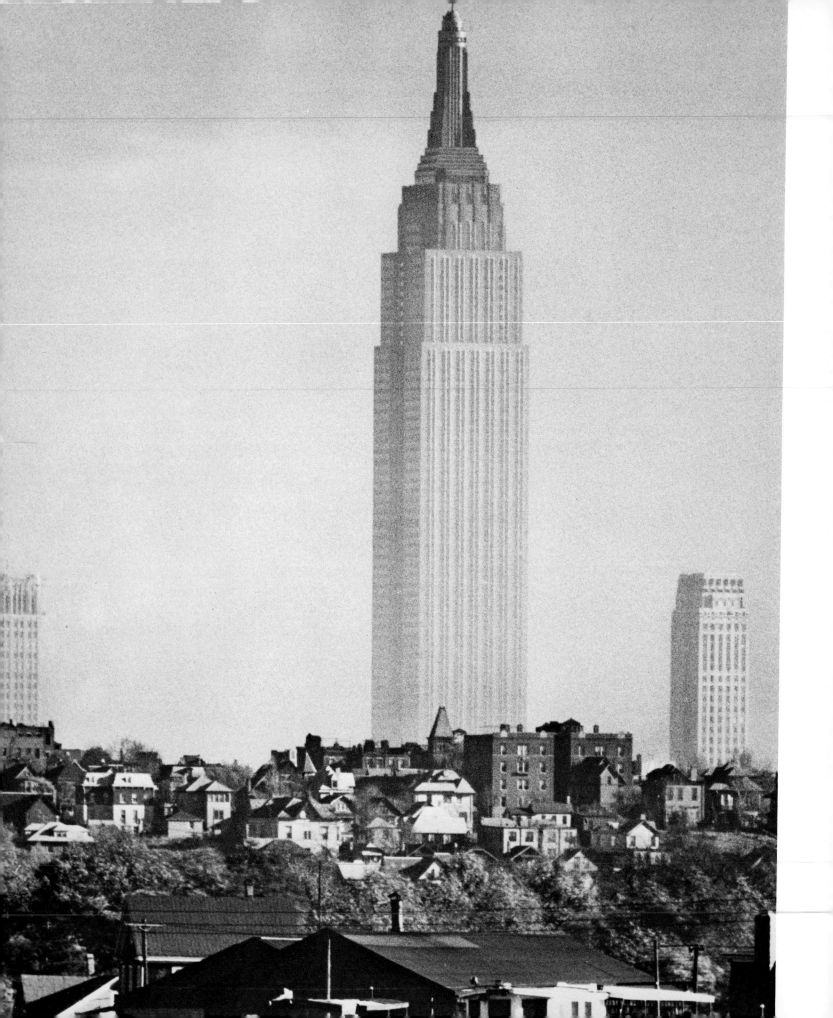

Andreas Feininger

NEW YORK IN THE FORTIES

with text by
John von Hartz

Dover Publications, Inc., New York

Published in Canada by General Publishing Company,
Ltd., 30 Lesmill Road, Don Mills, Toronto, Ontario.
Published in the United Kingdom by Constable and
Company, Ltd., 10 Orange Street, London WC2H 7EG.

New York in the Forties is a new work, first published by Dover
Publications, Inc., in 1978.

International Standard Book Number: 0-486-23585-8
Library of Congress Catalog Card Number: 77-087344

Manufactured in the United States of America
Dover Publications, Inc.
180 Varick Street
New York, N.Y. 10014

Introduction

Like any great city, New York has experienced the best of times and the worst of times. The 1940s were among the best of times. To the student of history, this seems inexplicable. The city began the decade still hurting from the great economic depression of the 30s. America's involvement in World War II plunged the city into an epoch of trauma and tragedy. Even with the war won, New York faced momentous adjustments to accommodate the returning veterans and populations eager to perpetuate the jobs and salaries of the wartime economy. Yet for all these staggering difficulties, the 40s maintained an internal stability. It was an era of turmoil without social upheaval, a time of transition made quietly behind a facade of normality. Ironically, the 40s linger in the collective consciousness of New Yorkers as "the good old days."

There are several valid reasons for this charitable appraisal. The city continued as a leader in commerce, industry and shipping. Almost every major corporation had or wished it had its national headquarters in Manhattan. Businesses were attracted by the vast pool of skilled clerical labor waiting in the city. New York also had a bottomless reservoir of laborers for the manufacturing jobs that thrived in the city's loft factories. And New York was a port town, the home of one of the world's finest natural harbors with 771 miles of sheltered waterfront. The Port of New York was a floating traffic jam with ships engaged in world travel and trade contending with fleets of boats on inter-harbor shuttle runs. In fact, the sea itself was a source of riches for the city. Passenger and trading boats sailed it, fishing boats harvested it, hauling their catches to the city markets, urban resorts like Coney Island flourished by it and trans-Atlantic planes landed on it.

The city was made up of hundreds of neighborhoods clustered together and united by a web of cheap transportation. Each neighborhood was actually a village measured in blocks. New Yorkers were born to a village, went to school there and then worked—or commuted to work from there. Mobility away from the neighborhood and into the suburbs was limited. Architecturally, New York still grew up, not out. In the previous decade, Rockefeller Center, the Empire State and Chrysler Buildings were constructed. By the end of the 40s, the United Nations complex was in its final stages.

As it always had, New York in the 40s exerted an irresistible appeal to the talented and ambitious. To be a success in New York was to succeed. People with something to say came to the city, which was the nation's disseminator of ideas through publishing, radio and, later, television. Whether they published books or ranted from atop a milk crate in Union Square, people with opinions gained an audience. The city was nothing if not an audience, the country's richest marketplace for plays, musicals, movies and nightclub entertainments as well as the staples of publishing —newspapers, magazines and books.

For a bustling, industrial town, New York during this period was surprisingly clean and demure. Garbage did not compete with cars for curb space and the sidewalks were not carpeted with wrappers and newspapers. New Yorkers still dressed with a certain formality as good grooming signaled respectability. Even the city's renowned "immoral" activities seem almost wholesome by today's standards: the famous burlesque houses with their neat, colorfully lit lobbies carried a subdued air of decorum, even gentility.

Andreas Feininger observed this intriguing decade with his practiced photographer's eye alert to every detail. He continually discovered in New York the elements that distinguish it from every other city on earth. No part of the urban landscape escaped his attention: the sweep of the cityscape; the ostentatious swank of the Diamond Horseshoe; the hard realities facing shopper and merchants on the Lower East Side. And he never neglected a basic truth about the city—it stood at the junction of the continent with the ocean. He was keenly aware that the meeting of land and water created the shape of the city in the 40s. It is all there in the juxtaposition of harbor and skyscrapers; the old waterfront edifices trying to hold against the tide of modern structures; the ways New Yorkers conquered the rivers and bays with bridges and ferries; the economic and recreational value of the waterfront.

As an artist and reporter, Feininger transmits the innocence of the age and the humanity of its people. His clean, uncluttered photographs catch the city with unabashed honesty. His portraits of people—ethnic shopkeepers, a newsman in Chinatown, arm-wrestlers in Harlem, bootblacks and their patrons—are real human beings preserved in their place and time. Even when documenting the dark side of the period—the unemployed, the neglected, the lost—his portraits reveal the compassion of a humanist.

The photographer leads us through the city of the 40s (and after, since a few of these photographs postdate the decade). Because he relishes the territory, he serves as a skillful guide. The journey is enchanting and educational as the photographer displays his unrivaled pictorial record of a memorable age. By studying what he has observed, we can recapture the look and texture of that remarkable time.

John von Hartz

NEW YORK
IN THE FORTIES

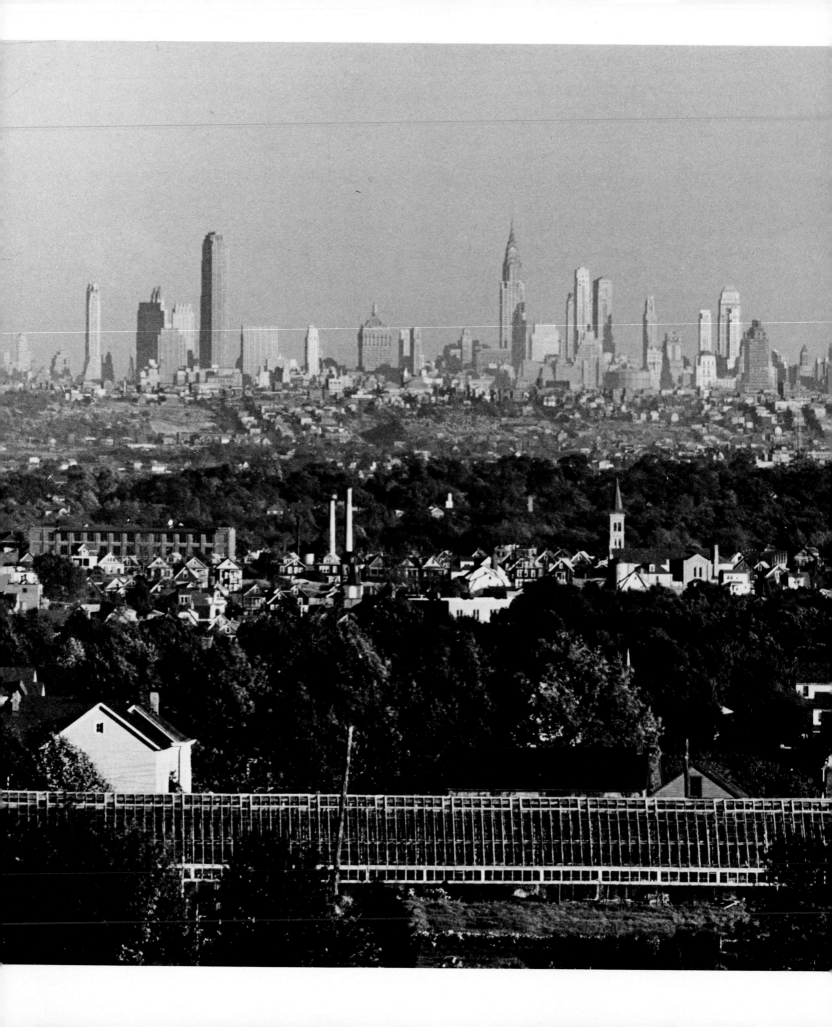

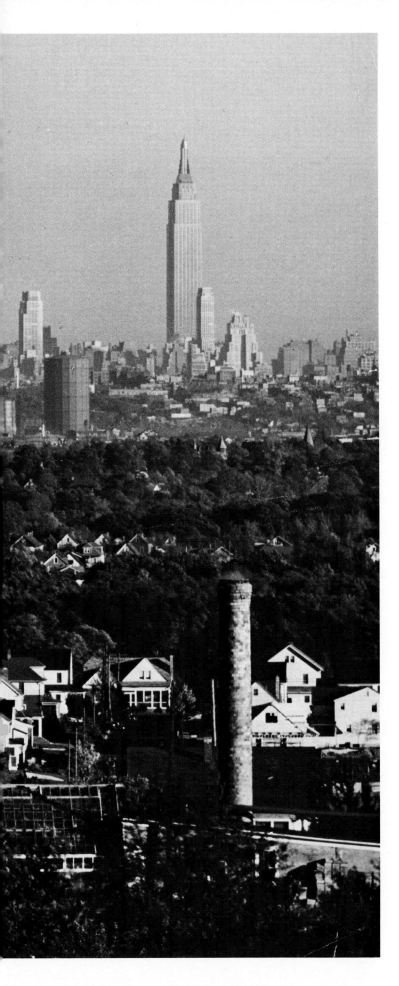

The Manhattan skyline from Paterson, New Jersey. Nothing symbolized New York in the 1940s as much as its skyline. The overwhelming profile of the city came to represent attainment, excitement, grandeur and action. People expected high drama from a city with this daring skyline and the city seldom failed to meet these expectations.

The cityscape at left was taken from the foot of Great Notch Mountain near Paterson, New Jersey, some 14 miles from mid-town. The contrast between the city and the low-rise towns that surround it could not be more extreme. In the foreground is the long, horizontal stretch of a professional greenhouse, behind which are rows of neat houses. The Hudson River cuts unseen below a wooded ridge while in the distance arises the array of many of the tallest and largest buildings on earth.

Some of the most prominent structures are, starting with the tallest tower at left: the General Electric Building; Rockefeller Center; the pyramidal roof of the New York Central Building and the needle-summited Chrysler Building. At the far right is the Empire State Building; immediately to its right is the Lincoln Building and the stairstep outline of the comparatively short Hotel New Yorker.

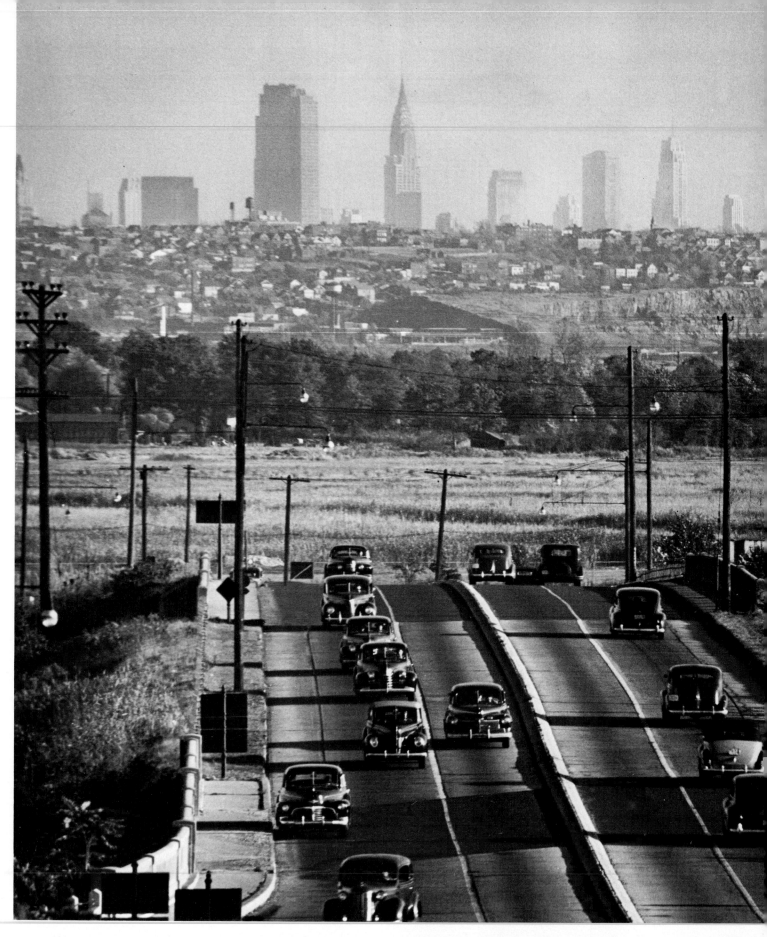

The view from Bendix, New Jersey, looking southeast. The city's skyline differs with every perspective. In this photograph taken from Bendix, eight miles from midtown, the four-lane tarmac of Routes 46 and 6 rise and dip toward the Meadow-

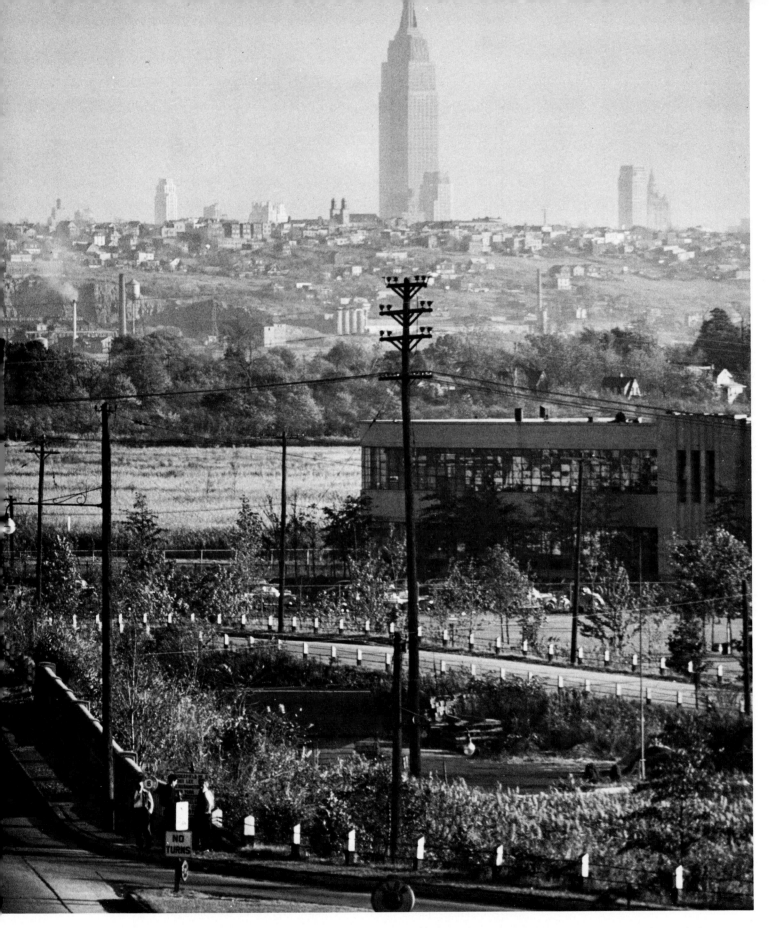

lands in the middle distance, their narrow widths adequate for the traffic. The valley of the Hackensack River runs in front of the ridge that rises above the Hudson River. And beyond this ridge, the tops of the skyscrapers perch like monoliths.

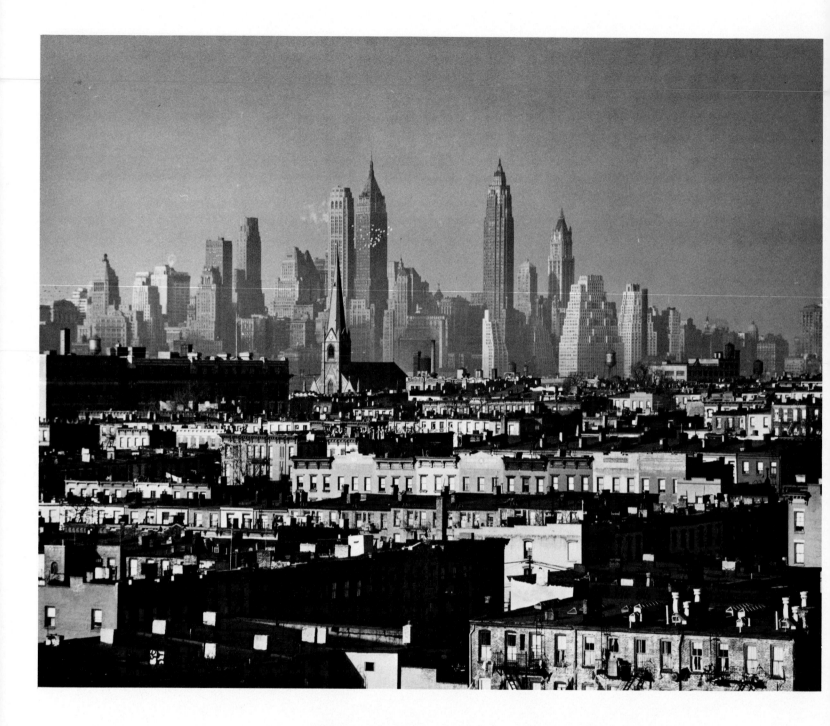

Manhattan from an elevated highway in Brooklyn [above]. Downtown Manhattan from Staten Island [opposite]. The city's boroughs were largely bedrooms for the workers in the skyscrapers of Manhattan. The humble rowhouses and tenements of Brooklyn spread beneath the lofty towers of the financial district. Even the impressive church spire is dwarfed by the Farmer's Trust Building across the East River. To the right of Farmer's Trust, a flock of city pigeons whirls in front of the Bank of Manhattan Building. The Cities Service Building, erected in 1932, stands at right-center and to its right is the venerable Woolworth Building. When the same area of Manhattan is seen from Staten Island, the Woolworth Building is at left, the Bank of Manhattan Building at the center, the Farmer's Trust to its right and then the Cities Service Tower. Freighters and tugs churn through Lower New York Bay that separates Staten and Manhattan Islands.

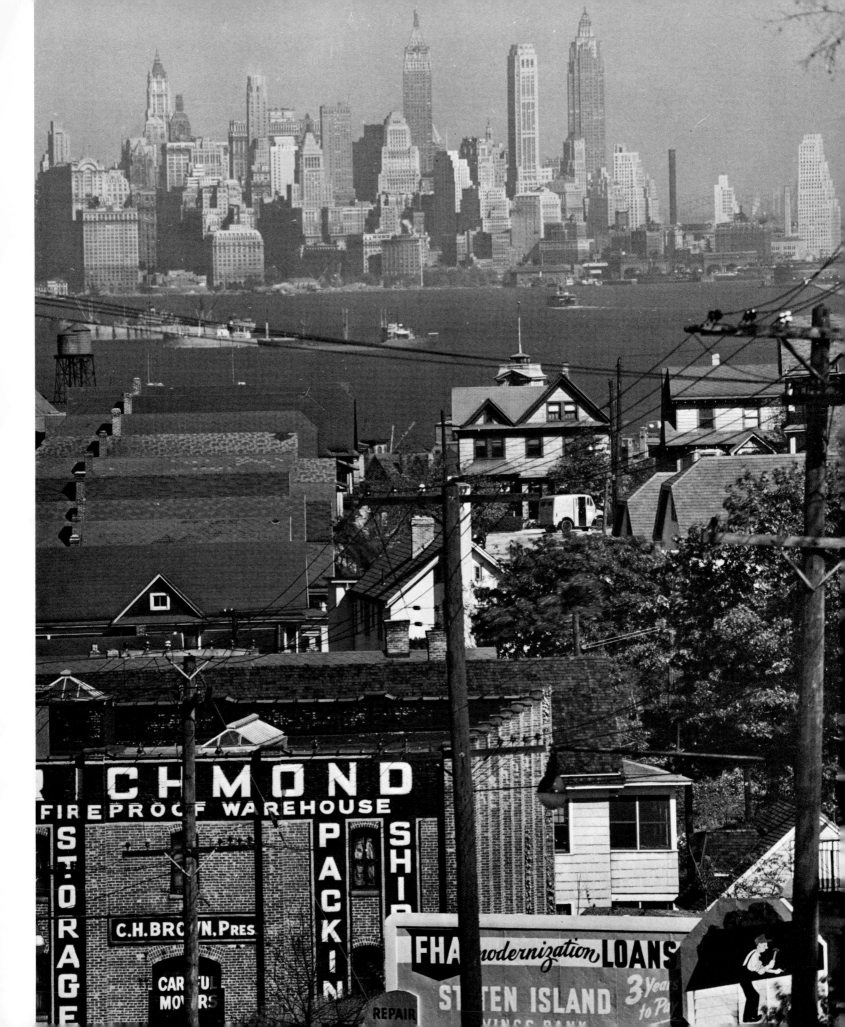

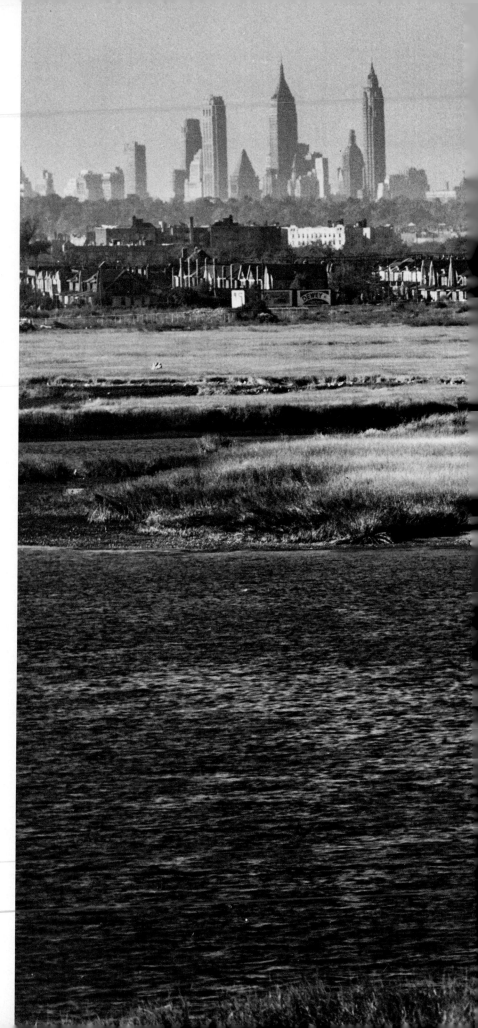

Fishermen in Sheepshead Bay. Although the city was packed with almost eight million people, much of the surrounding area managed to retain a rustic isolation during the 40s. Fishermen from the densely compacted city could hop a subway, rent a boat and fish the waters within sight of the city's skyline.

During this era when urban sprawl had not yet blighted the environs, New Yorkers continued their addiction to layered-living and working in high-rise buildings. The passion for the skyscraper, kindled in the 19th century, burned through the 40s. The small size of Manhattan island—22.6 square miles—left little room for horizontal expansion. But beneath the island's thin layer of soil was bedrock, an inviting base for buildings that soared vertically. Skyscrapers became economically feasible with two 19th-century building advances—the development of structural steel skeletons and the elevator. The technology for steel construction was perfected during 19th-century bridge building: the beams and trusses of the spans were applied to vertical construction. Steel girders driven into Manhattan bedrock enabled buildings to rise hundreds of feet into the sky. And the means of whisking people effortlessly between these steel-girder floors was revealed in 1857 with the installation of the first practical passenger elevator in the Haughwout Building at Broadway and Broome Street.

The appeal of skyscrapers often went beyond the obvious urban economic advantages; they were manifestations of prestige and power. The Woolworth Building, at right-center in the photograph here, was a case in point. The building came into being because the Metropolitan Life Insurance Company denied a loan to Frank Woolworth, lord of the 5-and-10-cent store realm. Vowing revenge, Woolworth pledged to construct a tower that would humble the Metropolitan Life Building at Madison Square, then the tallest building in the world at 700 feet. When the Woolworth Building opened in 1913 it stood at 792 feet, was hailed as "the cathedral of commerce," and justifiably laid claim to the title "world's tallest." The Woolworth reigned supreme, but in 1930 the Chrysler Building briefly topped it until the 1,250-foot Empire State Building took the title. Such was the nature of skyscraper competition that in the 1940s, the Woolworth had joined its rival, the Metropolitan Building, and many previous short-reigning champions as just another great building.

New Yorkers were so accustomed to skyscrapers in the 40s that few realized the engineering feats demanded for their construction. For the dominant tower of the era, the Empire State, the rock and earth removed in digging the foundation weighed three-quarters as much as the building itself. This fact caused Henry Ford to worry aloud about the building's potentially disastrous effect upon the rotation of the earth.

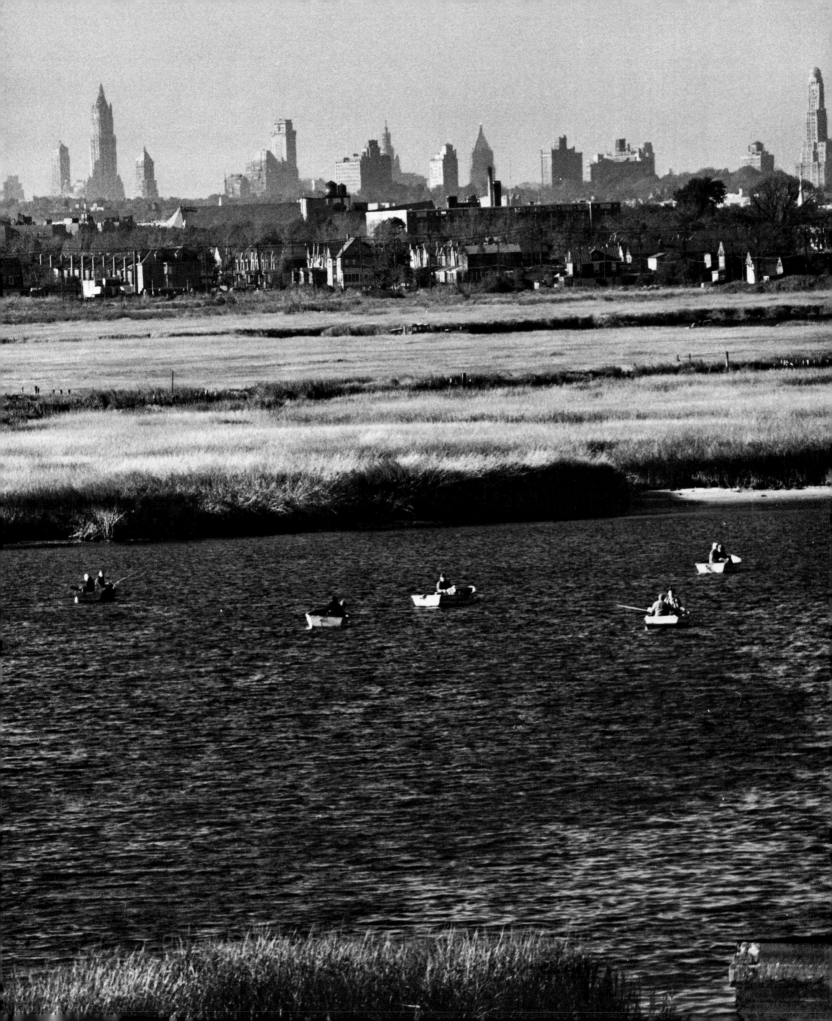

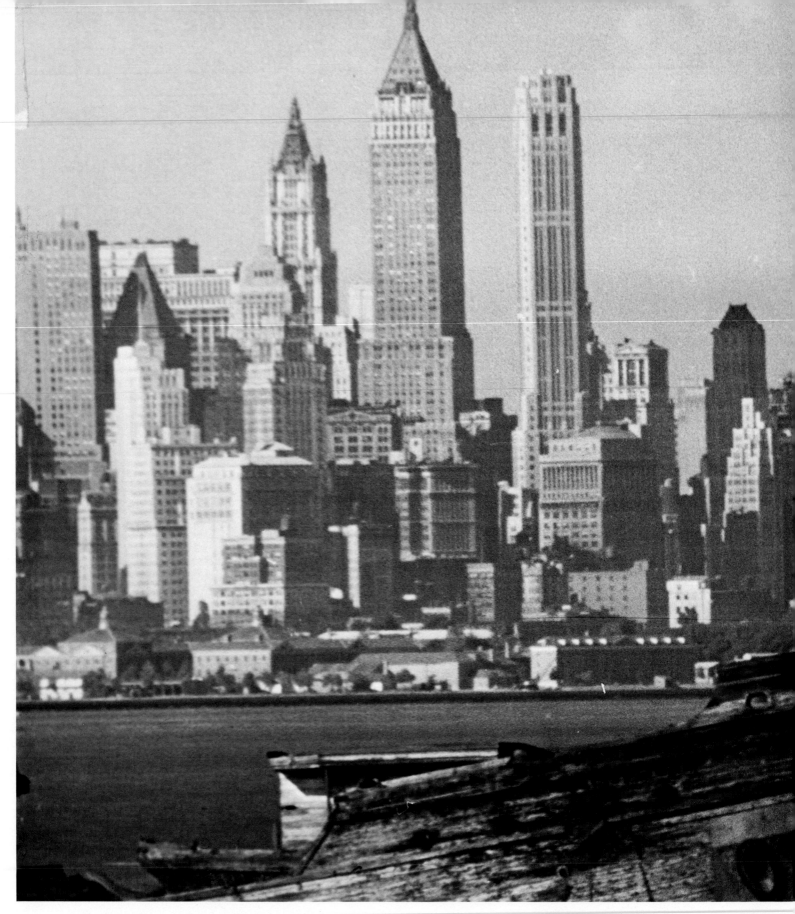

The Financial District from Shore Drive, Brooklyn. The paradoxes of New York are endless. In this photograph, the rotting wooden hull of an old-time sailing vessel decays at a pier near Bay Ridge Avenue while across the East River stands the buildings that represent the financial power of New York in the 1940s. The Woolworth Building is at left, and to its right the Bank of

Manhattan Building, the Farmer's Trust and the Cities Service Tower. The Roman classical Municipal Building with its gilded statue, *Civic Virtue*, atop its ornate cupola is at right-center. The building with a gold-roofed pyramidal top is the United States Court House at Foley Square while the Empire State Building and RCA Building are at the far right.

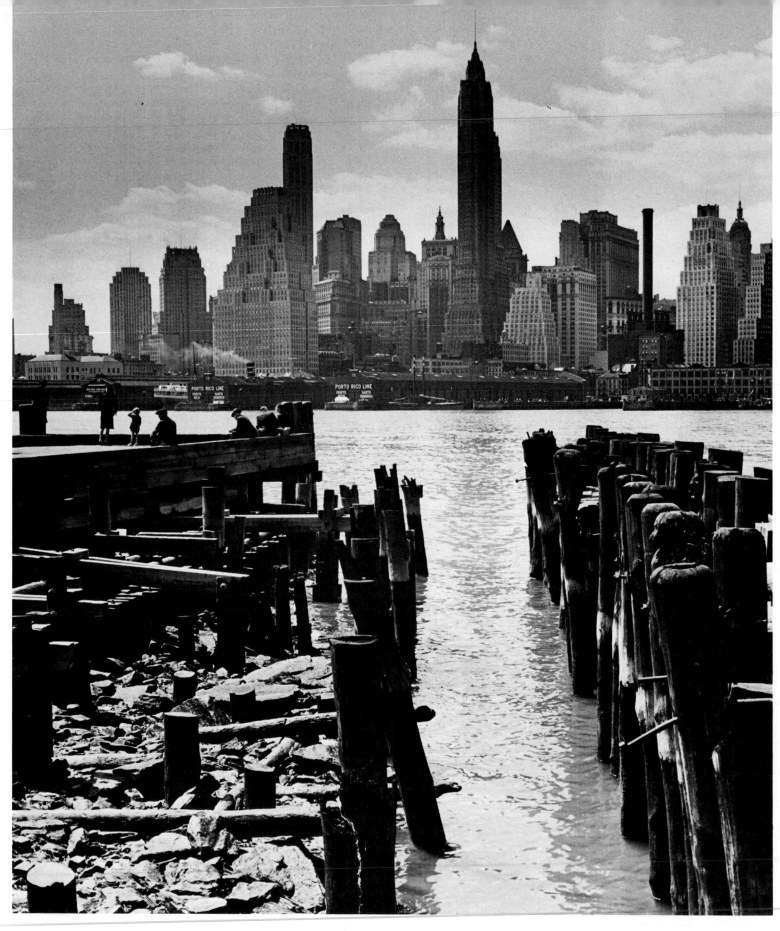

Downtown Manhattan from piers at Brooklyn Heights. With the financial district as a backdrop, Brooklyn residents gather on an old East River pier to take the sun and air. The white building with the stepped-back profile is the 33-story structure at 120 Wall Street, the latest building constructed on the street.

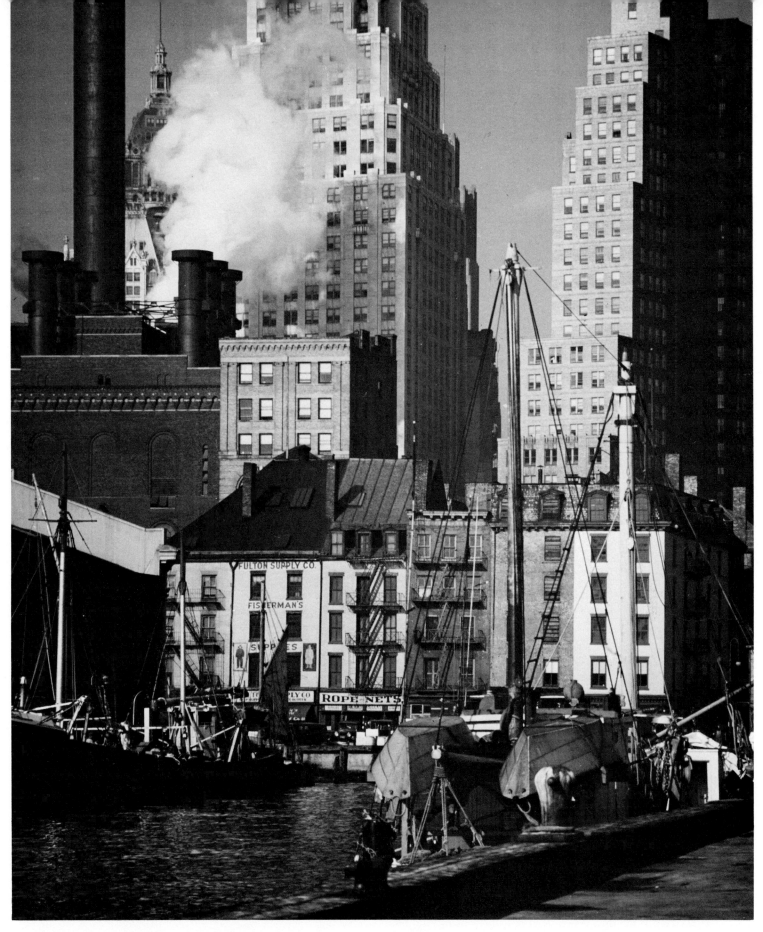

South Street from a pier at the foot of Fulton Street. During the heyday in the 19th century, South Street was known as "The Street of Ships." Winding along the East River in Lower Manhattan, South Street had piers where proud clipper ships and other sailing vessels tied up. South Street's prosperity passed with the sailing ship, but even in the 1940s vestiges of the old days remained. The massive brick building with the tall stacks at left is a steam plant that provided heat for the modern structures in the area.

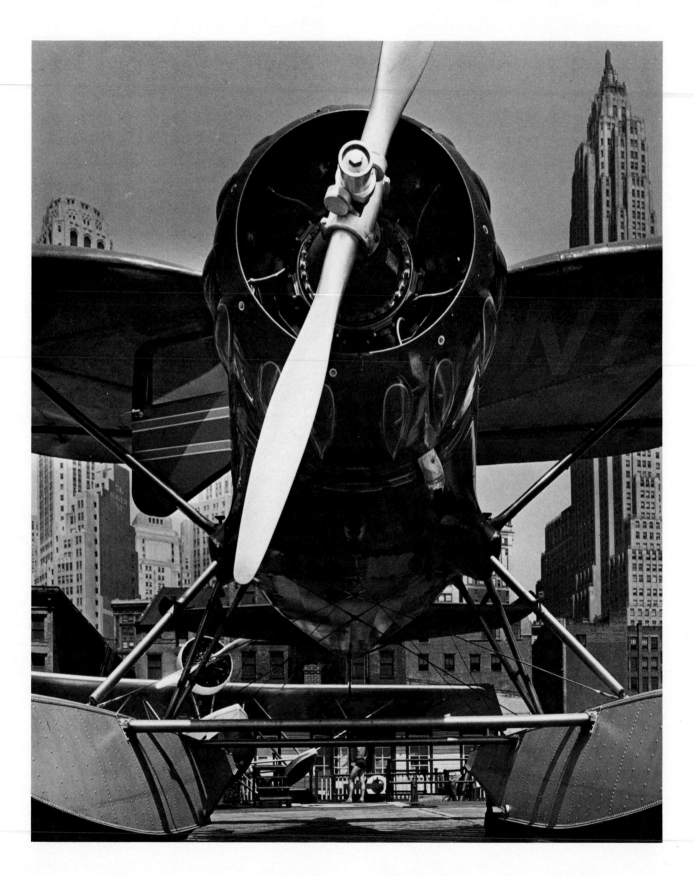

Two views of the downtown skyport at the foot of Wall Street. A few wealthy businessmen who lived in Long Island had an unusual way to commute to work at Wall Street—private seaplane. The planes took off from the Long Island Sound to land on the East River and taxi to the municipal Downtown Skyport between piers 11 and 12. For those who could not afford this costly means of travel, speedboats ran regularly from Long Island's North Shore to Manhattan. And those who merely wanted a quiet place to take a break at noon found the skyport piers a pleasant spot to relax.

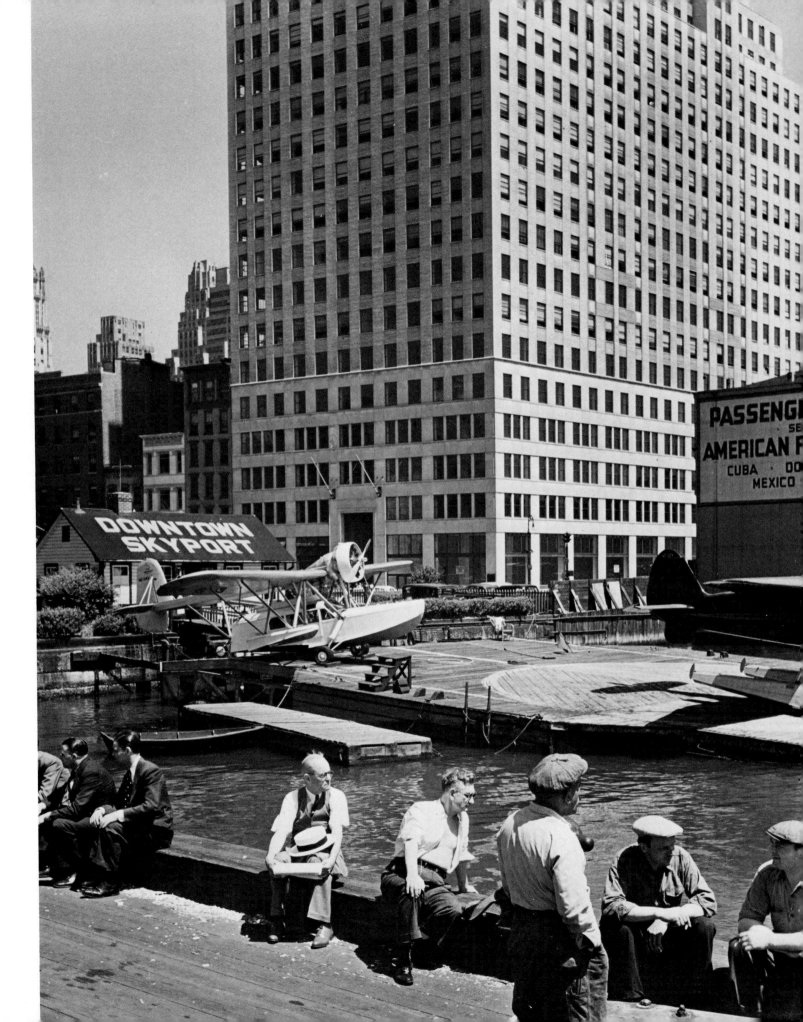

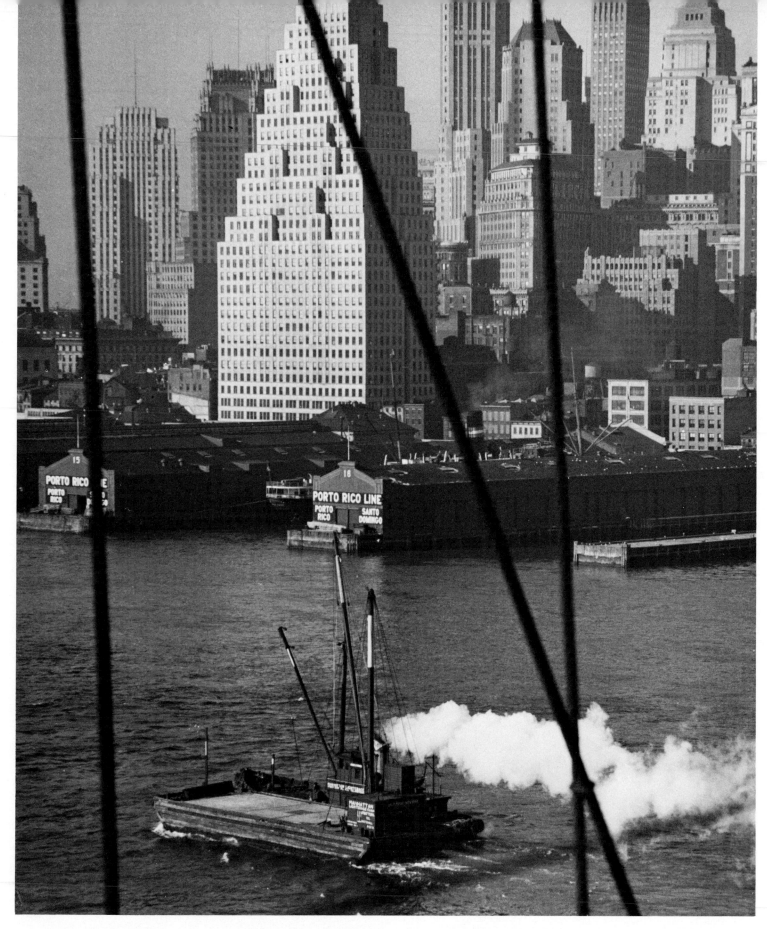

Lower Manhattan from the Brooklyn Bridge. Bracketed by cables from the Brooklyn Bridge, a lighter steams along the East River. In the busy port of New York in the 1940s, lighters puffed from cargo ship to pier, their booms and flat-bottomed hulls designed for loading and unloading vessels. Since overseas air transport was still in its infancy, commercial ship companies like the Porto Rico Line prospered and every pier was in active use.

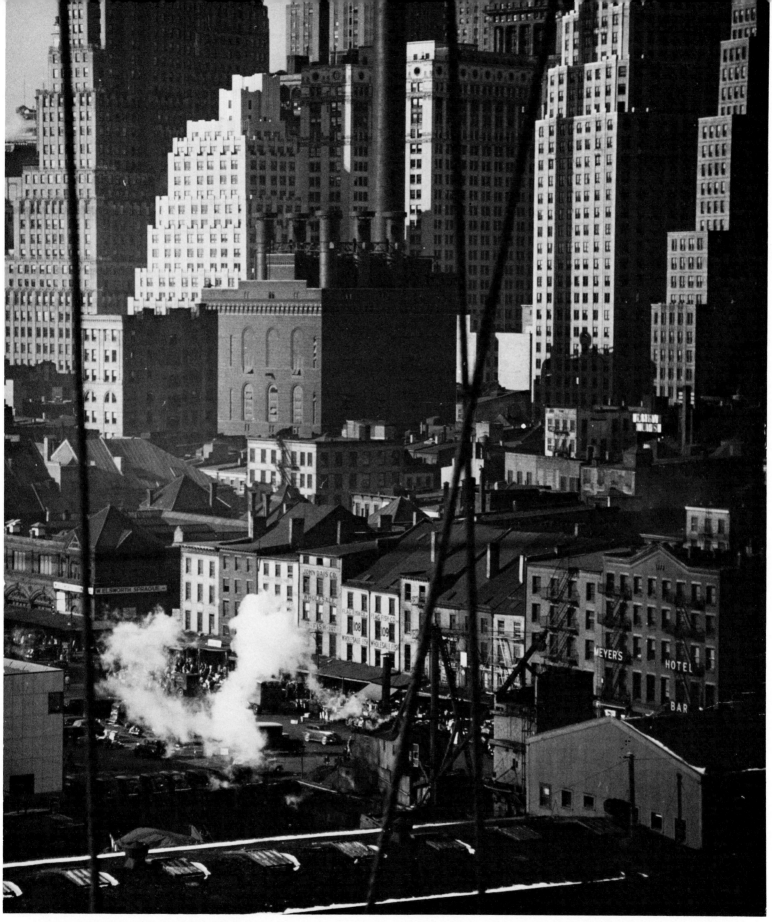

South Street from the Brooklyn Bridge. South Street was the home of the ship's chandlers in the days when sailing ships turned the East River piers into forests of masts. In the 1940s, suppliers continued to occupy the old buildings, side-by-side with wholesale fish companies serving the nearby Fulton Market and a hotel-bar for seamen on Peck Slip.

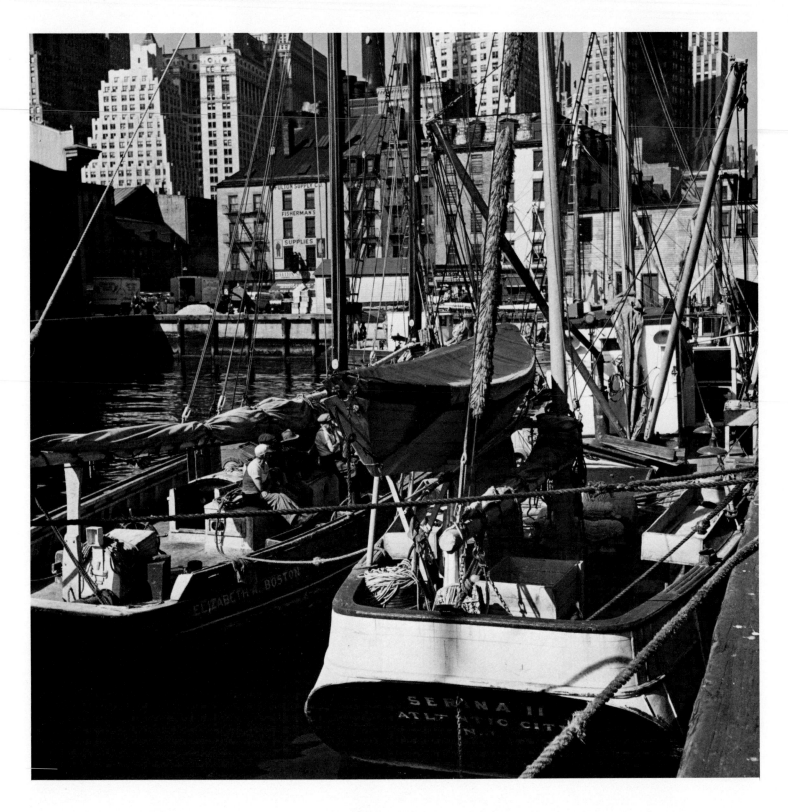

Fishing boats at South Street [above]. Ice on a fishing boat's rigging [opposite]. The fishermen who took sailing craft into the North Atlantic from South Street piers were a hardy crew. While most of the vessels had auxiliary engines to make navigation easier through the treacherous currents of the East River, once at sea the fishermen trusted the Atlantic winds to carry them to the fishing grounds. The weather was not always charitable, particularly in winter. The ice-encrusted vessel at right is testimony that the extreme weather made the lives of the fishermen in the 1940s as perilous as those of 100 years ago.

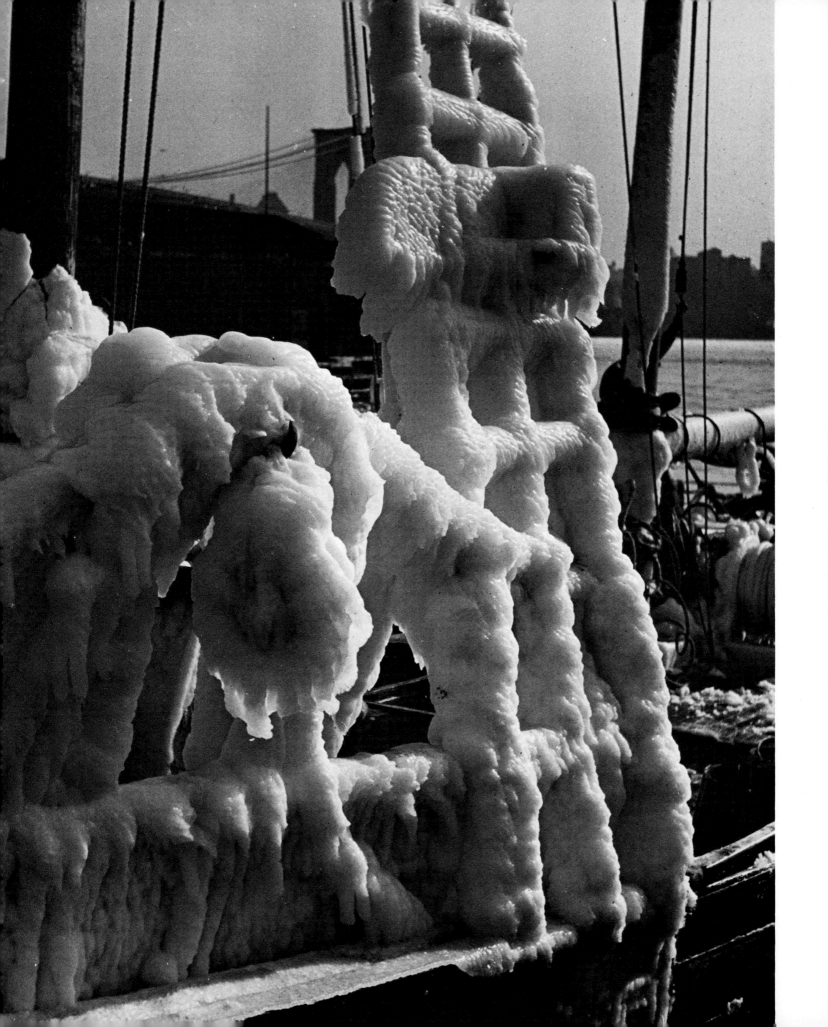

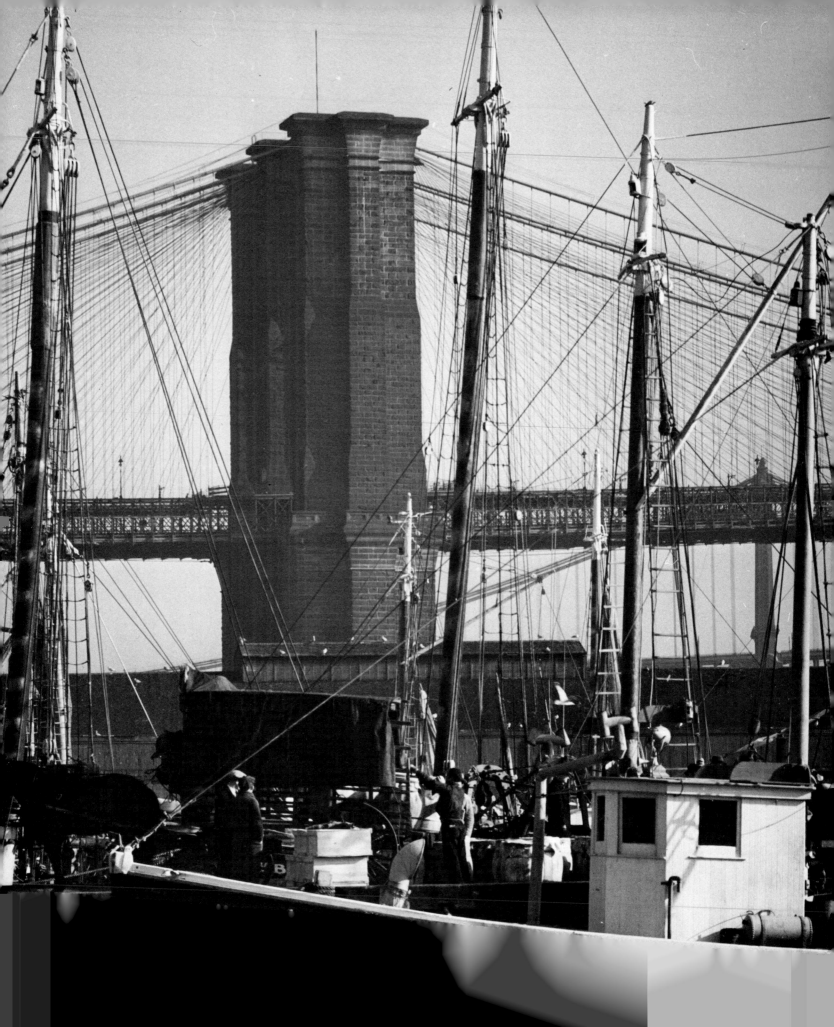

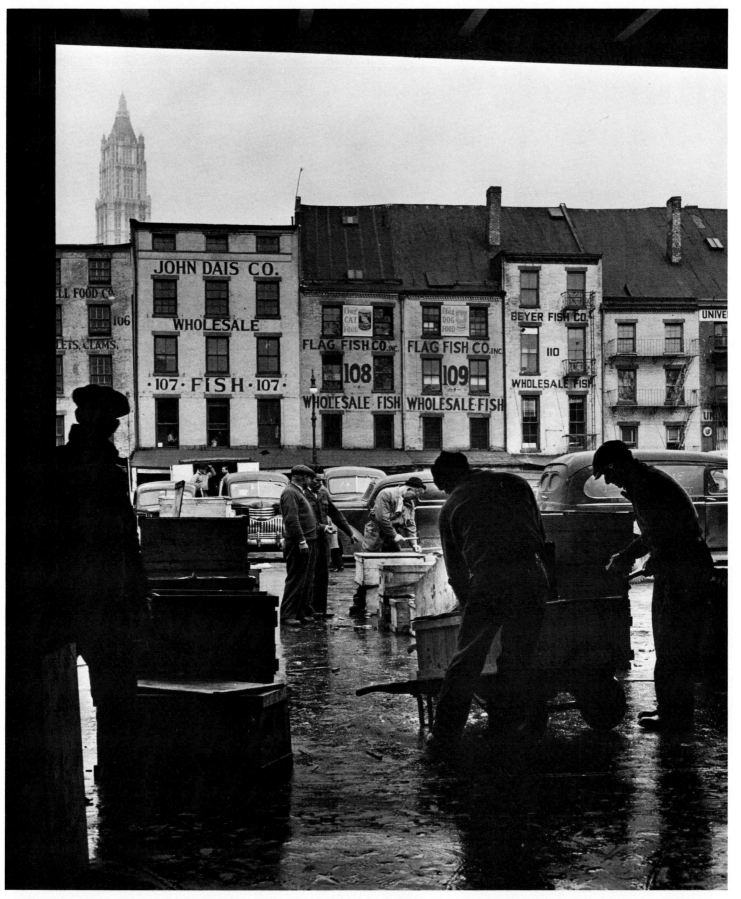

The Fulton Fish Market [above]. At the Fulton Fish Market workers crated in ice the fresh catch for shipment to markets in the city and along the Atlantic seaboard. The Woolworth Building juts above the wholesale fish buildings.

Fishing Vessels docked near the Brooklyn Bridge [opposite]. The tall-masted fishing boats with the Brooklyn Bridge in the background are reminiscent of the 19th century.

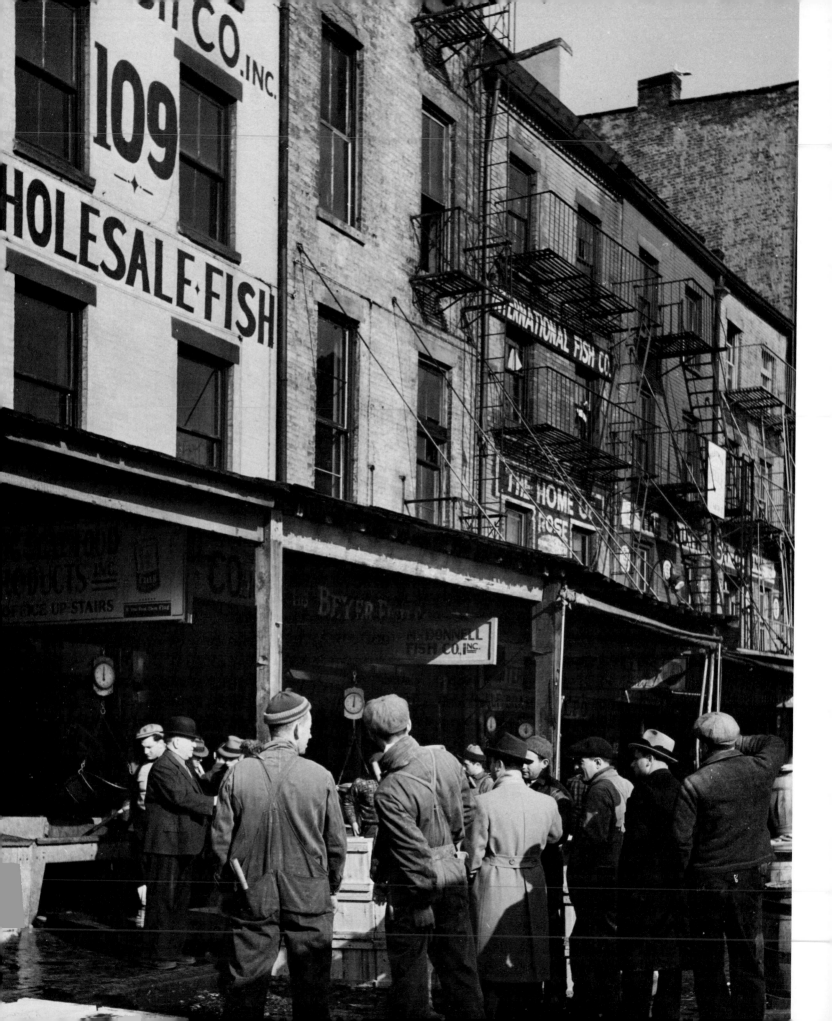

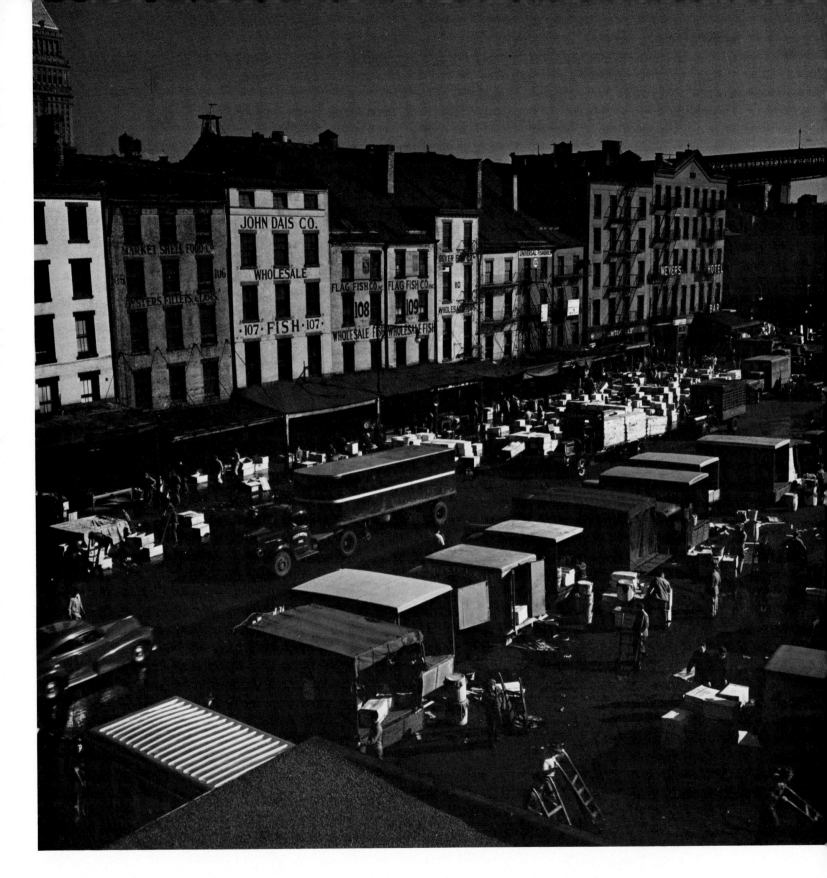

Two views of the Fulton Fish Market during the early morning hours. The Fulton Fish Market burst with activity between the hours of two and nine in the morning, reaching its frenzied peak at dawn, when trucks were loaded (above). Buyers, fishermen and workers continued business during the post-dawn hours, their day completed at the hour when most New Yorkers were beginning their day.

The crossing of Fulton Street and South Street on the East River had been a market for more than a century. Originally a retail outlet for meats, vegetables and other produce, it gradually became dominated by the fish merchants. Indeed, it was the largest wholesale fish market on the Atlantic seaboard, selling up to a million pounds of fish daily.

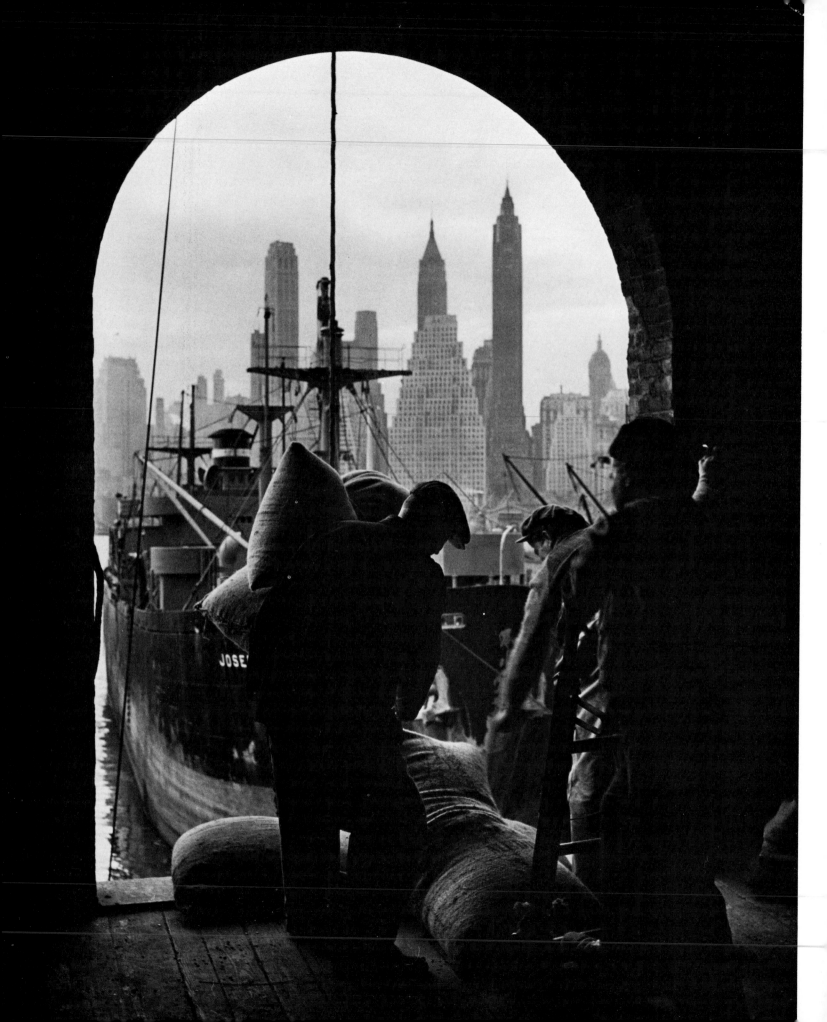

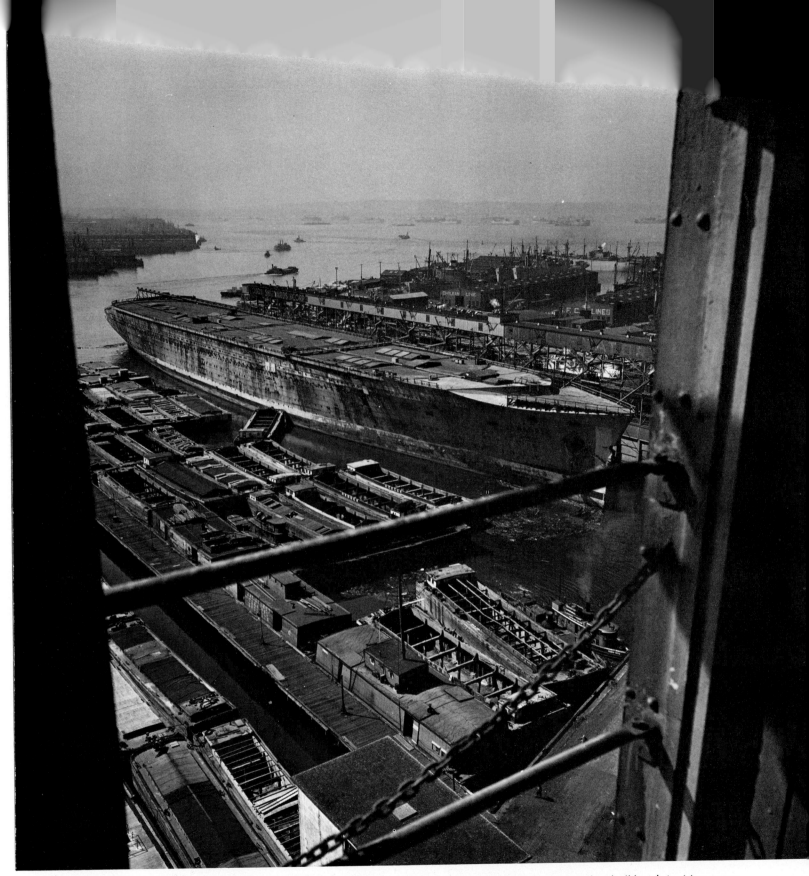

**The burned-out hull of the "Normandie" in Brooklyn [above].
Longshoremen unloading bags of coffee in Brooklyn [opposite].**
The busiest sector in the Port of New York was Brooklyn,
where the scent of Colombian coffee filled the morning air as
workers wrestled sacks of the beans from a freighter. And the
acrid stench of acetylene shrouded the once-proud French
liner *Normandie*. In 1943, after the outbreak of World War II,
the *Normandie* was being refitted as a troopship in New York
harbor. A welder's torch cut through a bulkhead, igniting some
inflammable material on the other side. While the luxury liner
blazed, water from the firefighters' hoses caused the ship to
roll over on its side. After the fire was doused, the remains of
the hull were towed to a salvage yard in Brooklyn — there to be
cut up into scrap metal for the war effort. For a sight of the
Normandie when she was the belle of the seaways, see page
60.

25

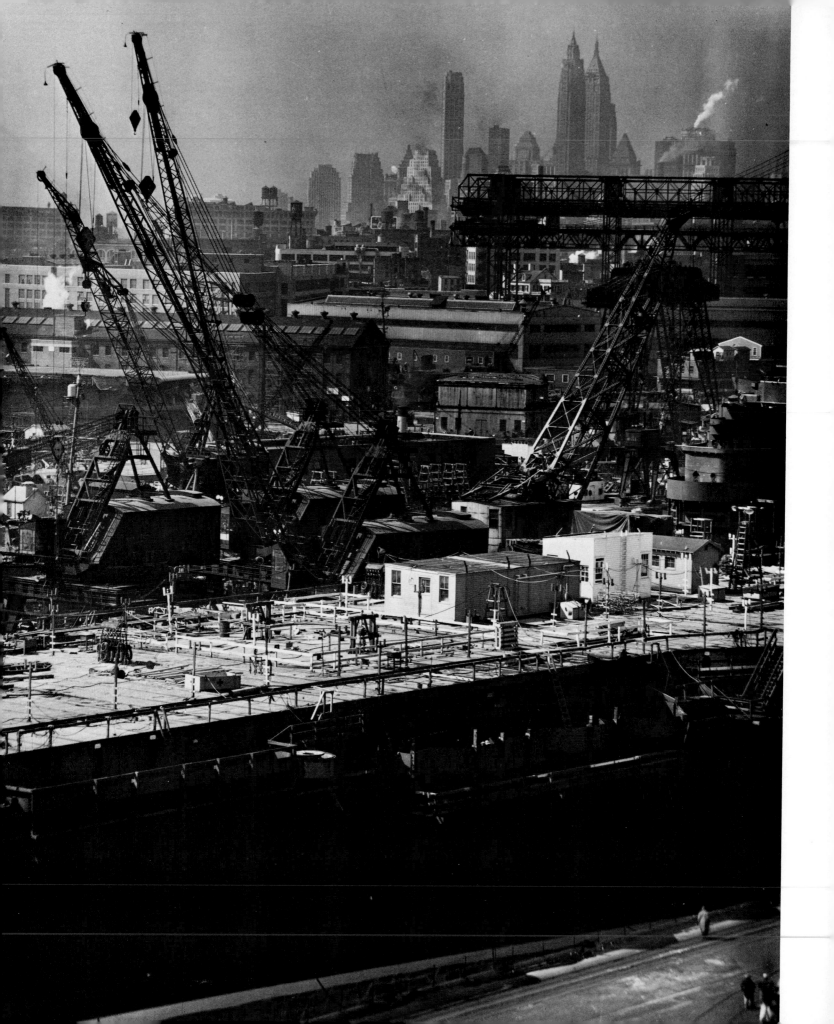

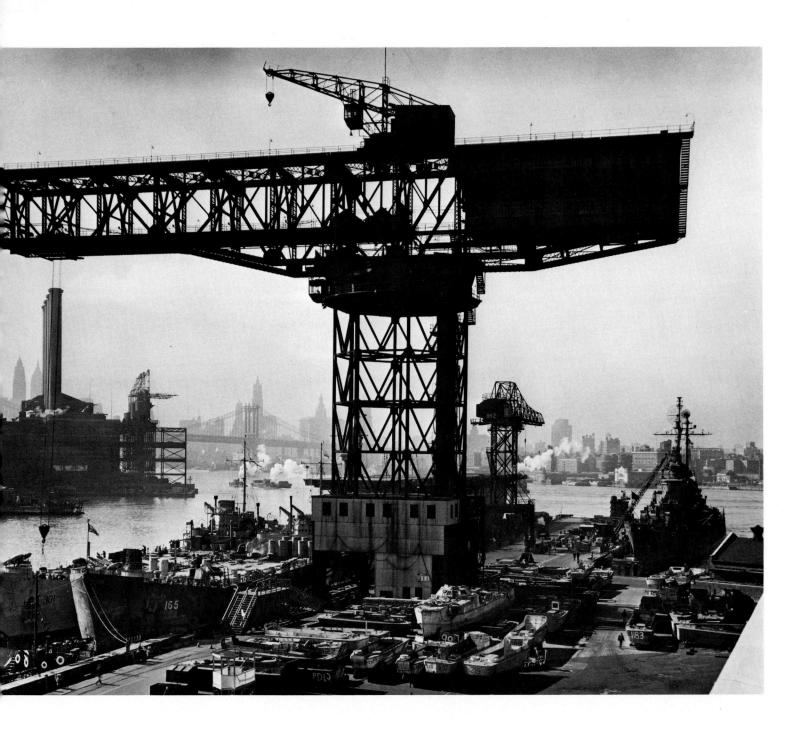

A mammoth crane at the Brooklyn Navy Yard [above]. An aircraft carrier under construction at Brooklyn Navy Yard [opposite]. In the 40s New York was still a center of ship construction. The port boasted 26 shipbuilding plants and 50 floating docks for repair work. These yards were alive with the staccato rhythms of rivet guns. Some of the largest cranes in the world rivaled the skyscrapers in creating a dramatic skyline. Four of the biggest boat-building and repair yards, including the world-famous Navy Yard, were in Brooklyn. During the war years, fighting ships like the aircraft carrier opposite were built there in record numbers. The landmark of the Brooklyn Navy Yard was the crane seen above. This behemoth could lift 250 tons without effort and was so large that it made the destroyer and other warships beside it seem like toys. For smaller lifts, a satellite crane rested atop its broad shoulders.

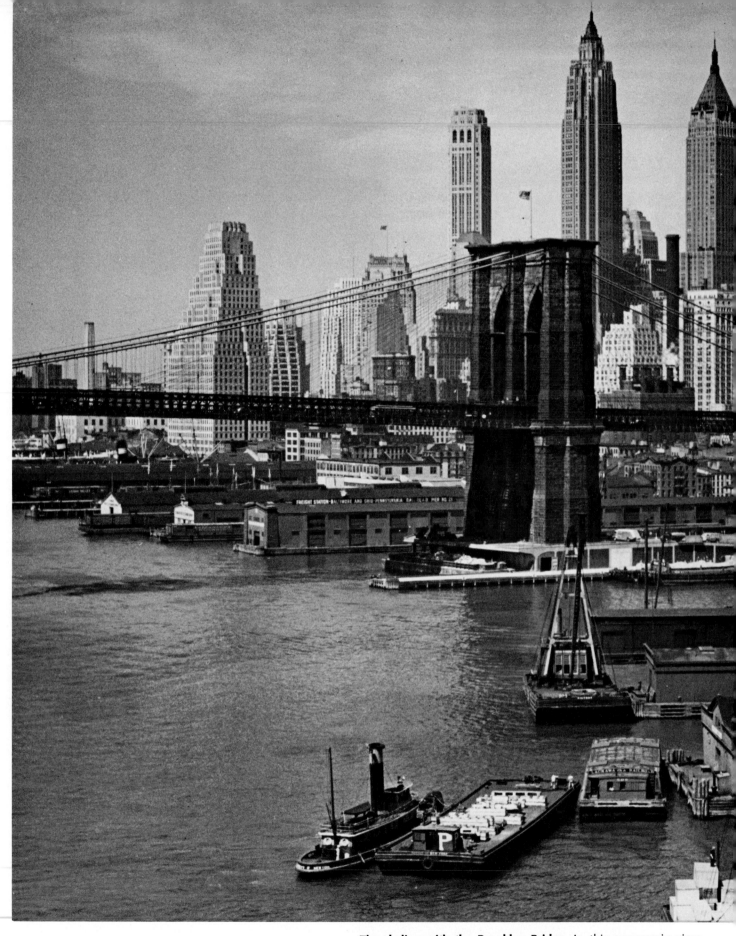

The skyline with the Brooklyn Bridge. In this panoramic view the rounded spire of the Singer Building is visible at the center of the right-hand page. Once the tallest building in the world at 612-feet until uncrowned by the Metropolitan Life Tower,

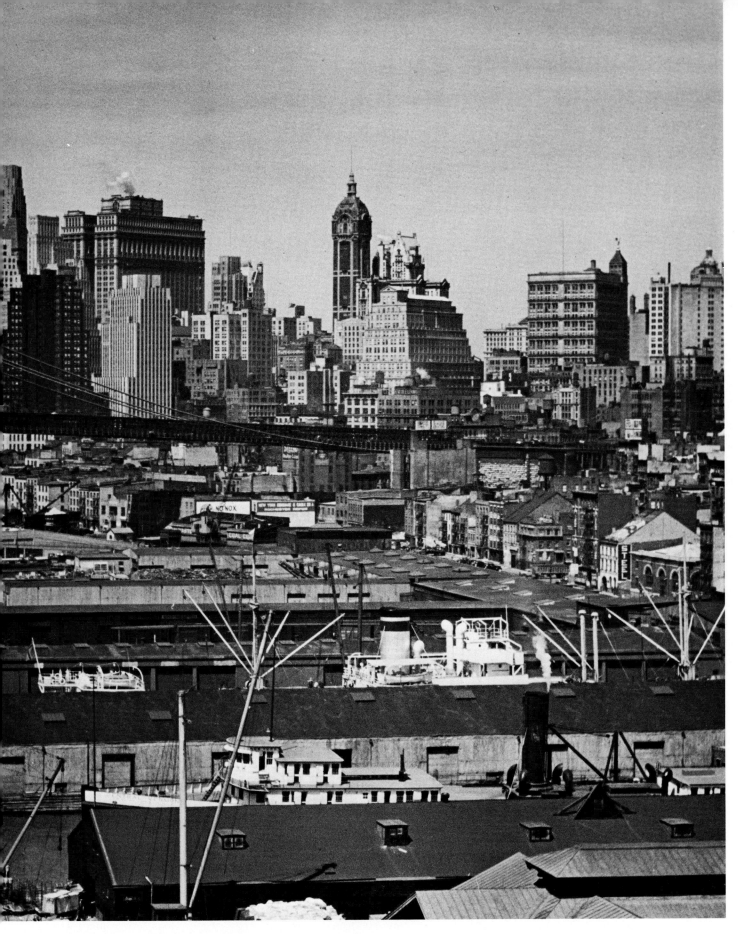

Ernest Flagg's fine architectural achievement was demolished in 1968. The skyline reflects the ziggurat, or stair-step, construction determined by the building codes of the time.

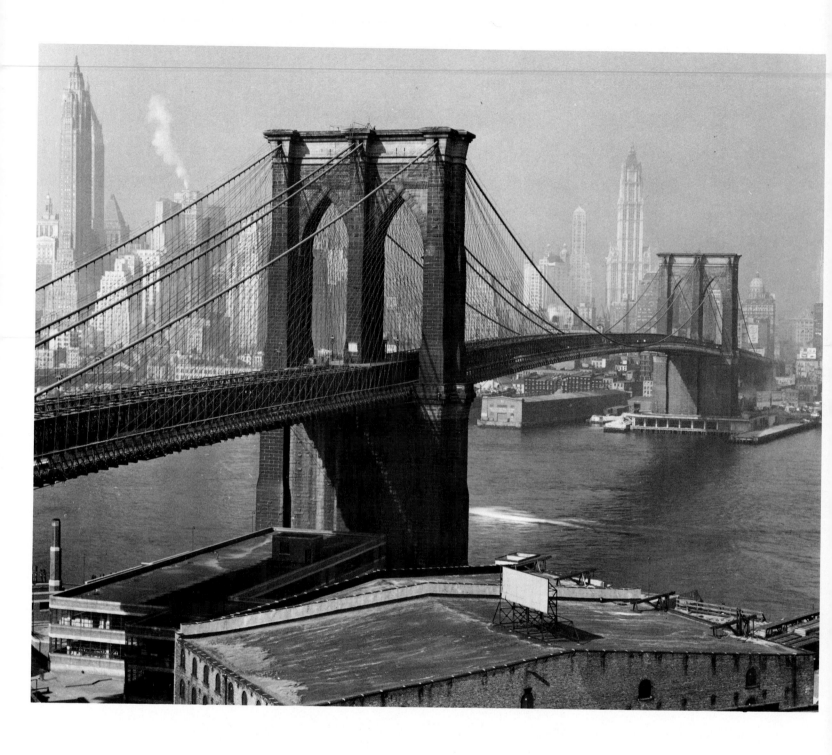

The Brooklyn Bridge as seen from Brooklyn [above]. Oliver Street on the Lower East Side with bridge in background [opposite]. The Brooklyn Bridge, one of the greatest engineering achievements of the 19th century, is a structure that has assumed mythic proportions. Facts about it are frequently stated: begun in 1870 and completed in 1883 at a cost of more than $25 million, its span of 1,595 feet is suspended from towers 271 feet tall. But the appeal of the bridge transcends statistics; it is a national treasure that inspires awe no matter what the neighborhood from which it is viewed.

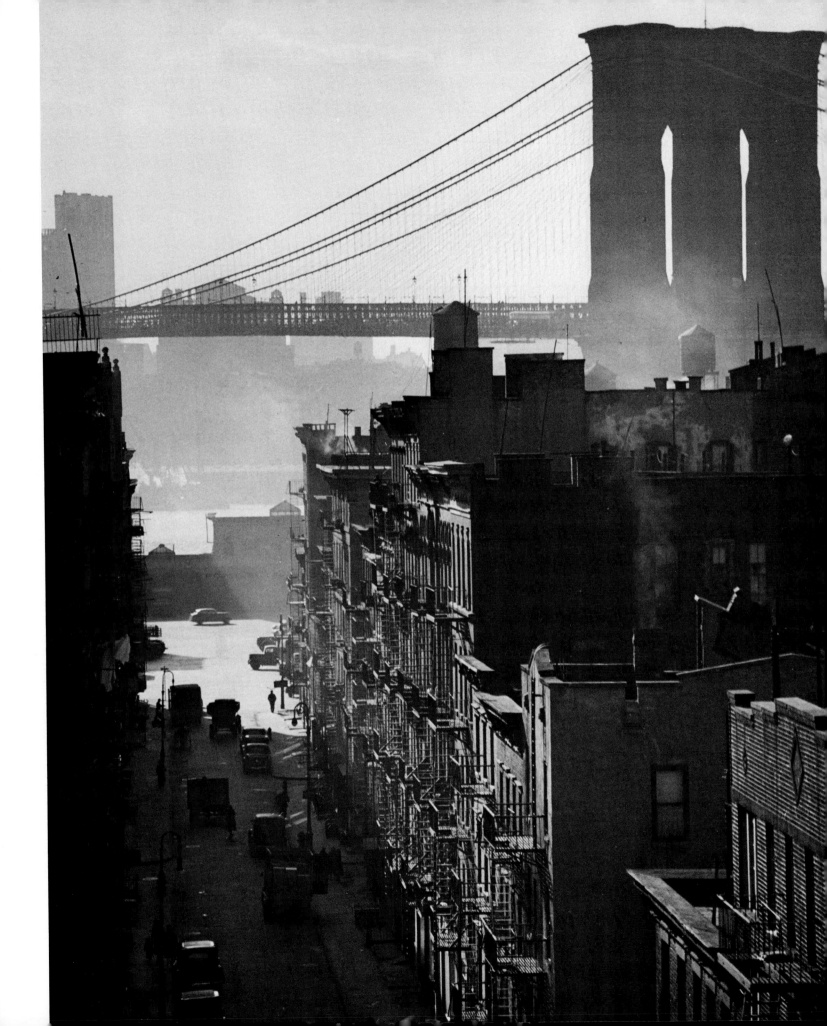

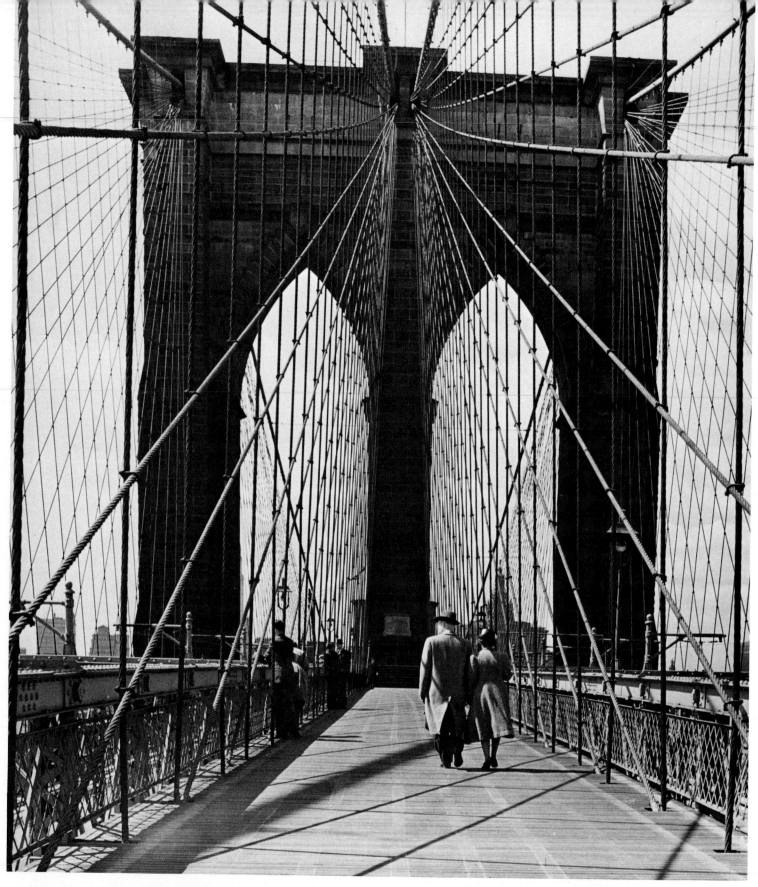

Two views of the Brooklyn Bridge promenade. Unlikely as it seems in our motorized society, the Brooklyn Bridge was designed primarily for pedestrians. The center lane of the magnificent suspension bridge was a raised promenade, a wooden boulevard that promised pedestrians relief from the endless shuttle of ferries across the East River. The bridge's vehicular roadways were of secondary importance to this bold walkway.

Pedestrians responded to their bridge, but they could not hope to compete with pressures from vehicular traffic. Inexorably, motor vehicles commandeered the bridge and extra lanes were added for them. But through the 40s, the 12-foot-wide promenade never lost its appeal to strollers, particularly on bright, clear Sundays.

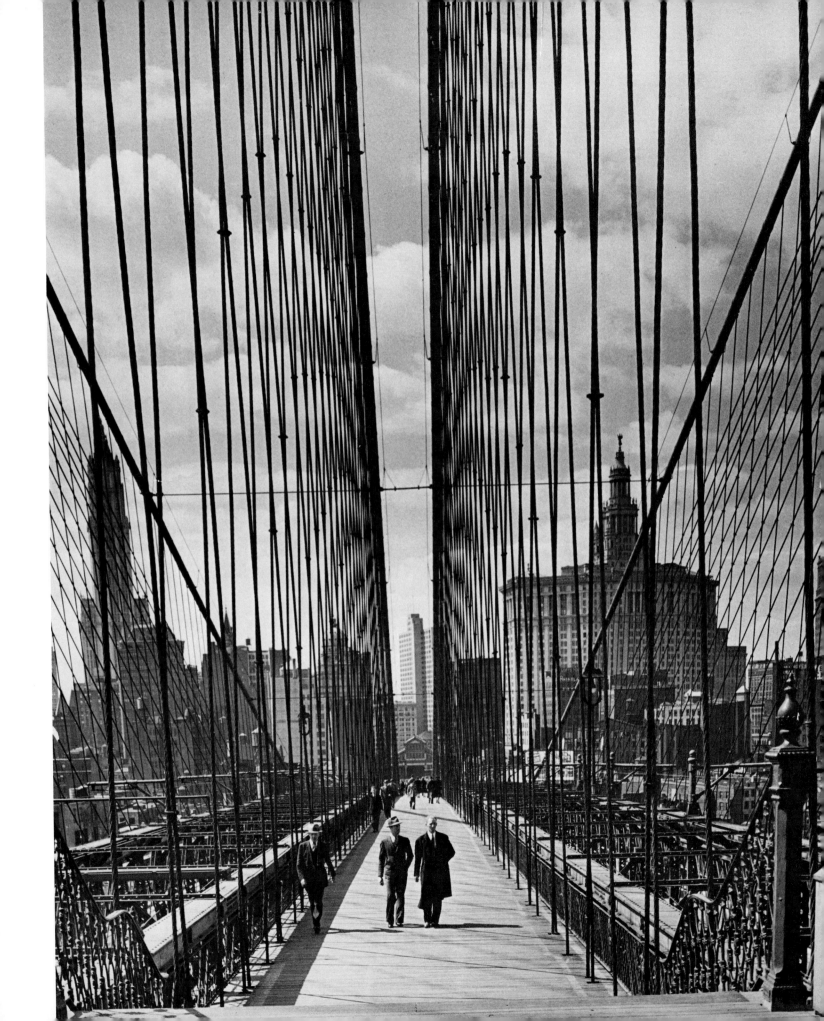

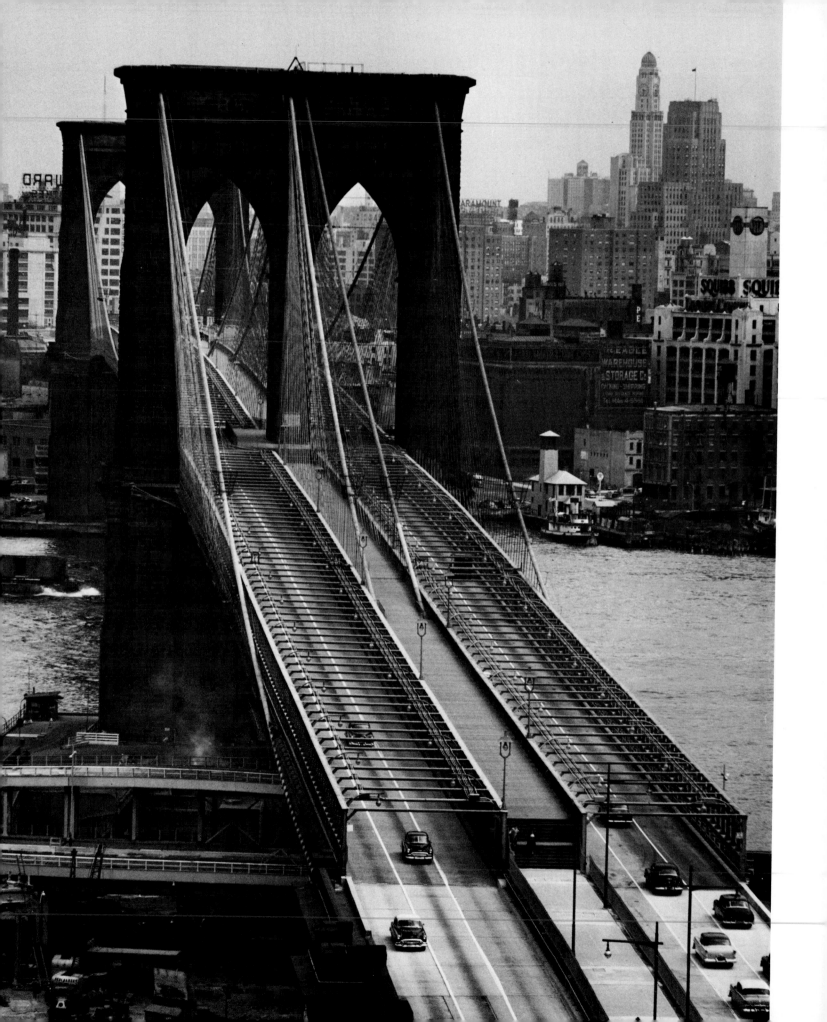

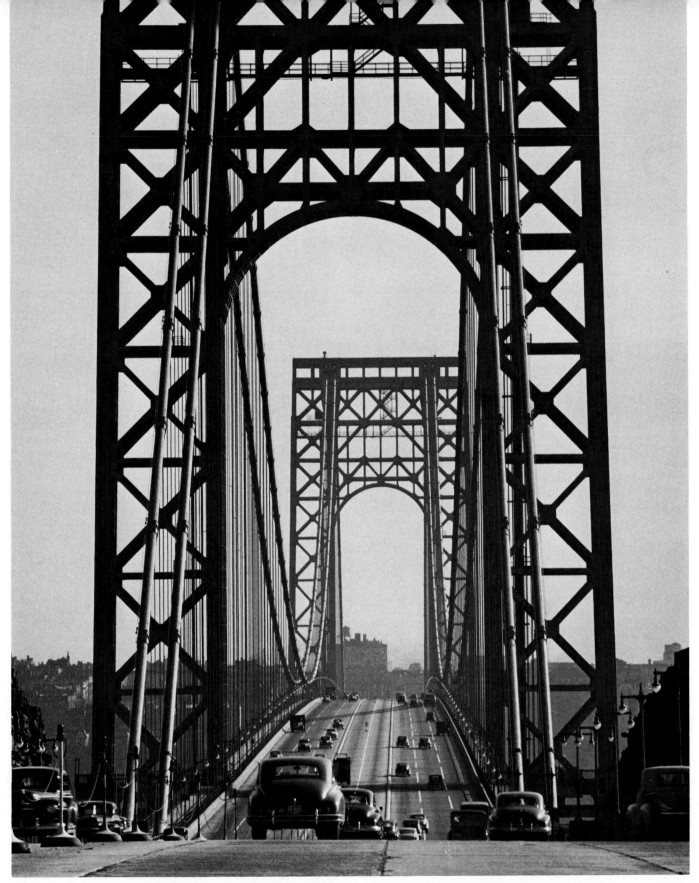

The George Washington Bridge [above]. The Brooklyn Bridge [opposite]. In the 40s, the George Washington Bridge was relatively new, the city's first—and only—span across the Hudson. Completed in 1931, the 3,500-foot bridge was the longest in the world; more than twice the length of the older Brooklyn Bridge. The new bridge had a six-lane highway and narrow pedestrian walk, which shows how the emphasis had shifted from walking to motorized transportation in the half-century since the Brooklyn Bridge was conceived. (The Verrazano Bridge, connecting Brooklyn and Staten Island and completed in 1964, contains no provision for pedestrians.) To resemble the Brooklyn Bridge, the towers of the George Washington Bridge were designed by architect Cass Gilbert to be encased in stone—hooks exist on the steel superstructure to hold the slabs. The stone was never added and the bridge remained a testament to the grace of pure steel.

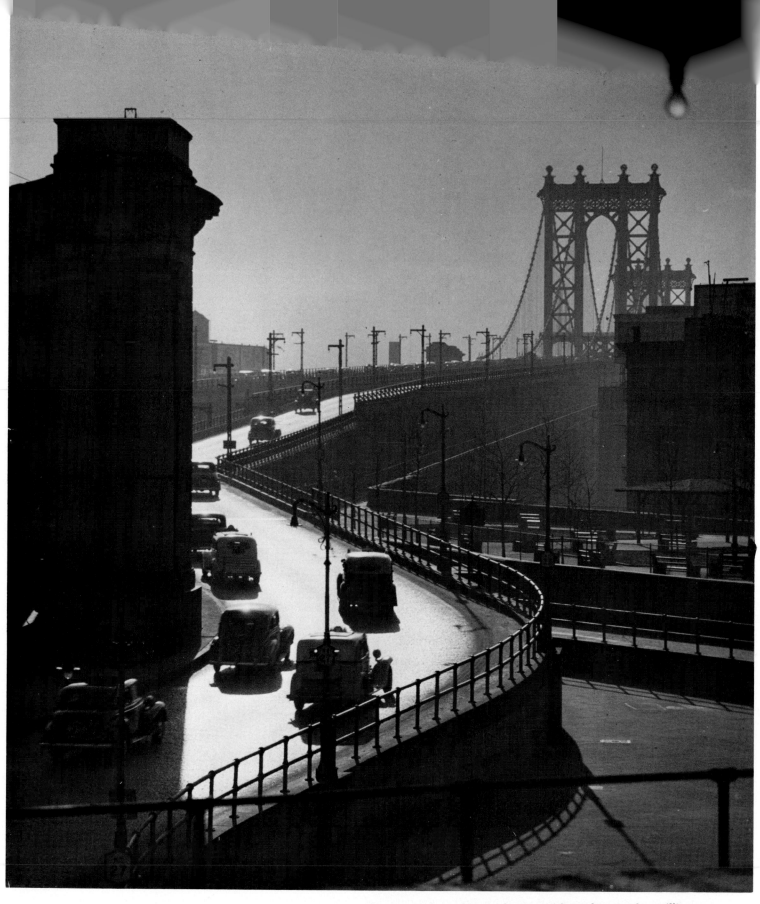

The approach to the Manhattan Bridge [above]. The Williamsburg Bridge [opposite]. Prosaic in design and execution, the Manhattan and Williamsburg Bridges inspired few words of praise. The approach to the Manhattan Bridge swung cars through the rundown blocks of East Side tenements on their way to Brooklyn. Similarly, the Williamsburg Bridge was but a

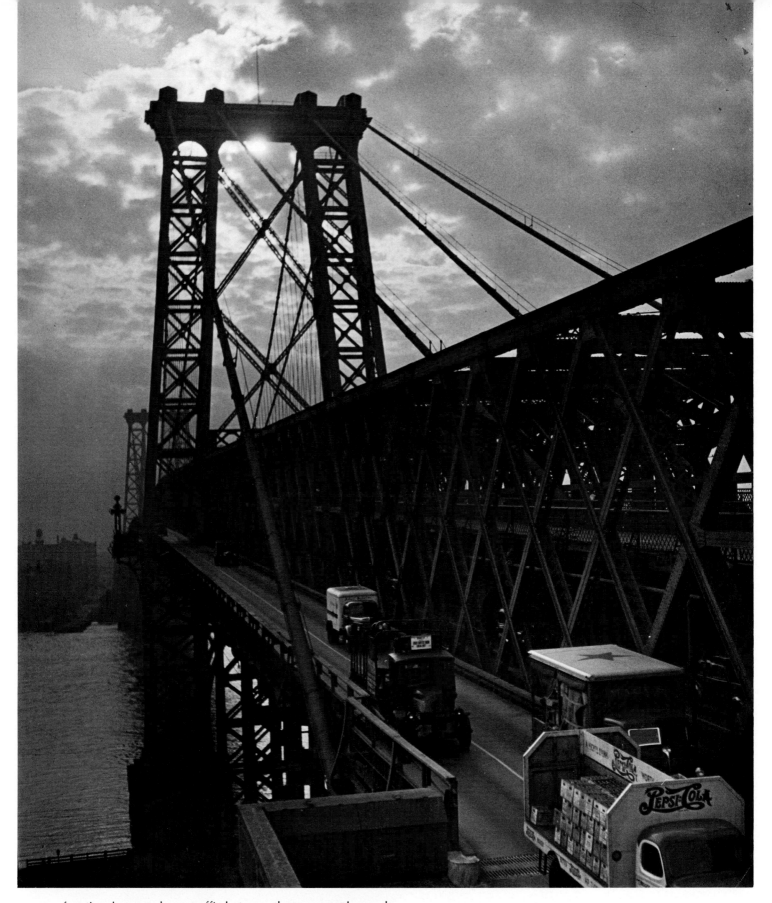

functional span to hurry traffic between the two great boroughs. In the 40s, the Williamsburg Bridge was still an important link for the Jews in their movement from the Lower East Side to Williamsburg and other parts of Brooklyn. Like the Brooklyn Bridge, the Williamsburg was built for heavy pedestrian as well as vehicular traffic.

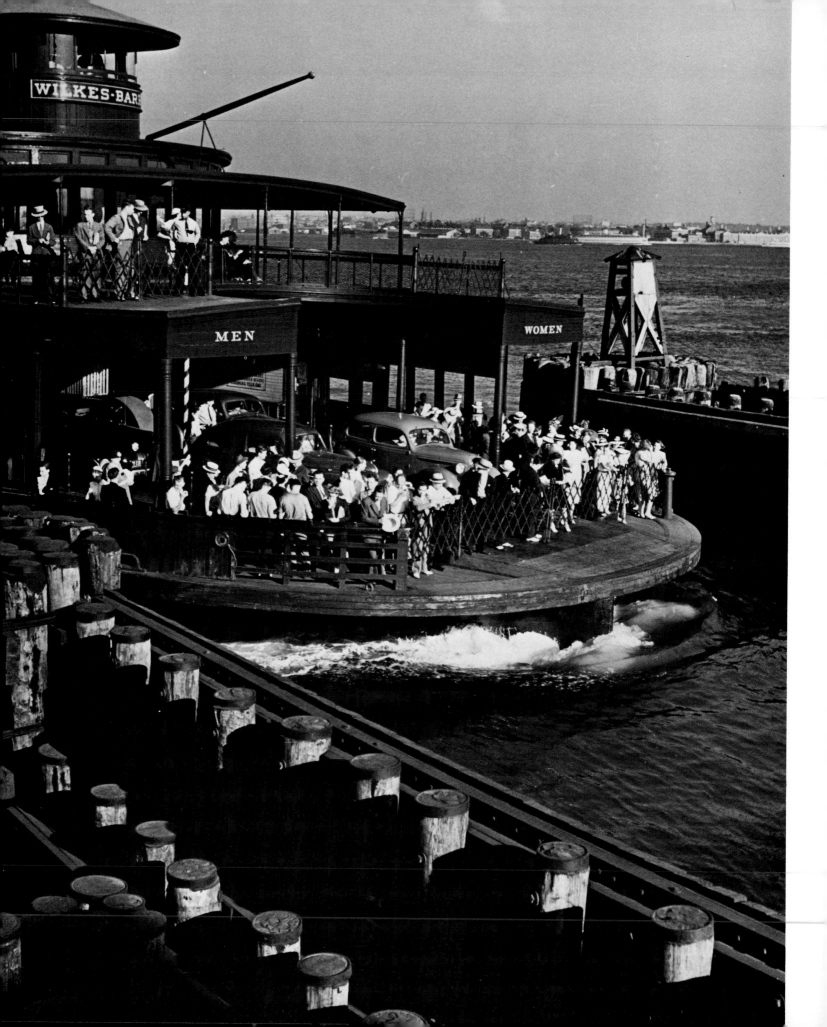

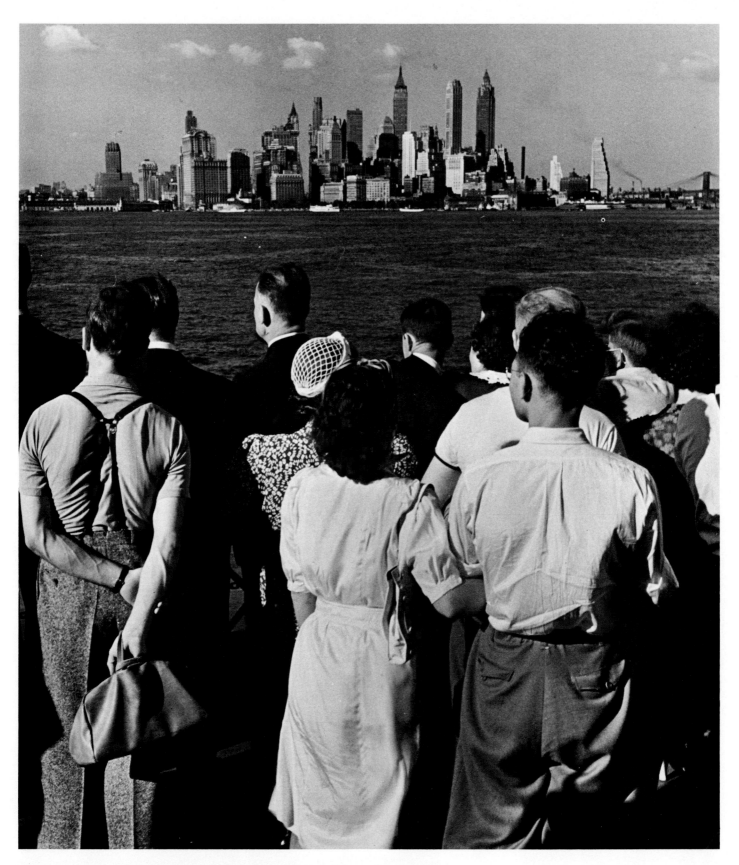

Lower Manhattan from the Staten Island Ferry [above]. Liberty Street Ferry pulling into Jersey Central Pier [opposite]. Manhattan in the 1940s depended heavily on ferries to carry passengers and cars to and from Staten Island and New Jersey. These charmingly archaic ferries, redolent of the 19th century, were part of the New York experience, giving the commuter a relaxed and poetic view of the city twice a day.

39

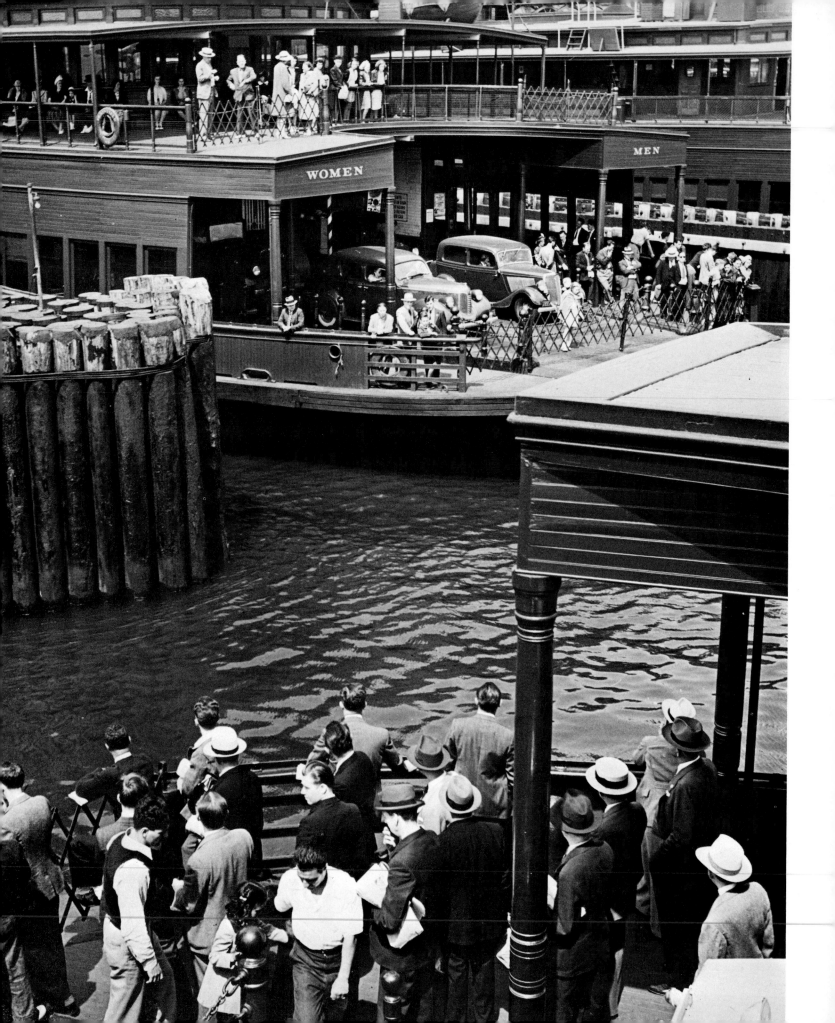

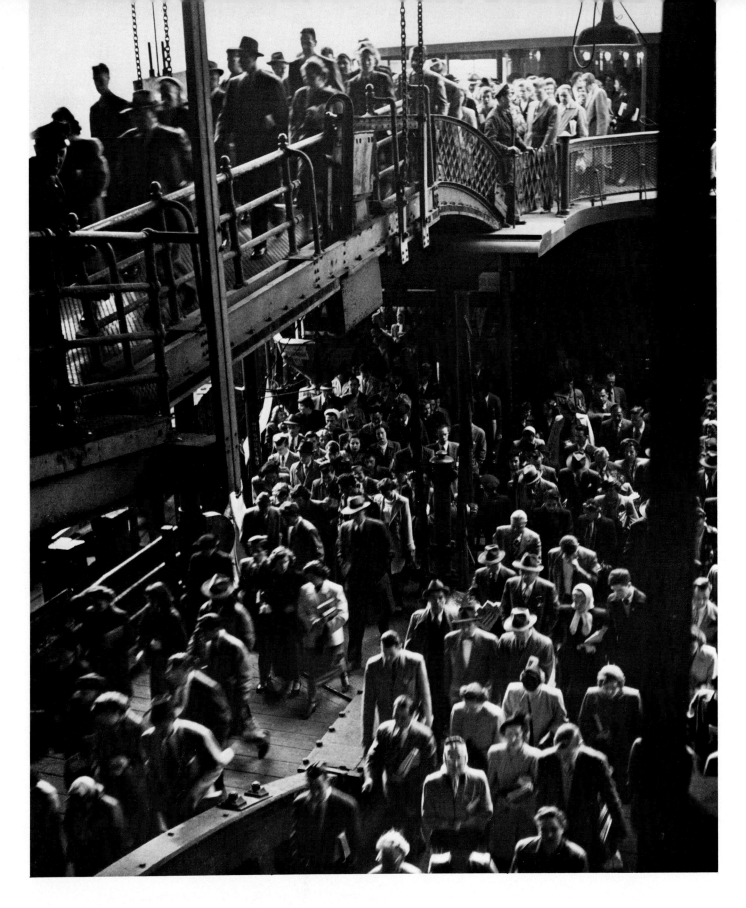

**Passengers debarking from the Staten Island Ferry at the Battery [above].
Hudson Ferry Terminal at Hoboken, New Jersey [opposite].** It's a warm summer day, but in the 40s hats, coats, neckties and dresses were still *de rigueur* for this crowd on their way to work by ferry.

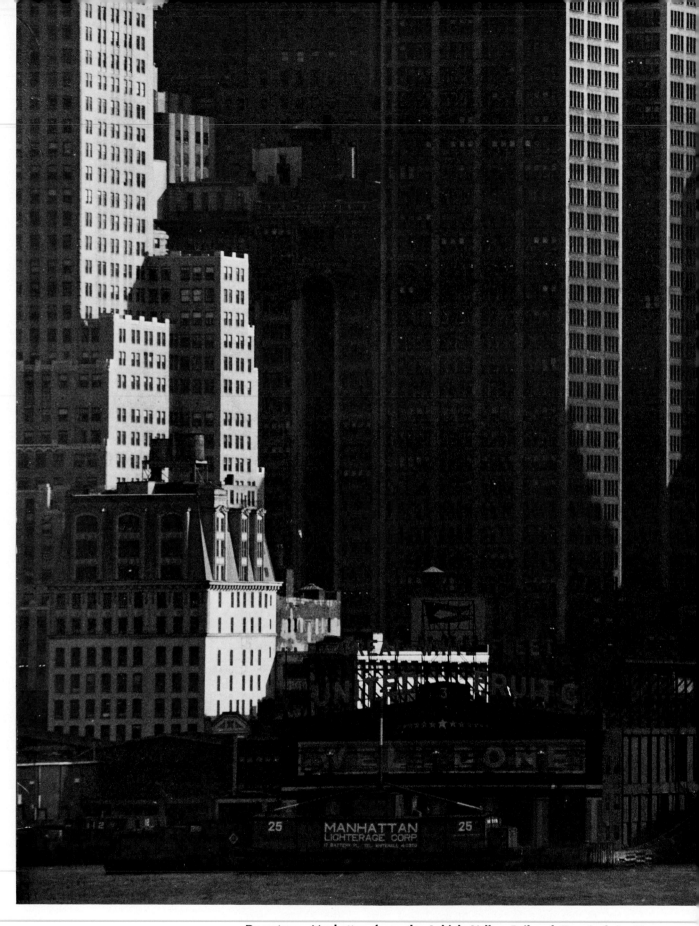

Downtown Manhattan from the Lehigh Valley Railroad Terminal in New Jersey. In this moody scene the rays of the sun dramatize the fact that in the

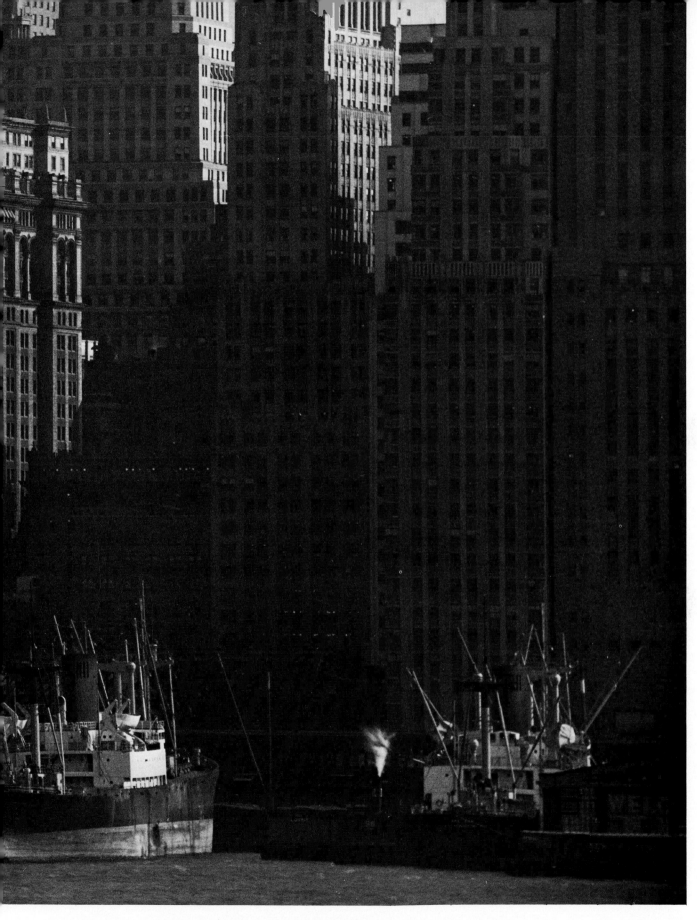

40s New York was a tightly packed city surrounded by hundreds of cargo ships loading and unloading merchandise from every port in the world.

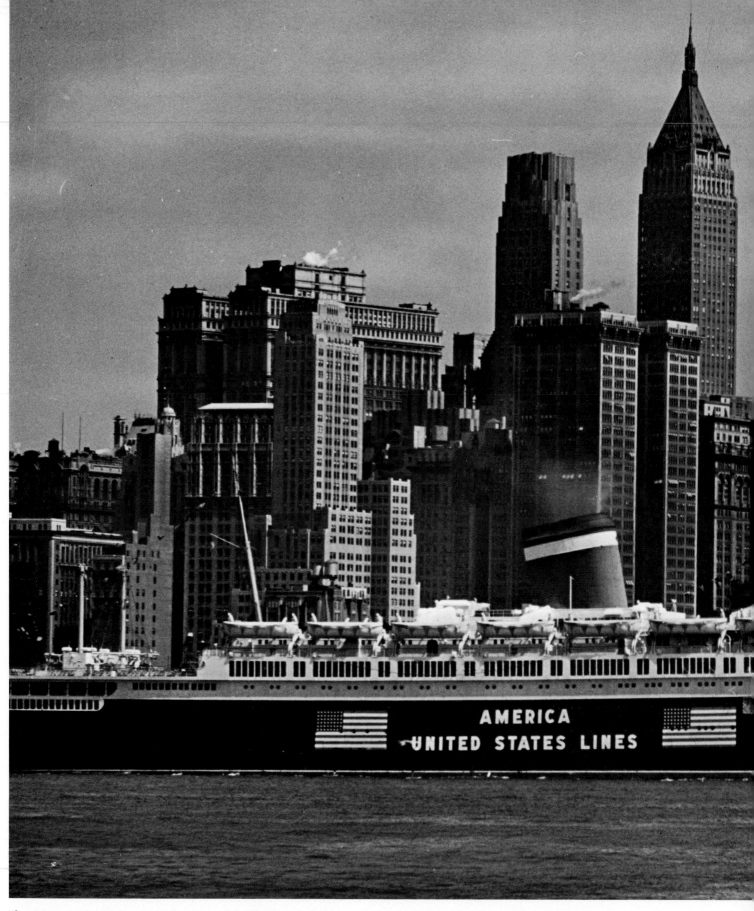

The "America" steams past the Financial District. The large lettering and flags on the flanks of the United States liner *America* served as more than casual identification. These were the days before the American involvement in World War II and the letters and flags announced the ship's neutrality to German submarines prowling the North Atlantic.

The war, of course, interrupted the luxury passenger ship trade in New York. But in the pre- and postwar days, the port was visited by the great ships of the age. With its unmatched natural harbor, New York became the gateway for 85 percent

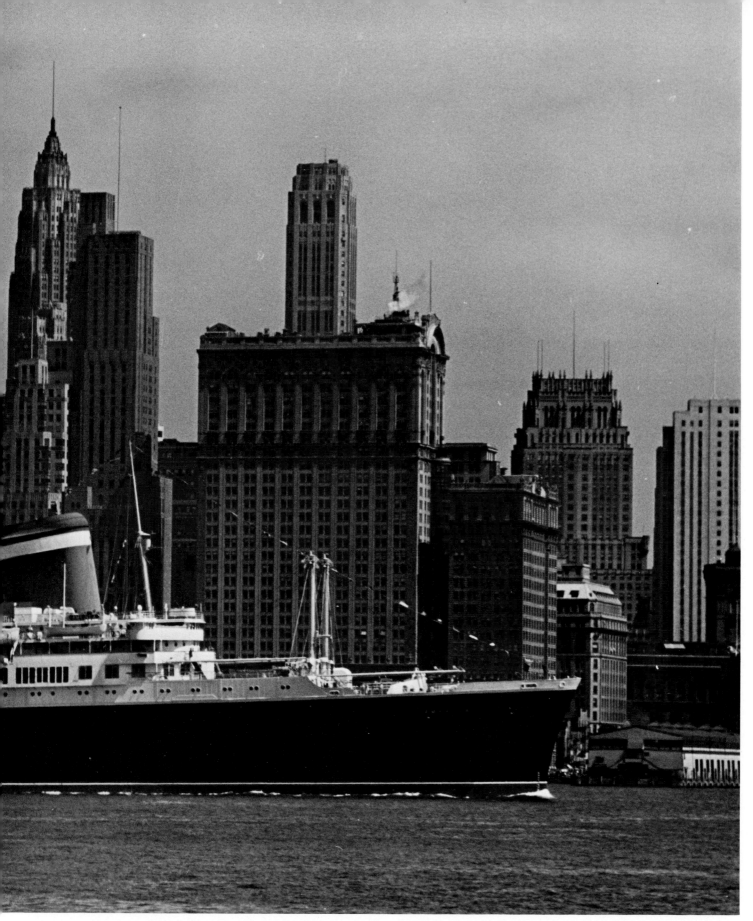

of the country's foreign passenger service. One of the most impressive was the *America*, a sleek vessel 723-feet long and weighing almost 34,000 tons. The sight of such passenger liners in the port was common—so much that they were taken for granted by most New Yorkers. During the decade about 200 vessels of one kind or another tied up every day in New York—one-third of these in Brooklyn and another one-quarter in Manhattan. About 90 steamship lines engaged in foreign trade out of New York while the port received about half of the country's foreign trade.

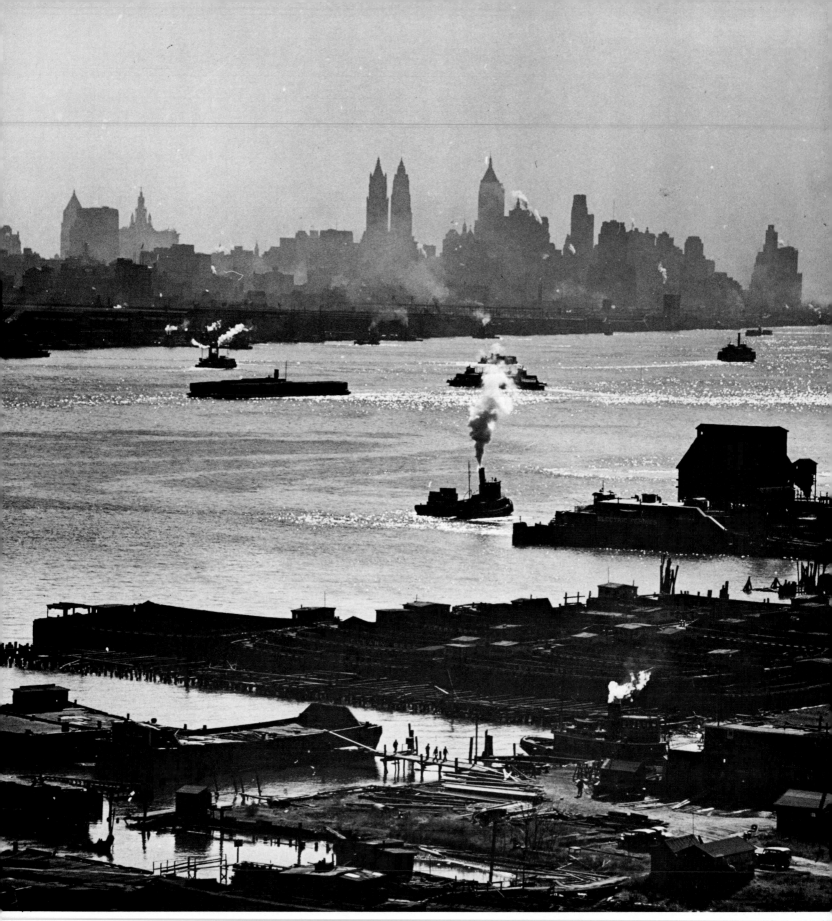

The Hudson River and Lower Manhattan from above the Weehawken docks. Even in the booming maritime decade of the 40s, the port of New York had pockets of blight. Some piers in Weehawken, New Jersey, lay burned and rotting in the mud. Only the port of New York could afford such obvious waste. Undisputedly one of the preeminent natural harbors of the

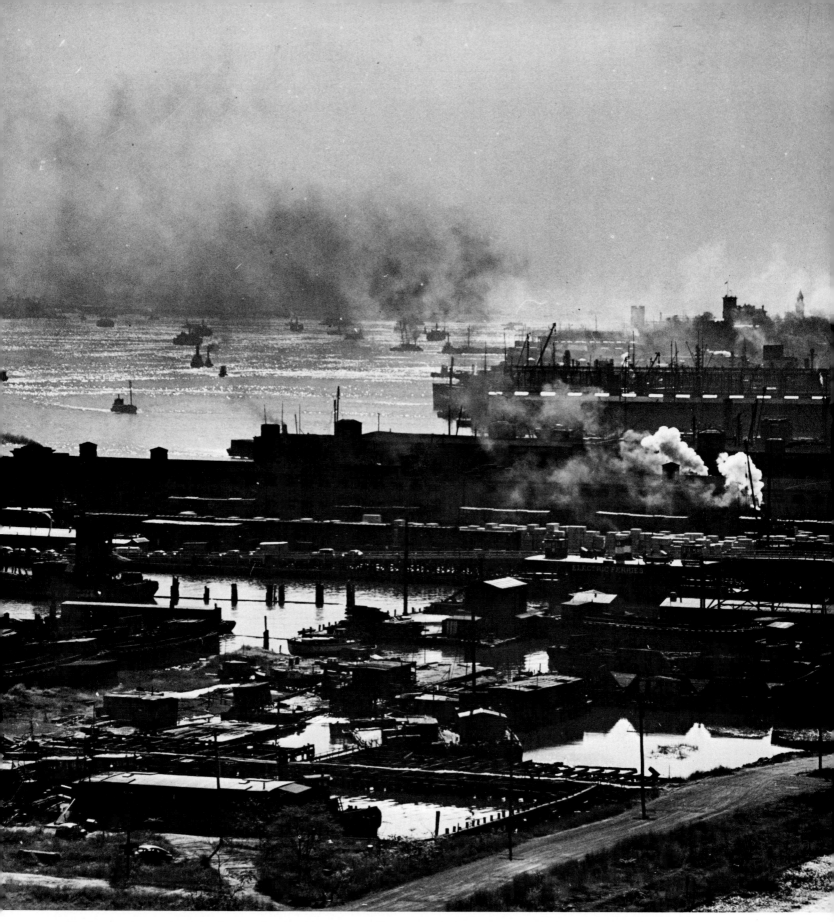

world, the port has seven major bays and 67 anchorage grounds in an area of 92,500 watery acres. The port is replete with other natural advantages. Seldom ice- or fogbound, it is landlocked 17 miles from the open sea to shelter ships from ocean storms and has a moderate tidal range of a mere 4½ feet. Finally, the port is blessed with deep natural channels.

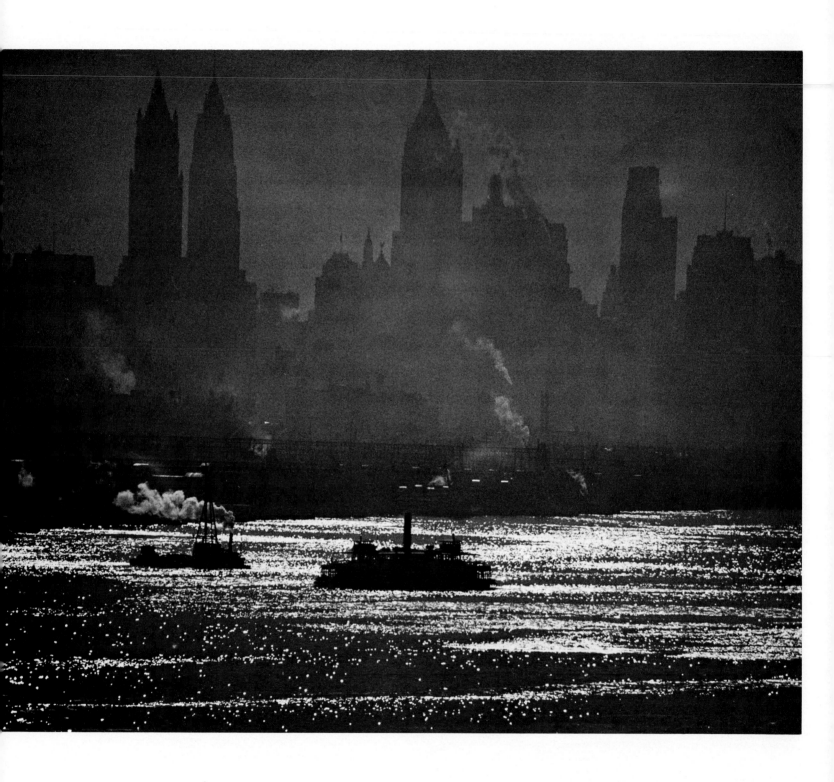

Two views of Lower Manhattan and the Hudson River from Weehawken. The decade saw the increased reliance on Hudson River piers by the heavy shipping traffic in the Port of New York. The Hudson was not always so gainfully employed. Rushes and weeds sprouted on its banks in the 19th century when South Street on the East River was "The Street of Ships." But as the days of the clipper ships came to an end, many steamships turned away from the tricky tidal currents of the East River with its deep but narrow channel. Shipping interests discovered just around the Battery the broad, more placid,

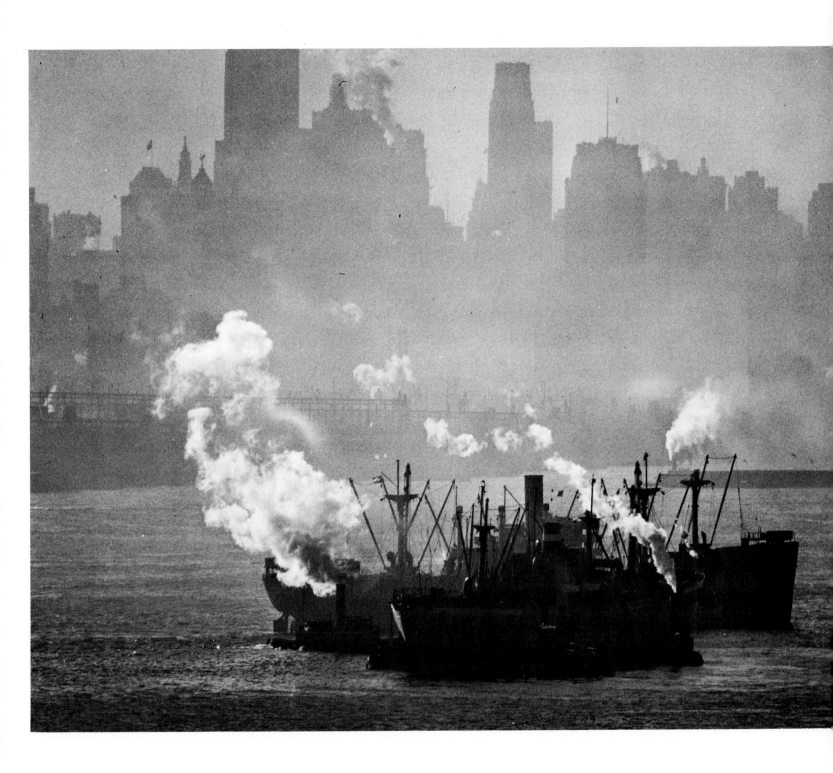

North River–the formal name for the lower end of the Hudson. From Lower Manhattan to West 59th Street dock facilities were constructed—in all, 110 piers, 24 ferry slips and eight float bridges to service the railroad freight cars. By the 1940s, the Hudson was one of the busiest port areas in the world. The whistles and horns of the different boats raised such a cacophony that a trip across the Hudson seemed like a ride on a fire engine headed to a four-alarmer. Tugs, ferries, lighters, freighters, ocean liners and some adventurous pleasure craft made the Hudson into a river of ships.

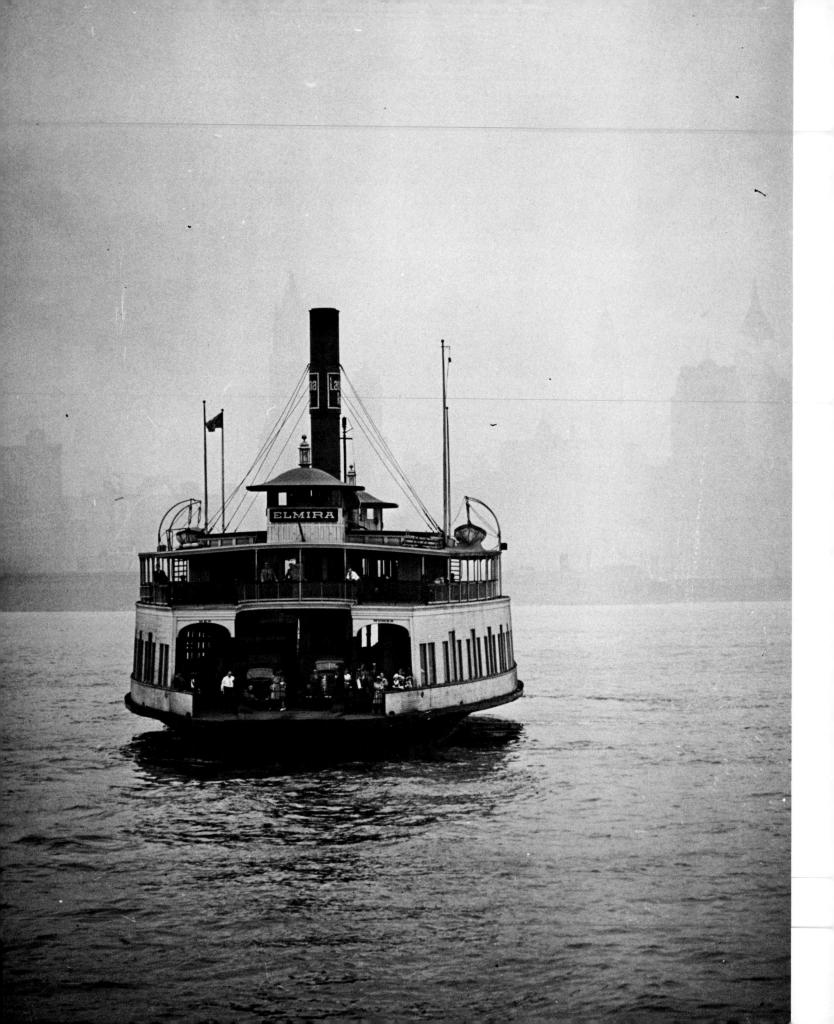

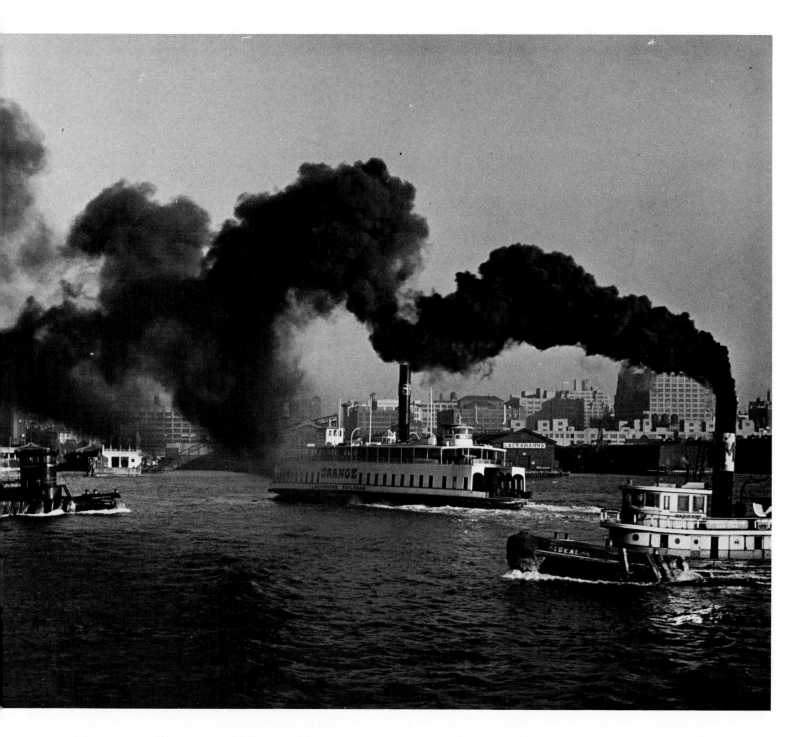

Traffic on the Hudson River [above]. The Manhattan-Hoboken Ferry on a foggy morning [opposite]. While ferry rides to Manhattan had charm, they were not always the most comfortable voyages. A foggy morning made for a clammy crossing. And the thick black smoke from the passing boats gave passengers in the 40s a foretaste of the yet unpublicized problem of air pollution. Passengers continued to rely on ferries for several practical reasons. Driving to work in the city was not yet a practical alternative. The Holland and Lincoln Tunnels as well as the George Washington Bridge had been completed in the previous decade, but the highways were narrow and not made for masses of cars. Most workers, still reeling from the effects of the Great Depression of the 1930s, could not afford the car for daily commutation.

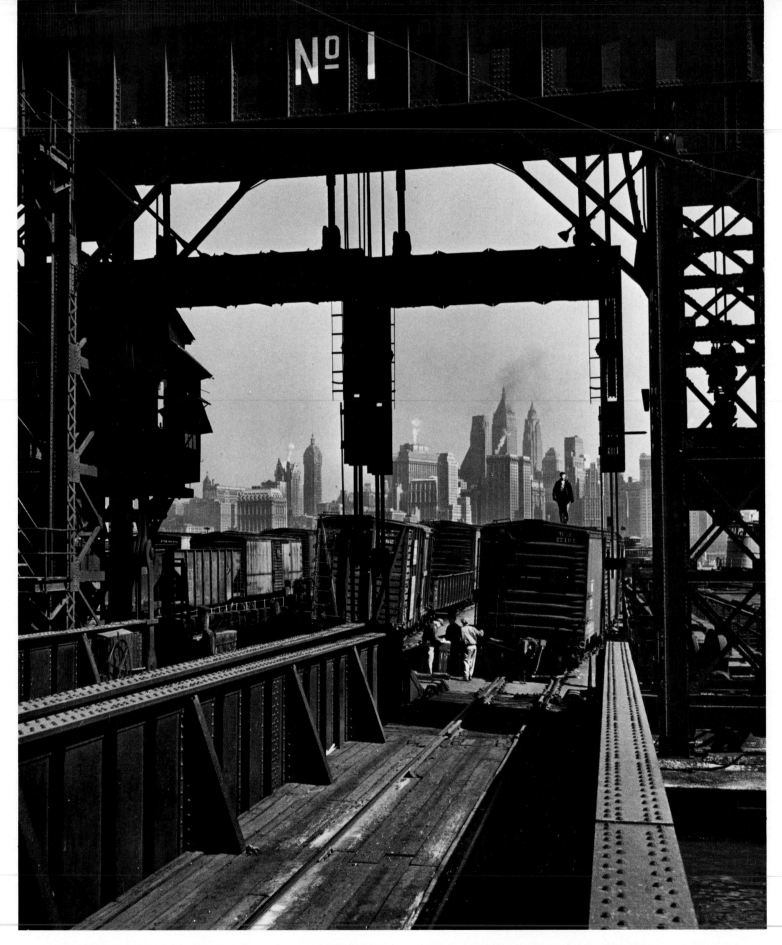

Two views of barges carrying freight cars across the Hudson.
The superhighways with their massive truck transports that
supplied the city were still a few years away in the 1940s.

Bringing produce to the island of Manhattan often meant a
combination of railroads and shipping. Many of the major trunk
lines ended at terminals in New Jersey. From there, freight was

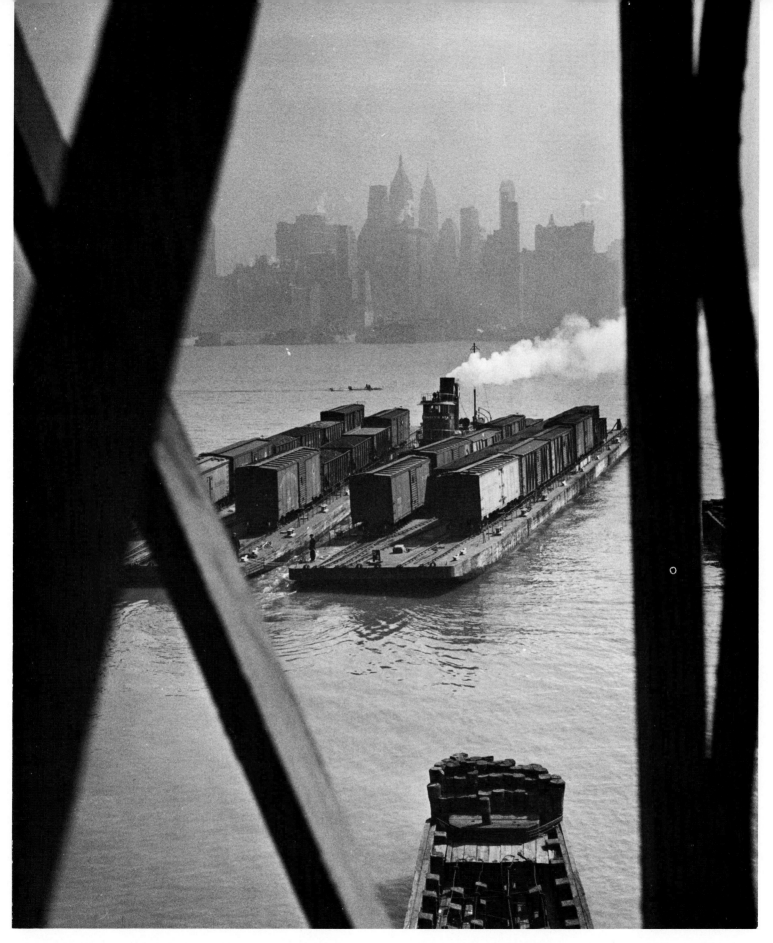

ferried to the city by carfloatage—railroad cars carried across the Hudson by barge.

Accomplishing this transfer of goods meant a substantial investment in marine equipment by the railroads–about $35 million in 150 towboats, 323 carfloats, 1,094 lighters and barges. This small navy was manned by 3,400 men.

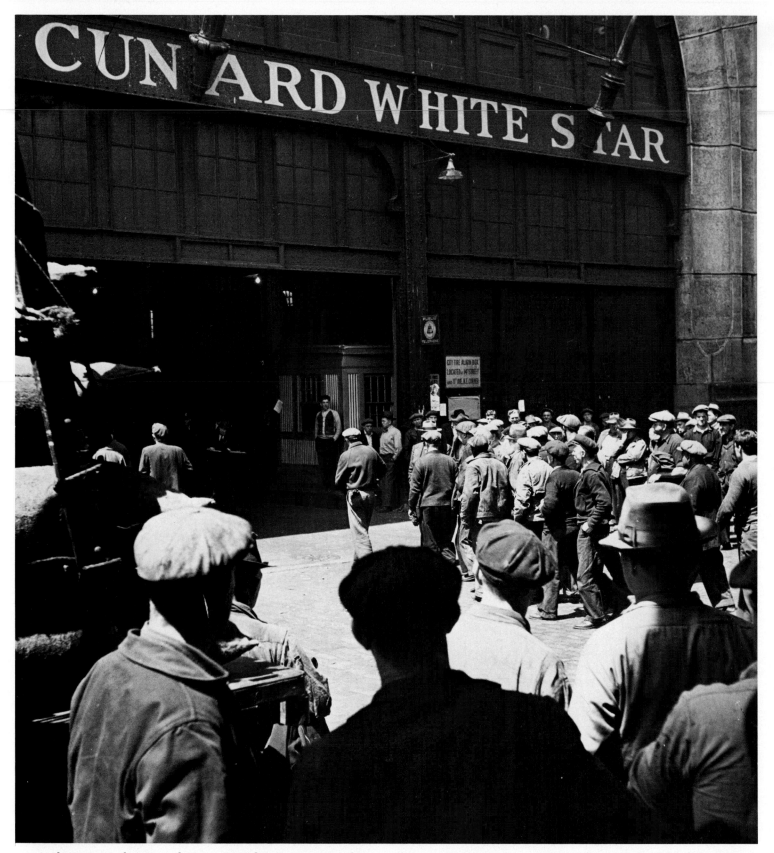

A shapeup at the Cunard Line pier [above]. Excursion boat loading for Coney Island [opposite]. The port meant both work and relaxation to New Yorkers. The work included the back-breaking toil of the longshoreman, an ordeal that started with the agonizing ritual of the shapeup. Here, workers were chosen on the whim of a straw boss or union leader, a choice often influenced by financial kickbacks from the laborer. The shapeup, however, did affirm the economic viability of the city's water-front during the period. For thousands of workers and tourists, the waterfront meant a cooling ride to Coney Island or Bear Mountain. In a scene straight from the gay 90s, men in straw boaters and women in fresh cotton dresses queue up at the Battery to board a boat bound for the shores of Coney Island. In the last decade without air conditioning, these outings on jammed boats offered a respite from the hot, still days in the city. Tours like this to Coney Island had been a custom since the mid-19th century and lasted out the decade. They were discontinued in the 1950s.

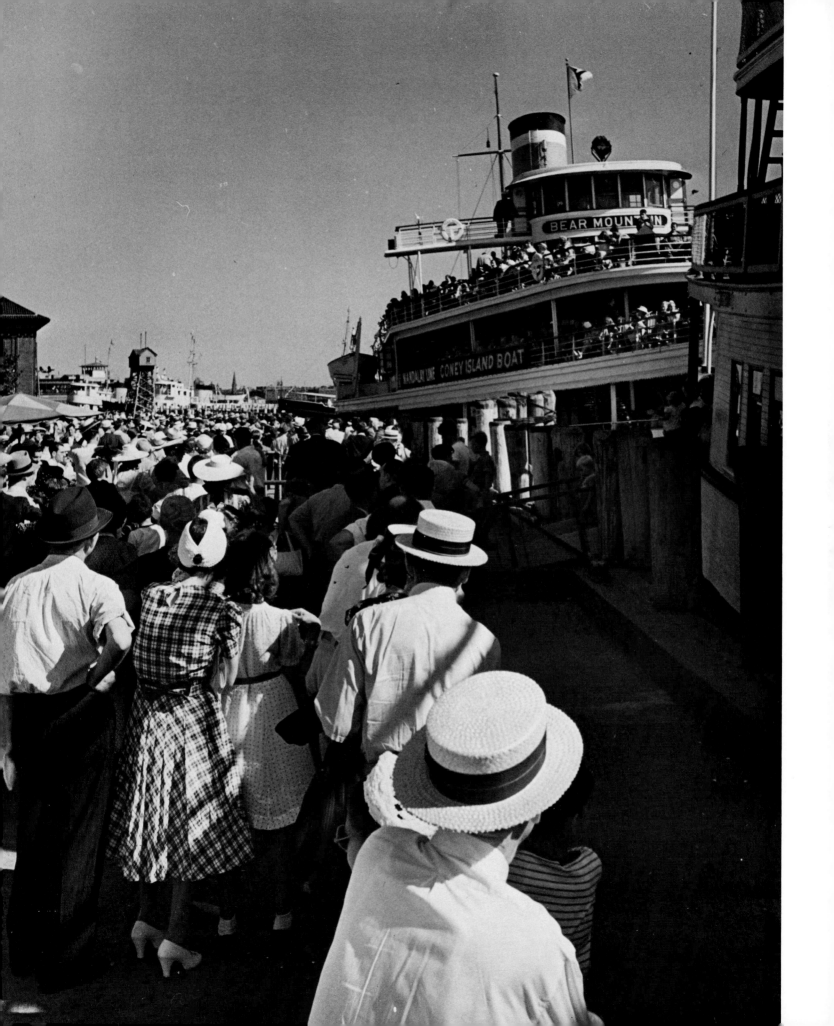

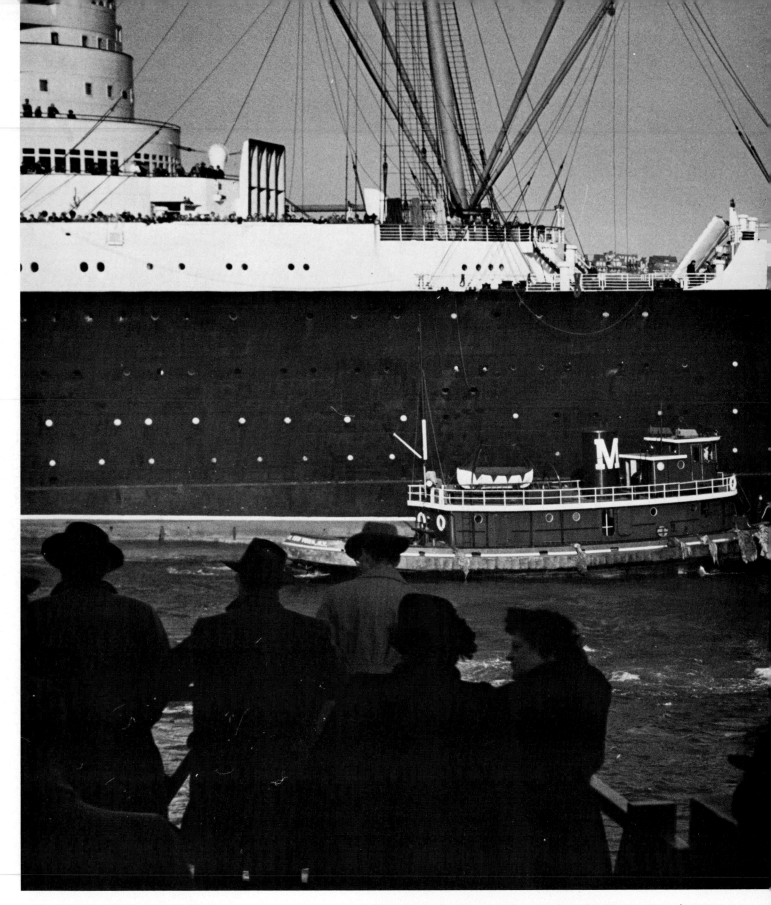

Tugs berth the "Queen Mary." When the *Queen Mary*, largest passenger liner of her day, arrived on her maiden voyage, New York staged a gala welcoming. On June 1, 1936, the 1,019-foot-long vessel cruised into the harbor. Airplanes circled overhead, fire boats spouted plumes of water and the harbor was dark

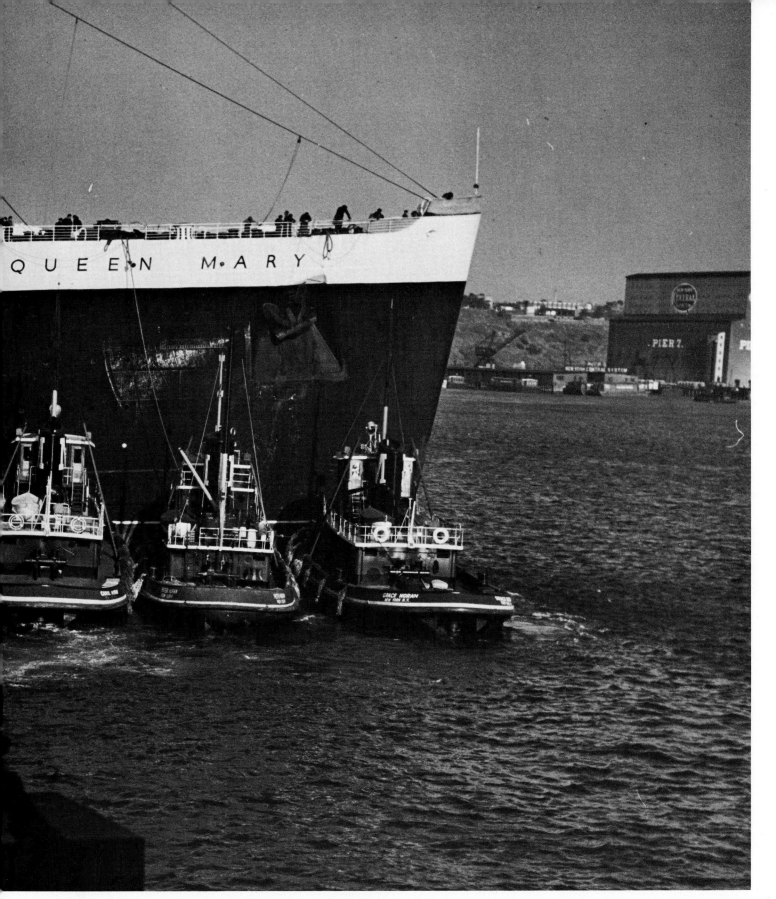

with masses of small craft bobbing in the imperial wake of the 81,237-ton queen. When it came time to berth the vessel at the Cunard Line's Hudson River pier, four powerful tugs were required simply to maneuver the bow alone, just as in this photograph, taken almost twenty years later.

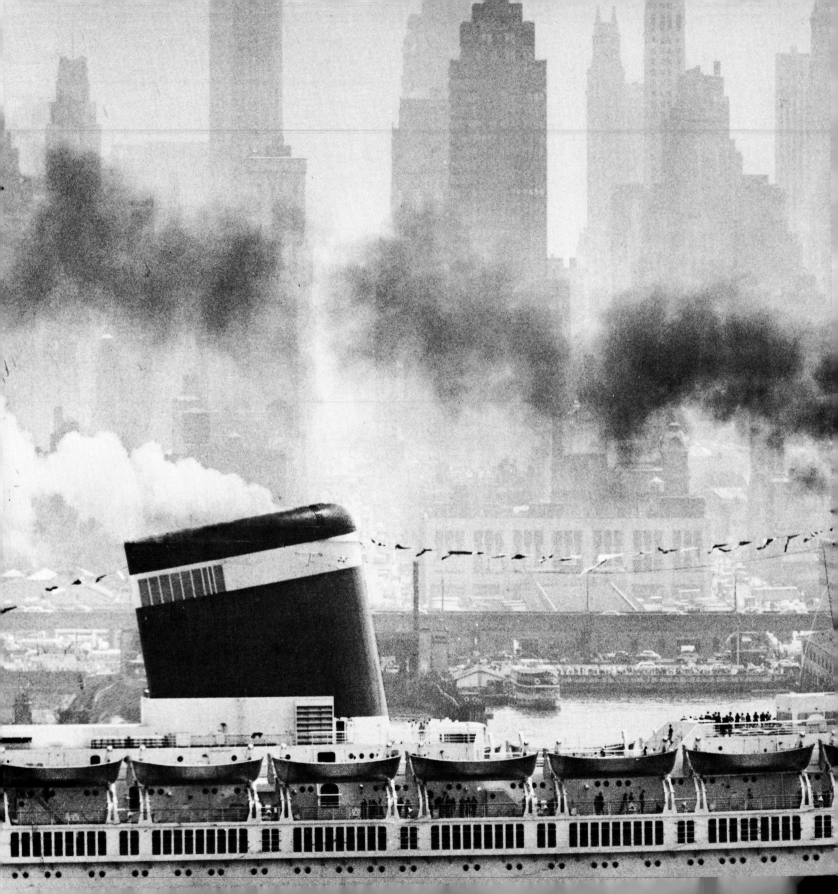

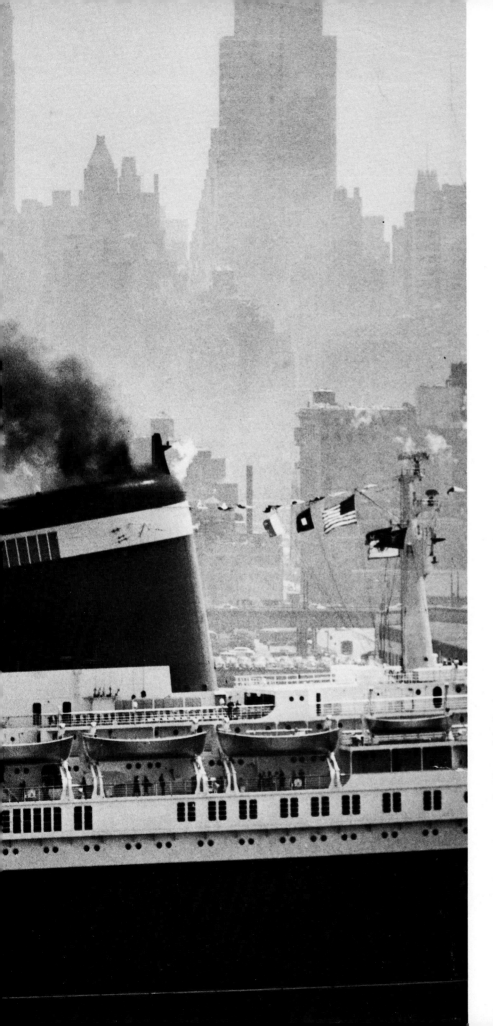

The "United States" setting sail for Europe. The departure of a luxury liner like the U.S. *United States* from the Port of New York was an event that symbolized the romance of travel. The harbor water churned and roiled as the tugs gallantly pushed the 52,072-ton behemoth into the main channel. Deep whistles sounded from the smoke stack as the 990-foot-long pride of the United States passenger fleet gained control under its own power. People watching from the piers and ashore waved and cried wishes for a good voyage. Passengers lined the railings to shower paper streamers, confetti and release colored balloons. The ship steamed down the Hudson River and the passengers enjoyed a magnificent view of the city as they romantically contemplated the voyage ahead.

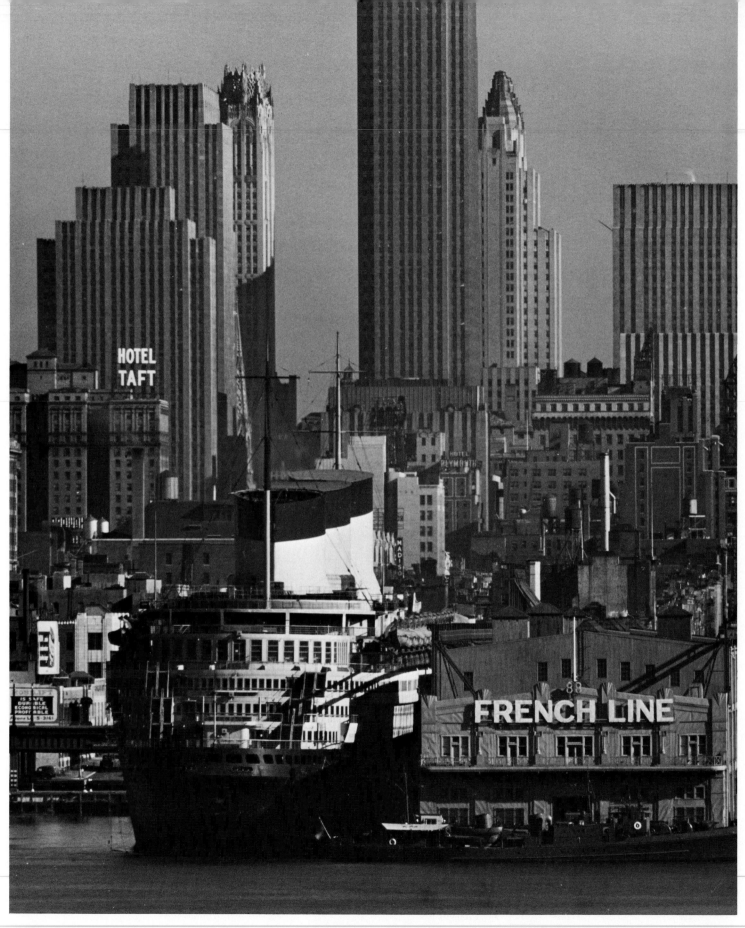

The "Normandie" at its French Line berth, 1940. The queen of the French Line from the mid-1930s through the early 40s was the *Normandie*. On her maiden voyage in the spring of 1935, she covered the nearly 3,000 nautical miles from Cherbourg to New York in four days, three hours and 13 minutes—the fastest time yet for such a voyage. Two years later she would trim about five hours off that time to become the first vessel to cross the Atlantic in less than four days. In 1943, fire destroyed her.

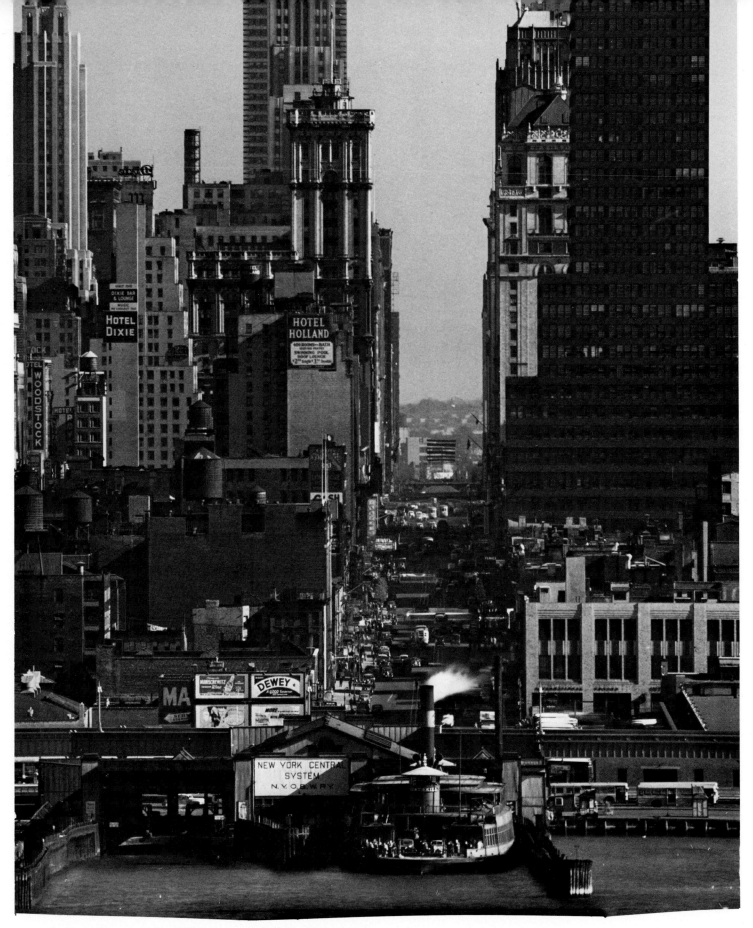

Manhattan's 42nd Street from Weehawken, New Jersey. This view of Manhattan across 42nd Street compresses the miles between the Hudson and East Rivers, emphasizing the narrowness of the island. The Weehawken ferry is in the foreground while the McGraw-Hill Building on the south side of 42nd Street stands at the right. Built in 1931, the McGraw-Hill Building's sheer flanks of glass and steel proved an architectural harbinger of the latter-day skyscraper.

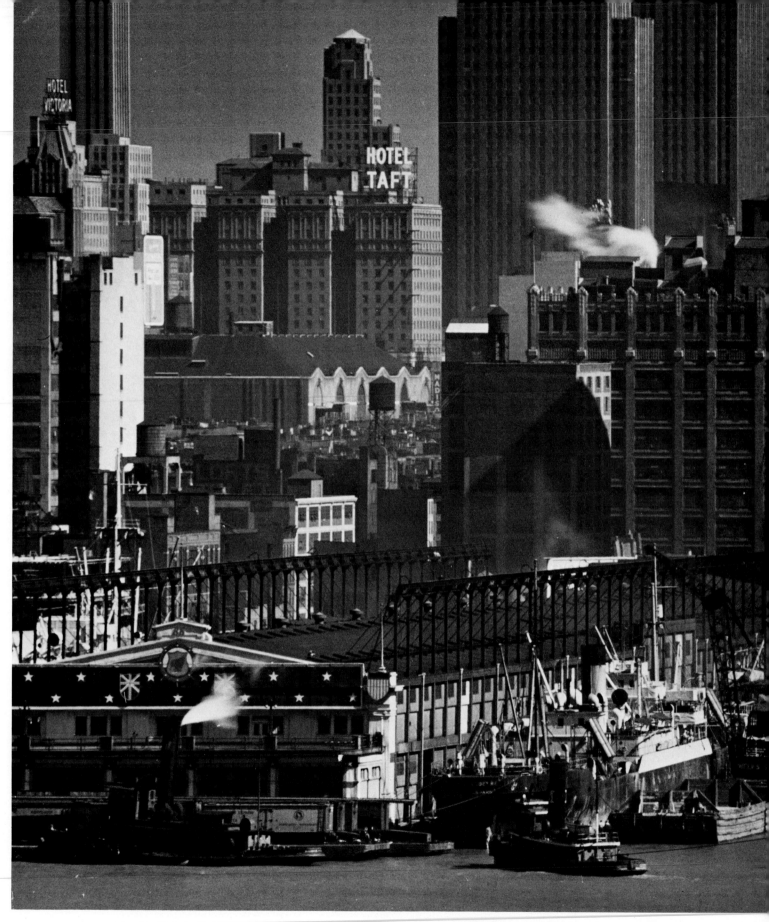

Hudson River waterfront at midtown. The prosperity of the waterfront during the post-World War II era is evident in this sunny picture. The midtown piers burst with energy and activity. Tugs nudge mammoth vessels, cranes dip over open cargo hatches, lighters and carfloats ply the calm waters. This is the

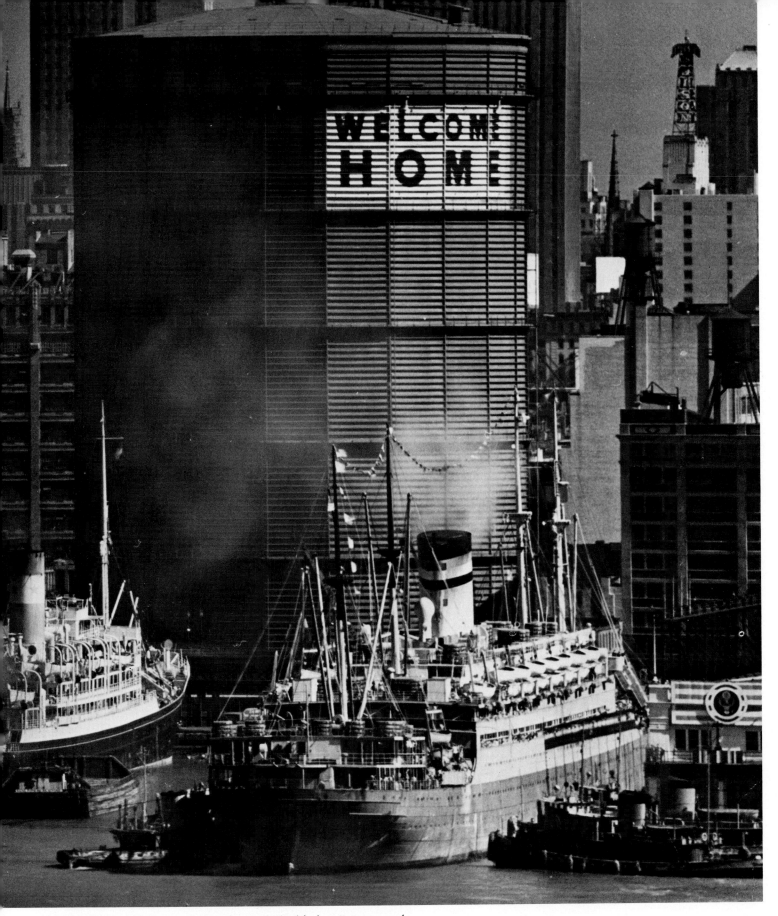

New York waterfront during the "good old days," an era of jobs—or the promise of jobs—still recollected by maritime workers. Even the sign welcoming home the fighting men from the European battlegrounds lends an optimistic, festive air to the scene.

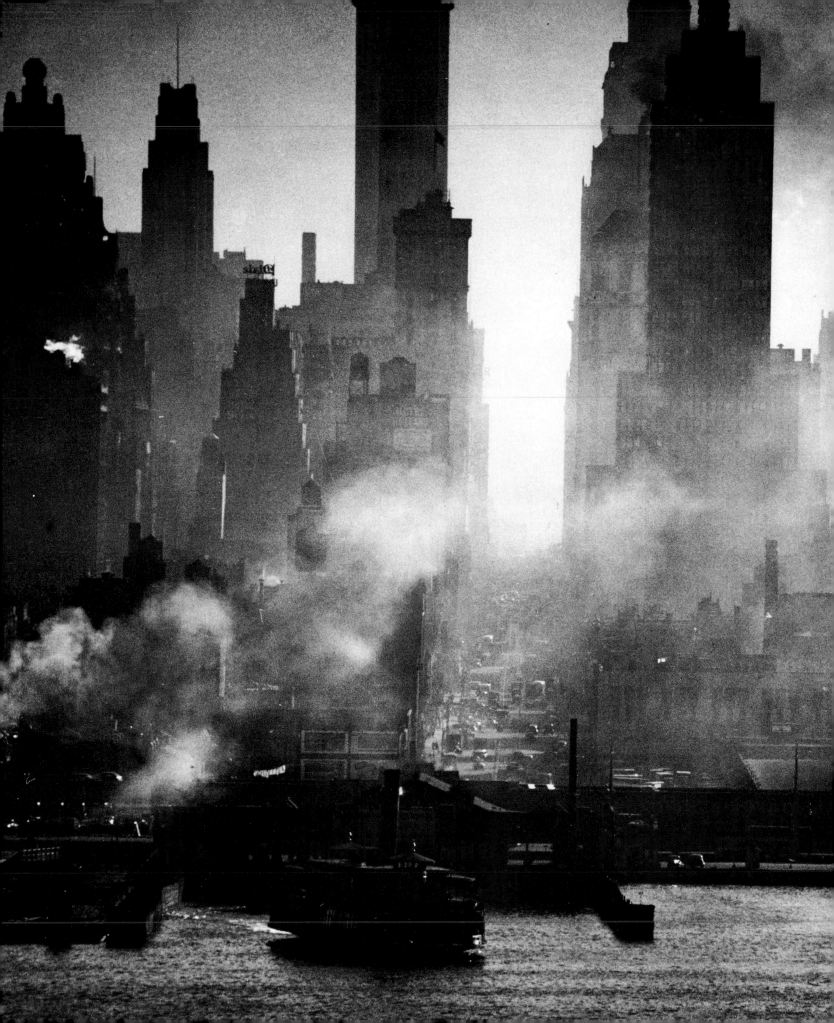

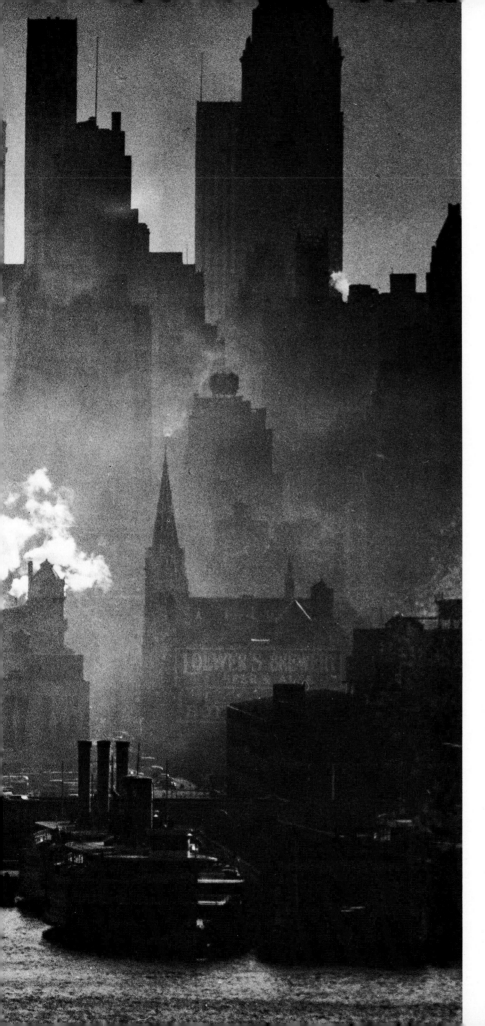

42nd Street as viewed from Weehawken. The smoke and steam of commerce and industry, as well as steamships on the move, cast a misty mantle over the waterfront. The city towers pierce the mists while an aged excursion boat moored at right lends a touch of the 19th century to this portrait of an industrial port.

Not only was New York a port of entry and departure for foreign trade, nearly half of its waterborne commerce was inner-harbor traffic. Just to carry the local freight demanded a harbor fleet second to none: 6,000 barges, scows, lighters, carfloats and tugs, all manned by a task force of 15,000 hands. The eight large trunk-line railroads that hauled freight into Manhattan ran and financed much of this shipping. But most of the inner-harbor business was conducted by private ship lines which made money by never leaving the sanctuary of the port.

65

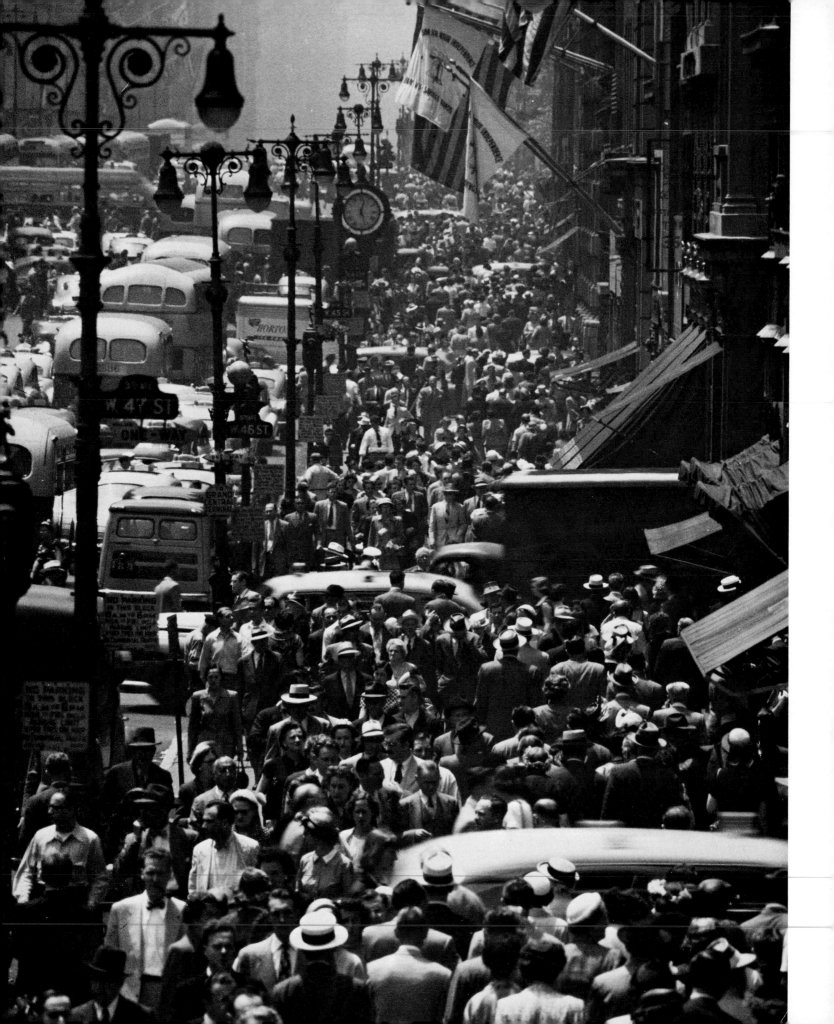

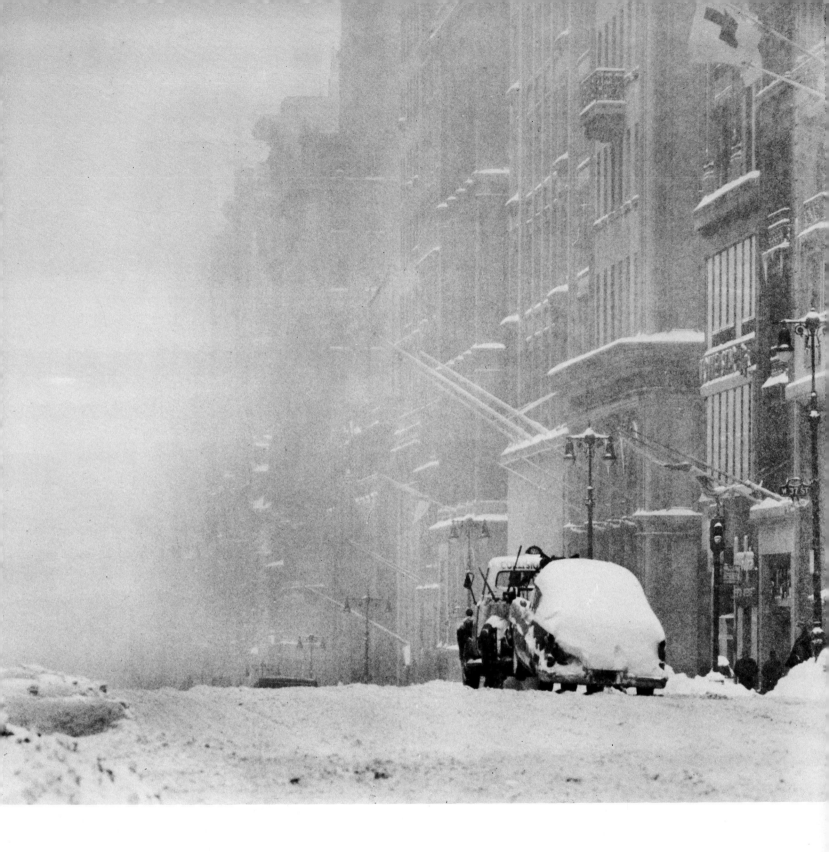

Fifth Avenue during the blizzard of '47 [above]. Midtown Fifth Avenue during lunch hour [opposite]. Manhattan was the marketplace of the nation and Fifth Avenue its Main Street. People swarmed along the avenue on their way to shops and stores during lunchtime while trucks, buses (including double-deckers), cabs and cars bumped along at speeds slower than that of a determined pedestrian.

Yet on isolated occasions, Fifth Avenue was silenced by the hand of nature. Overnight on December 26–27, 1947, New York was buried under 25.8 inches of snow—almost five inches more than fell during the legendary blizzard of '88. Fifth Avenue was blown clean of shoppers, cars stalled and tow trucks worked ceaselessly. The blizzard of '47 transformed the avenue into a winter wasteland touched with its own tranquility.

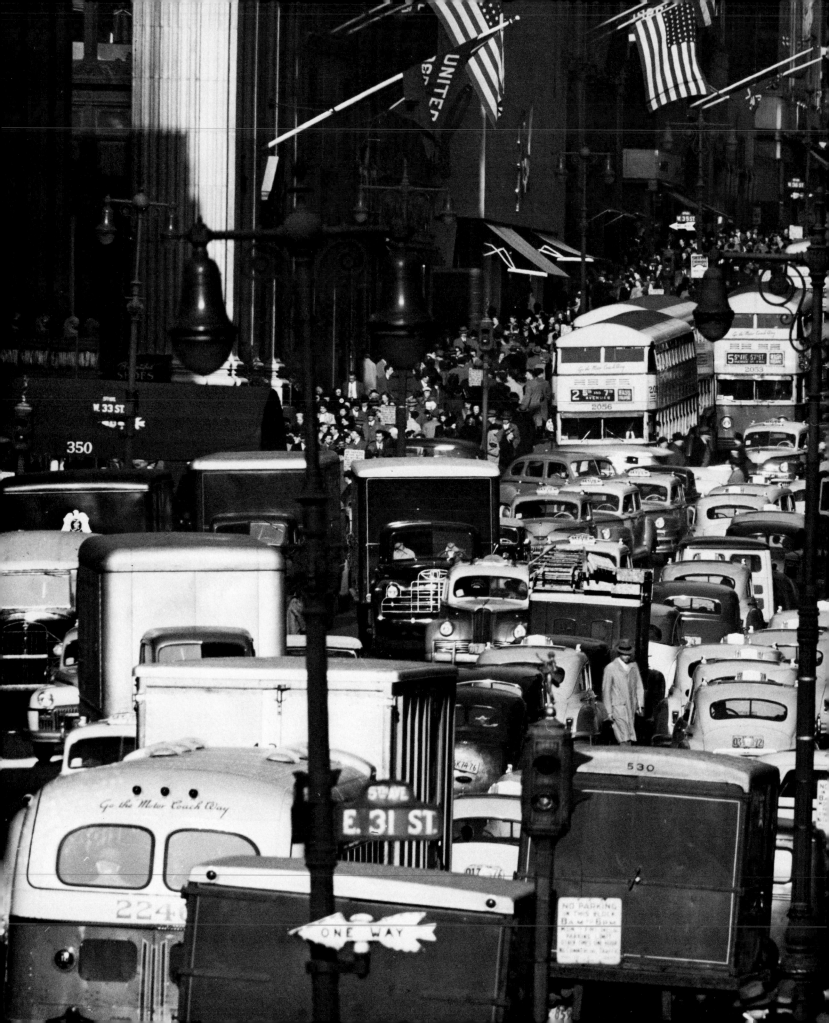

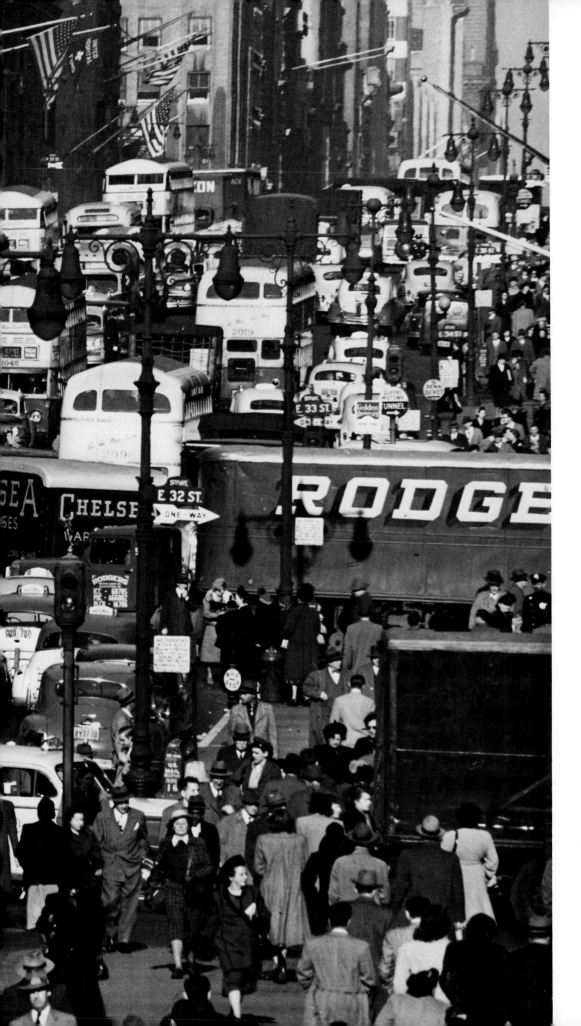

Fifth Avenue looking north from 32nd Street. Manhattan traffic was impossible, but not quite as bad as this photograph, made with a telephoto lens, might indicate. The long focal length of the lens foreshortens the perspective, stacking the images of cars, trucks and people on top of one another. Even the street signs seem as close together as slats in a picket fence. While the photograph overly-dramatizes the condition, traffic was a major problem, particularly in this section of the avenue where trucks that served the garment district added their bulk to the already jammed streets. The decorative lampposts that form an attractive overhead pattern have since been replaced by stark high-intensity street lights.

69

Rockefeller Center from 53rd Street [above]. St. Patrick's Cathedral from Rockefeller Center [opposite]. Both Rockefeller Center and St. Patrick's Cathedral were magnets to visitors. Rockefeller Center had two popular attractions: Radio City, the studios of NBC; and Radio City Music Hall, home of the latest in Hollywood family movies with the dancing Rockettes kicking in unfailing unison on the stage.

One of Rockefeller Center's monuments is the sculpture by Lee Lawrie of Atlas holding the world on his shoulders. Across from this statue stands St. Patrick's Cathedral.

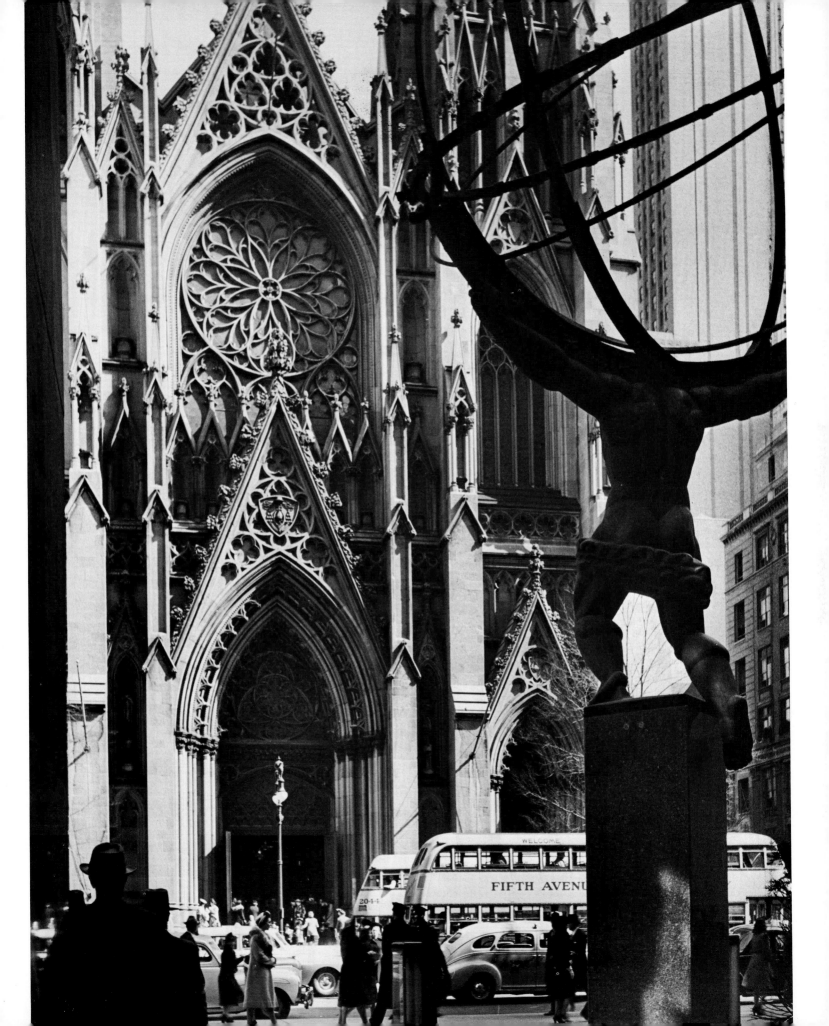

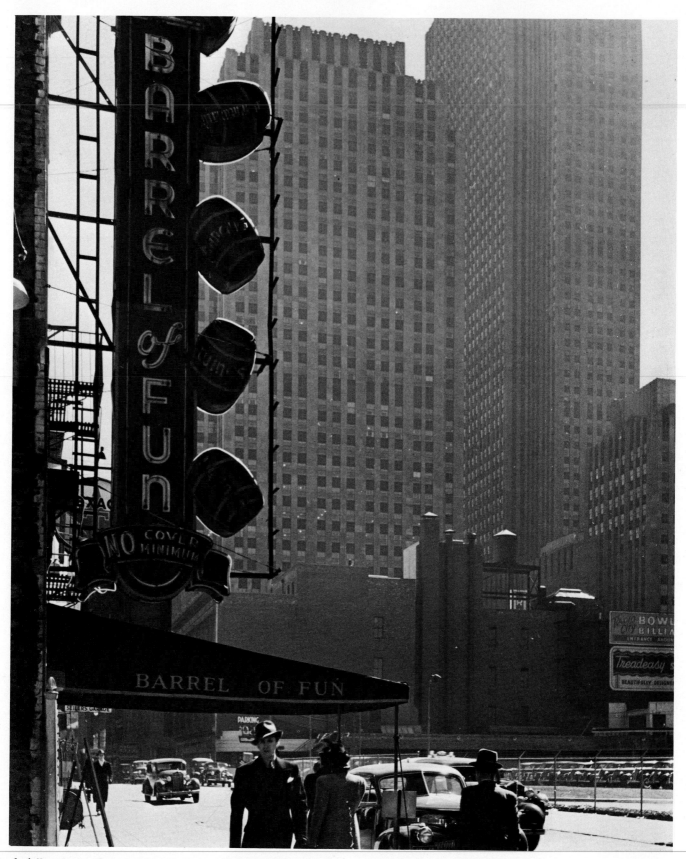

Rockefeller Center from West 51st Street [above]. The Flatiron Building at Broadway and Fifth Avenue [opposite]. While Rockefeller Center loomed above the old brownstones and sleazy bars of its midtown neighborhood, some blocks of New York were miraculously unchanged. The scene at right where Broadway cuts across Fifth Avenue at 23rd Street appeared in the 1940s much as it did when the Flatiron Building was completed in 1902—the 22-story building was Fifth Avenue's first skyscraper. Cars and motor buses have replaced the horse-drawn vehicles, but most of the surrounding buildings, the streets paved with Belgian blocks and even a street clock on its stand are the same. Indeed, except for the asphalt paving of the streets and more modern motor vehicles, this view would be valid in the late 1970s.

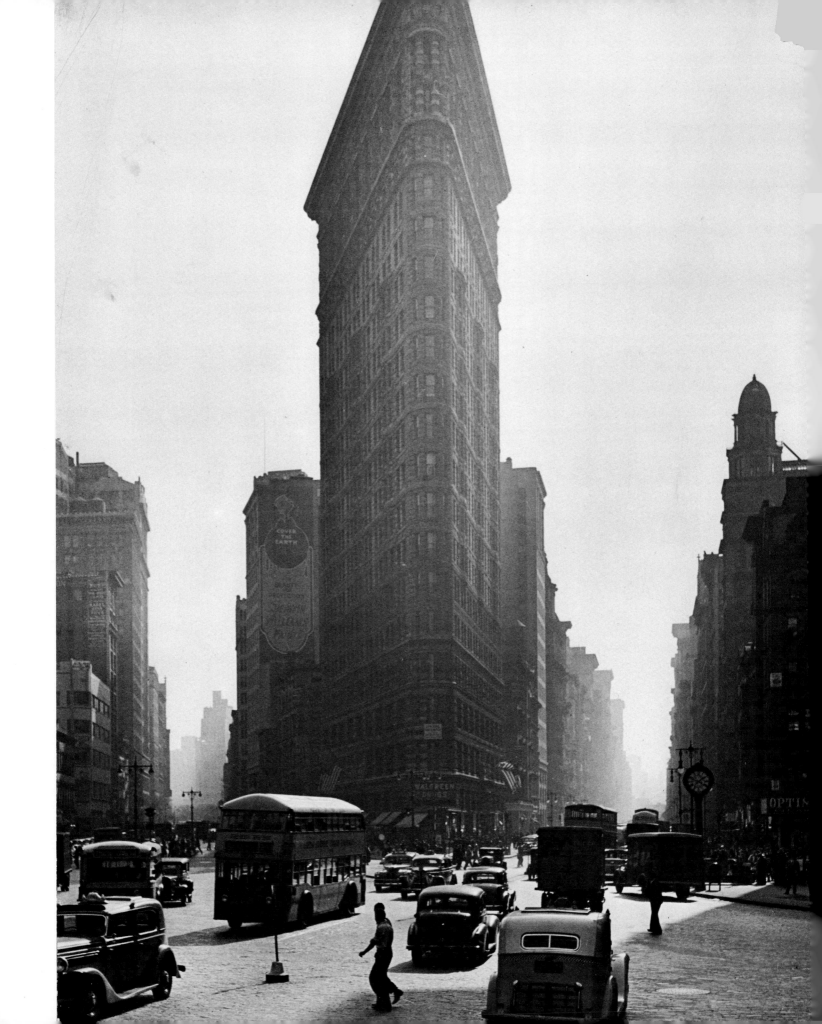

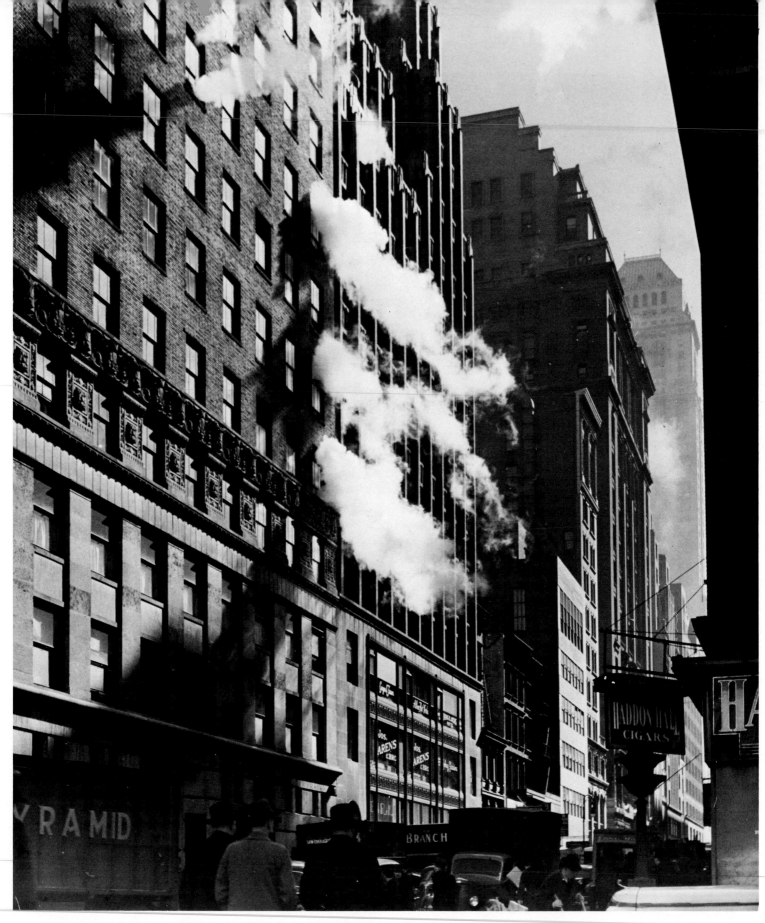

The garment district at 39th Street and Sixth Avenue [above].
Macy's entrance at 34th Street [opposite]. The clouds of steam
that wafted from the pressing machines in Manhattan's loft
factories gave evidence of the good health of the city's garment
industry. Clothier to the nation, the garment district provided
about three-quarters of the country's apparel. Shoppers at

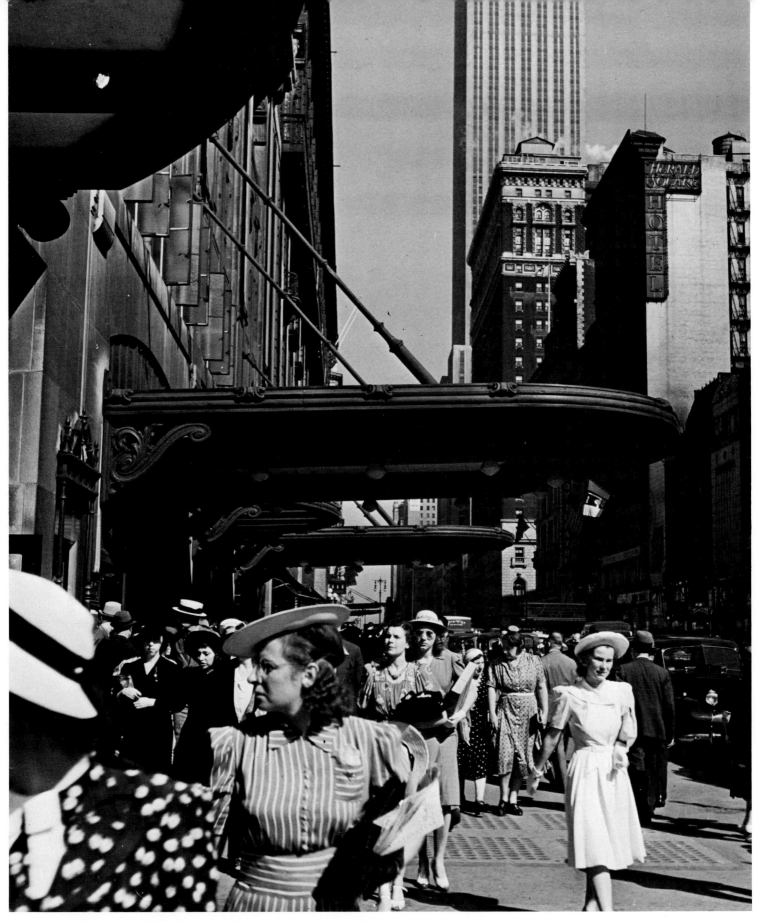

Macy's, Gimbel's or Saks-34th may not have been aware that
the garments they bought were manufactured just a few blocks
away.

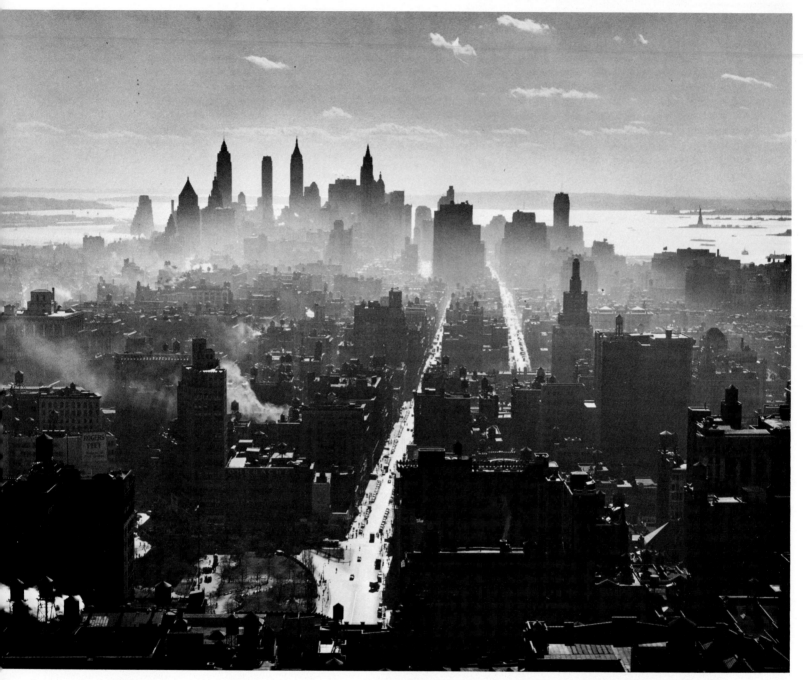

Lower Manhattan from midtown [above]. Midnight skyline during the dimout [opposite]. By day, New York during World War II continued to delight the eye. In the picture of downtown Manhattan (above), Union Square is in the foreground, Broadway curves to the left around the square. University Place cuts a broad swath to the south. To the right of University Place is the wide ribbon of West Broadway.

At night, New Yorkers experienced a unique event during the war—a dimout of their beloved nightlights. Bright lights could reflect on the night sky, making the city a glowing target for marauding German submarines or aircraft. Lights in offices were flicked off when work ceased, display illumination was shut down and only necessary lights showed in the dark. Wartime New York became a somber ghost of its former gay nighttime self, as is seen in the photographs on the following pages, taken in 1943.

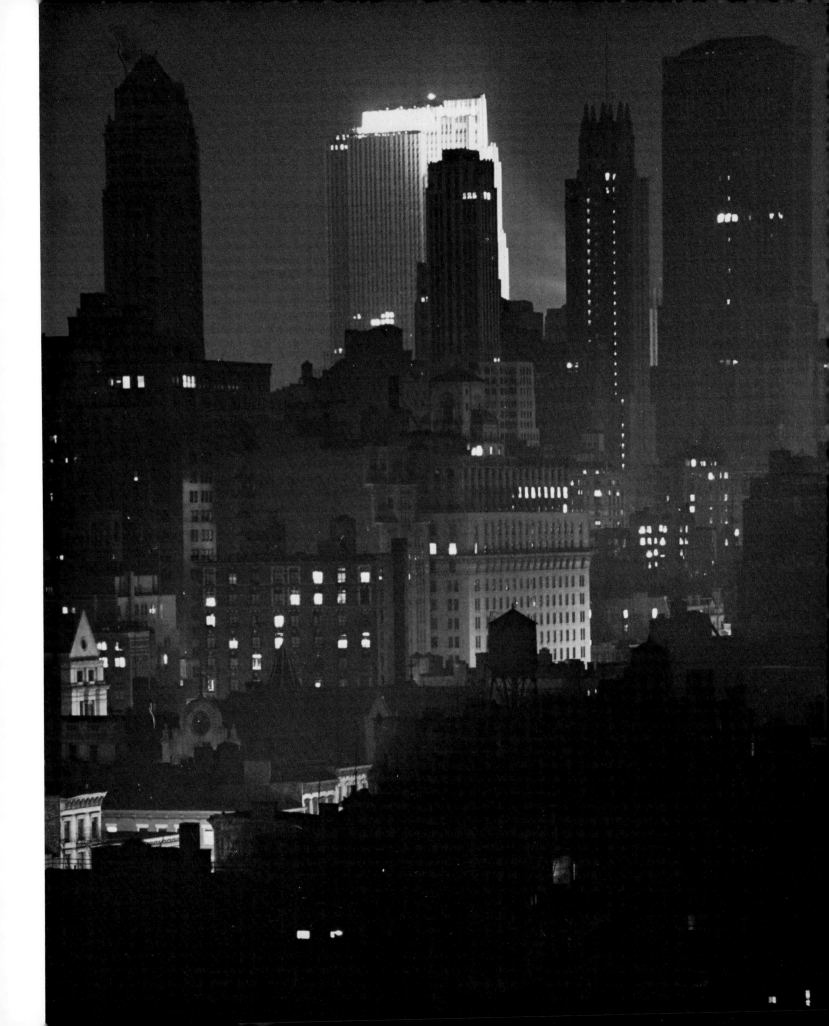

Times Square and Pennsylvania Station during the dimout.

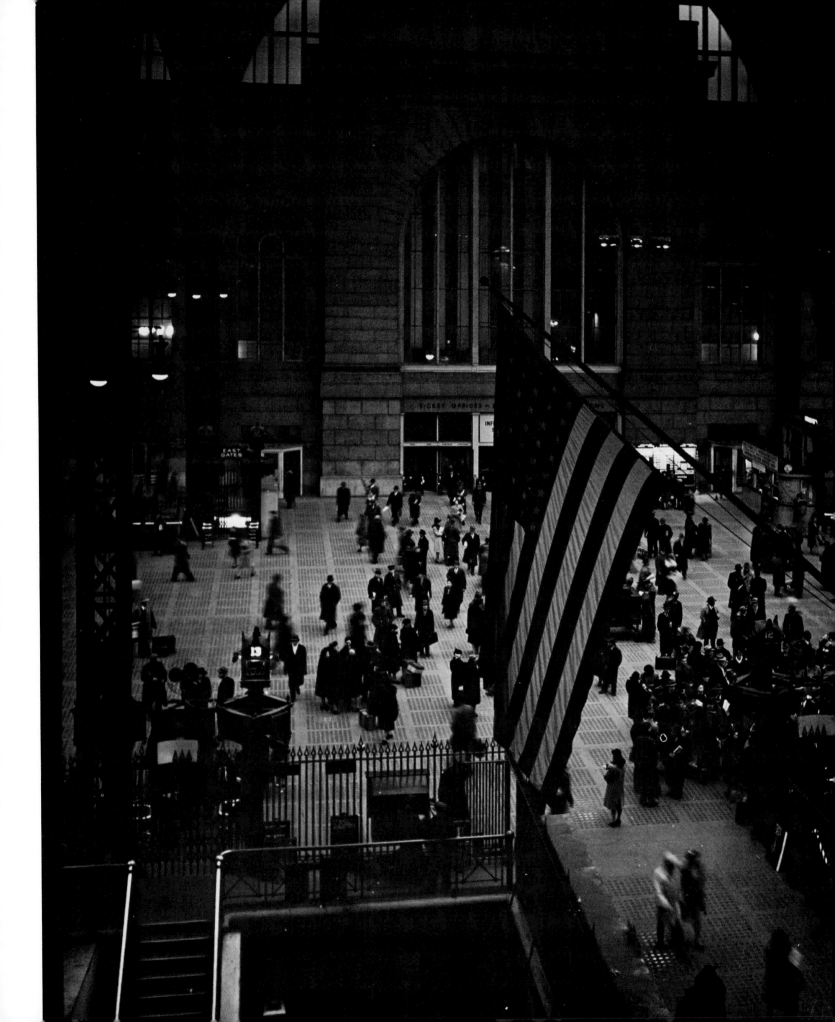

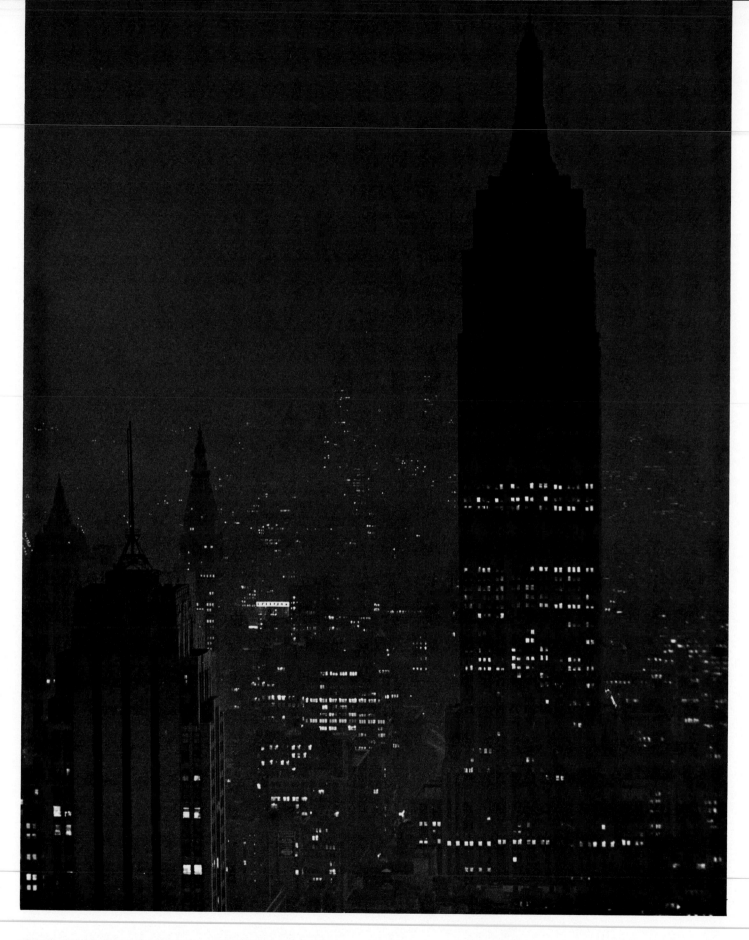

The dimout obscures the Empire State Building and midtown.

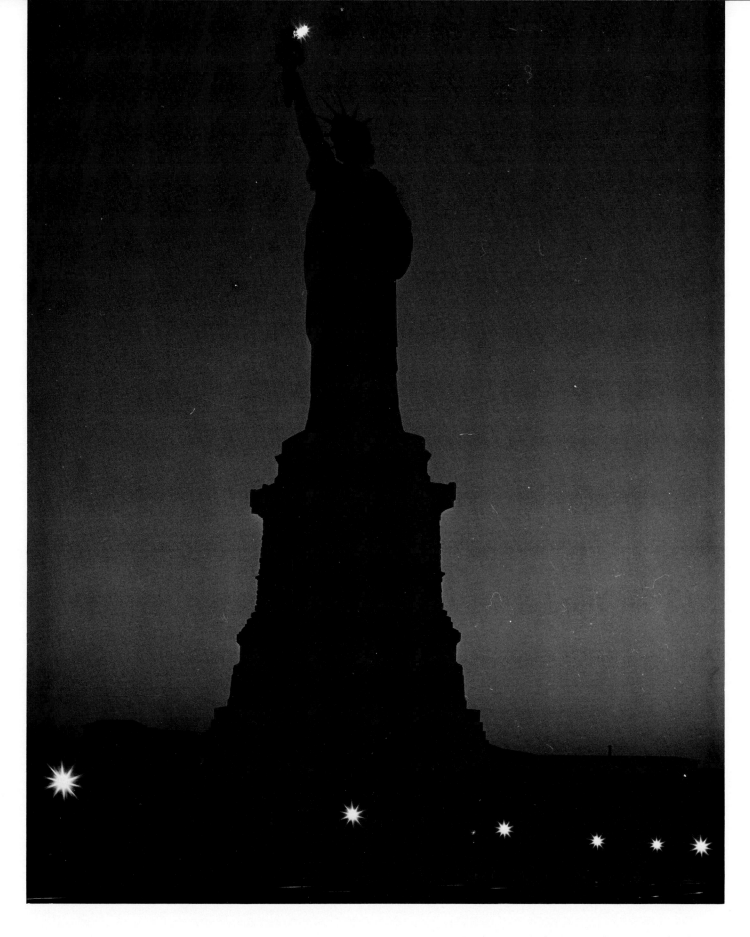

The Statue of Liberty is a silhouette in the dimout.

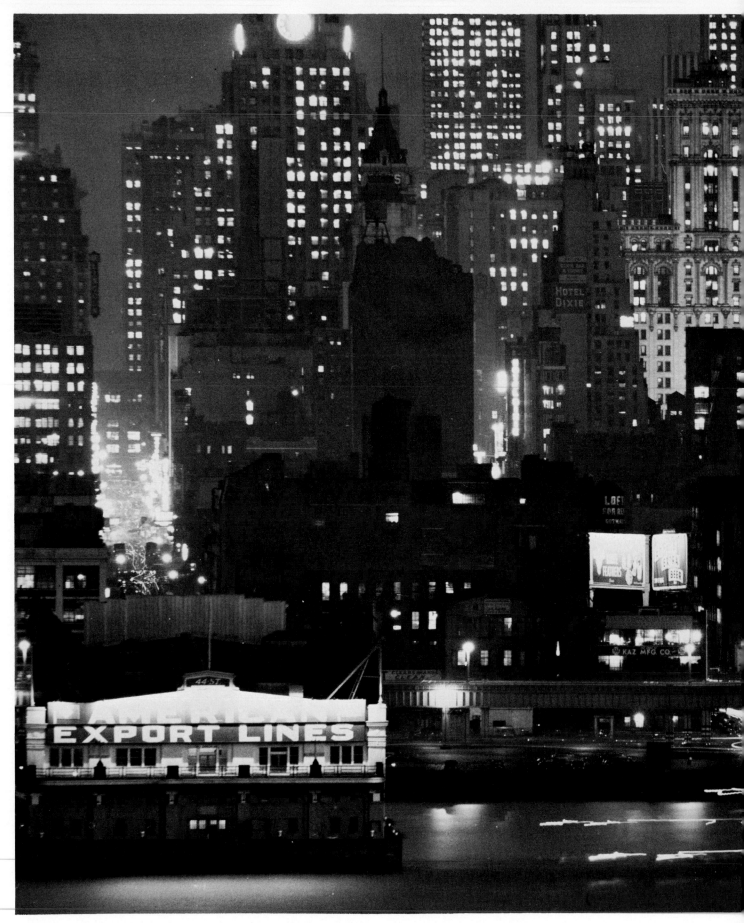

Midtown around 42nd Street comes to life after the dimout is lifted.

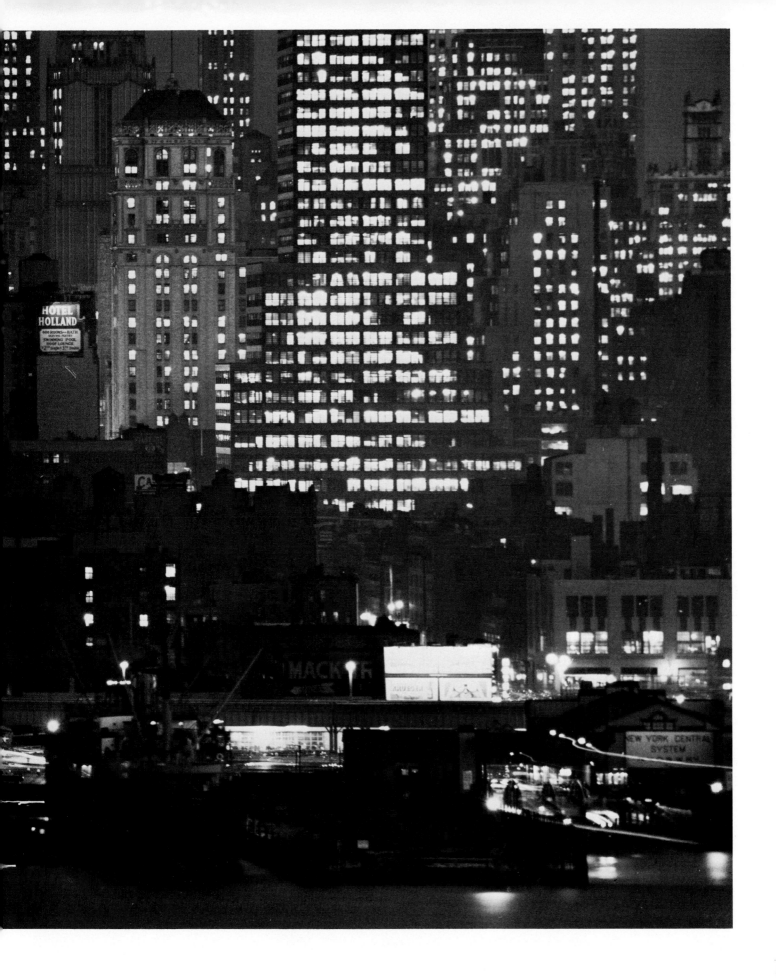

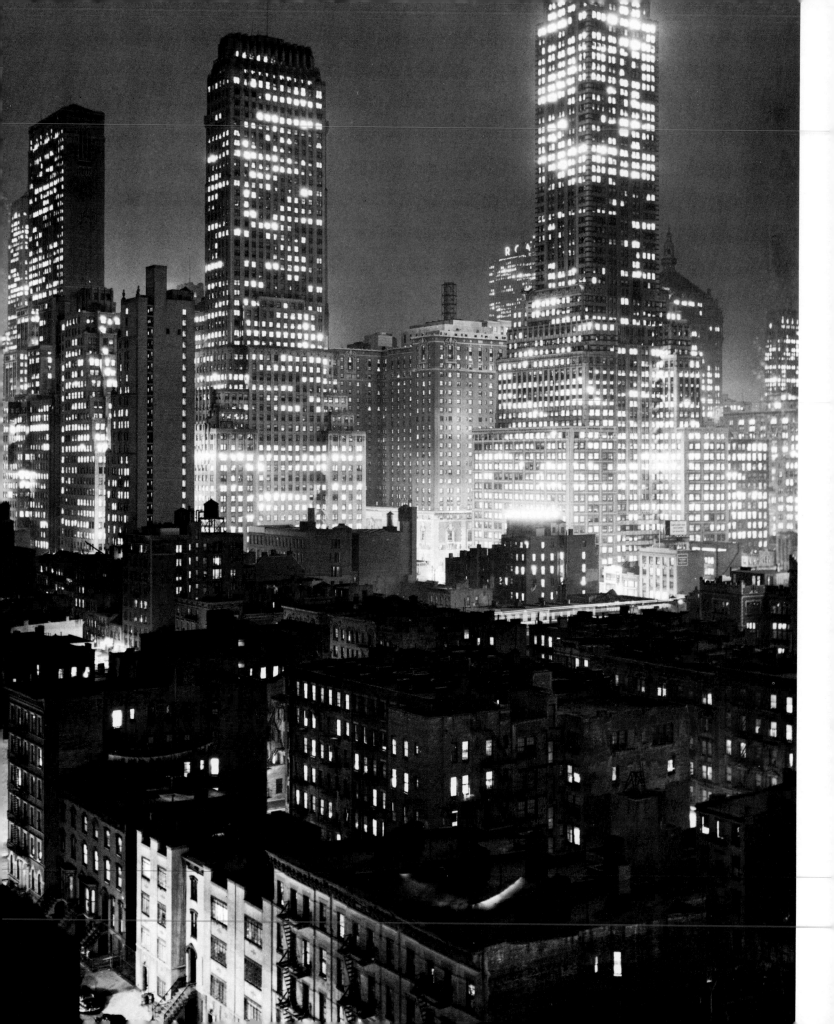

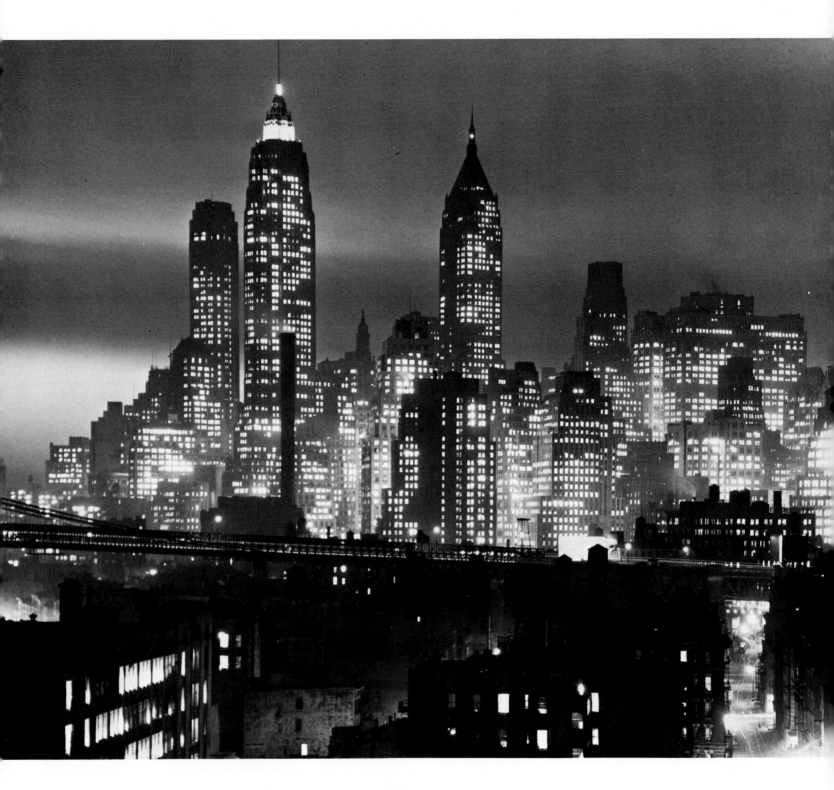

Downtown Manhattan after dark [above]. Midtown at night [opposite]. New York turned the lights on at night after the end of World War II. Perhaps in contrast to the dimout, the lights in the office towers seemed brighter than before. The electrical capacity of the city to transform night into day acted as a torch in the darkness that drew the curious to its flame. New York, with its high density of buildings, all equipped with an abundance of lighting fueled by relatively inexpensive power, could come ablaze with a flick of the switch. The result caused even the most blasé visitor or native to gasp in wonder.

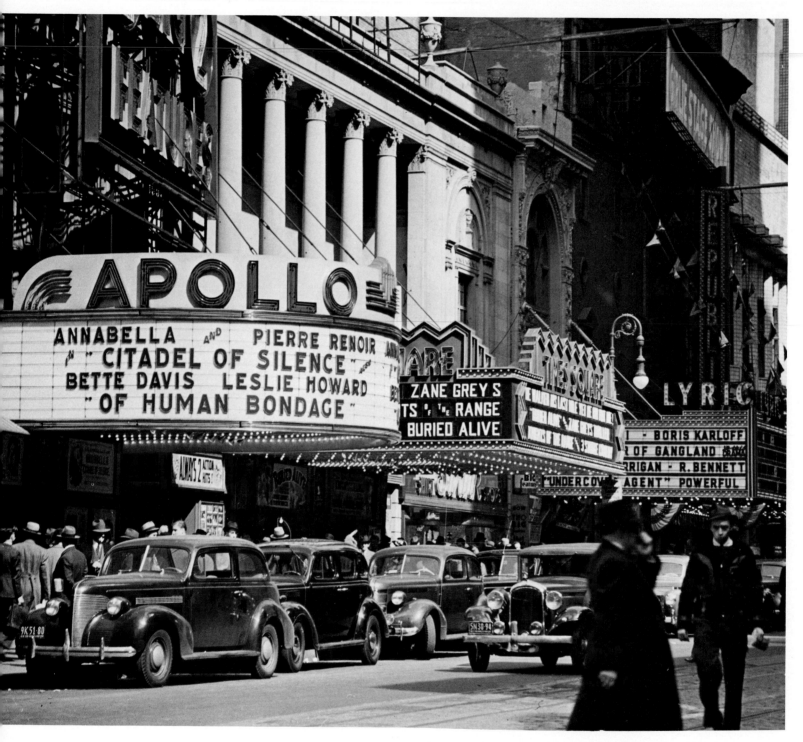

Two views of 42nd Street. New York's 42nd Street had something for everyone. The scores of movie theaters along the street—many of them former legitimate theaters and vaudeville houses—showed an endless supply of double-features to a generation hungry for entertainment. (Television sets were not yet available for every home.) Two things stand out about the scene above: the cars were small, about the size of today's compacts; and there's not a pornographic movie house in sight. The street also had a more sedate side (opposite). As seen from the Chanin Building, the street has an air of respectable commerce, with the Lincoln Building at left and the needlepoint protrusion of the Salmon Tower at 500 Fifth Avenue at right.

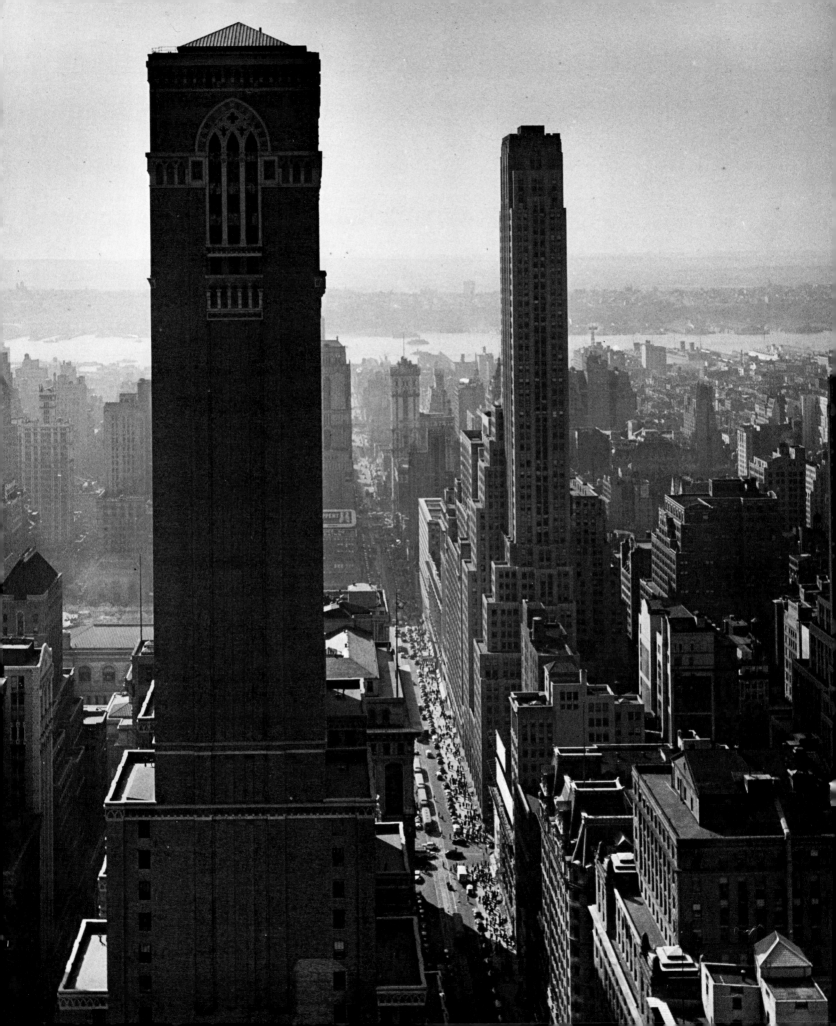

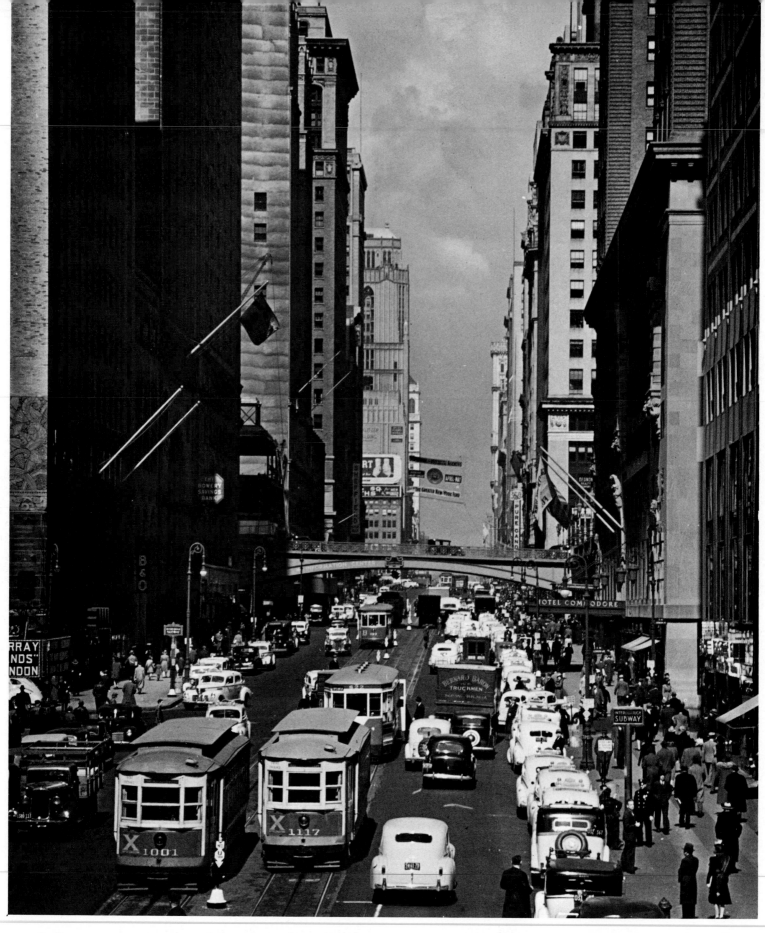

42nd Street looking west from Tudor City [above]. The New York Times Building at Times Square [opposite]. The 40s were the last decade of that venerable and valuable institution—the streetcar. Streetcars were noisy and drafty but they emitted no

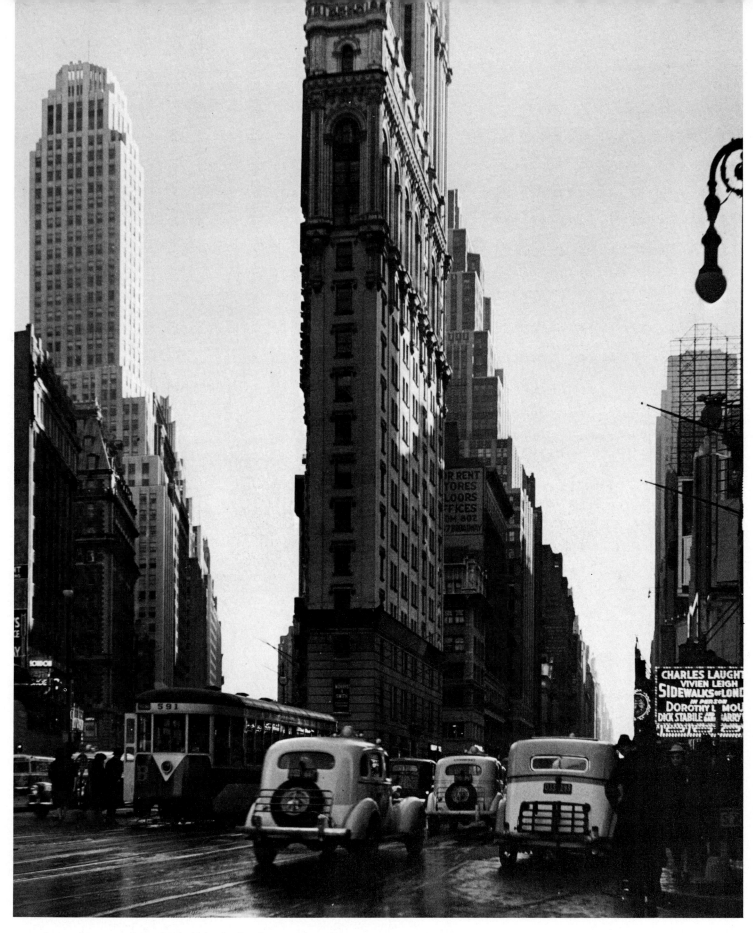

exhaust fumes and reached their destination on time because
they had the right of way.

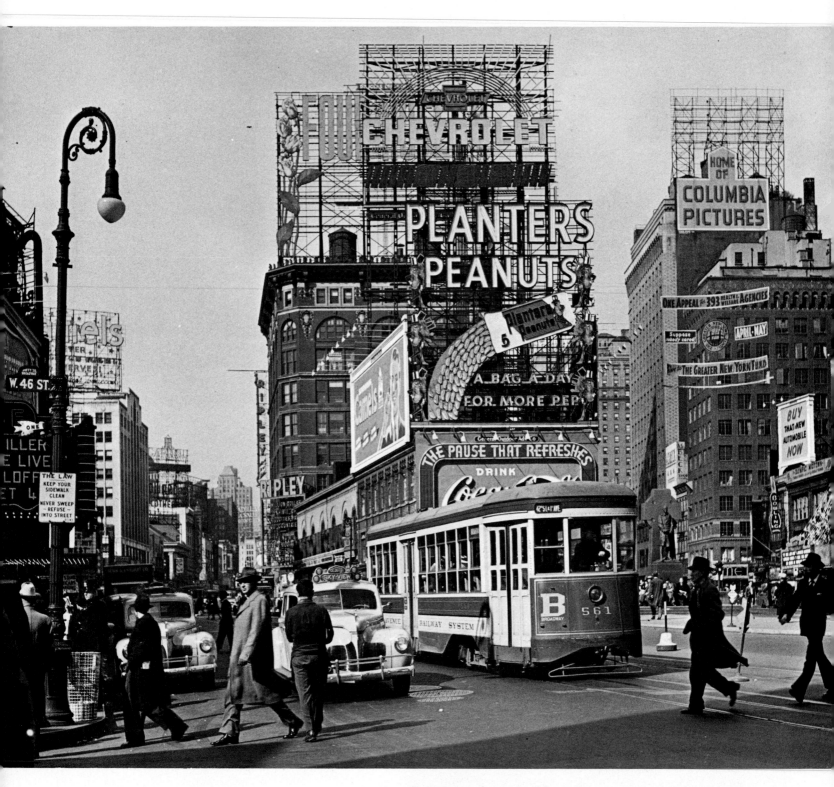

Times Square by day and by night. Times Square in the 40s was clean in every respect. Even its well-traveled streets appear virtually spotless, its trash cans not even close to full. In this fresh atmosphere the Hotel Astor flourished for the rich and powerful while the less exalted dined at the Automat. Both establishments have since succumbed amid the disintegration of the area.

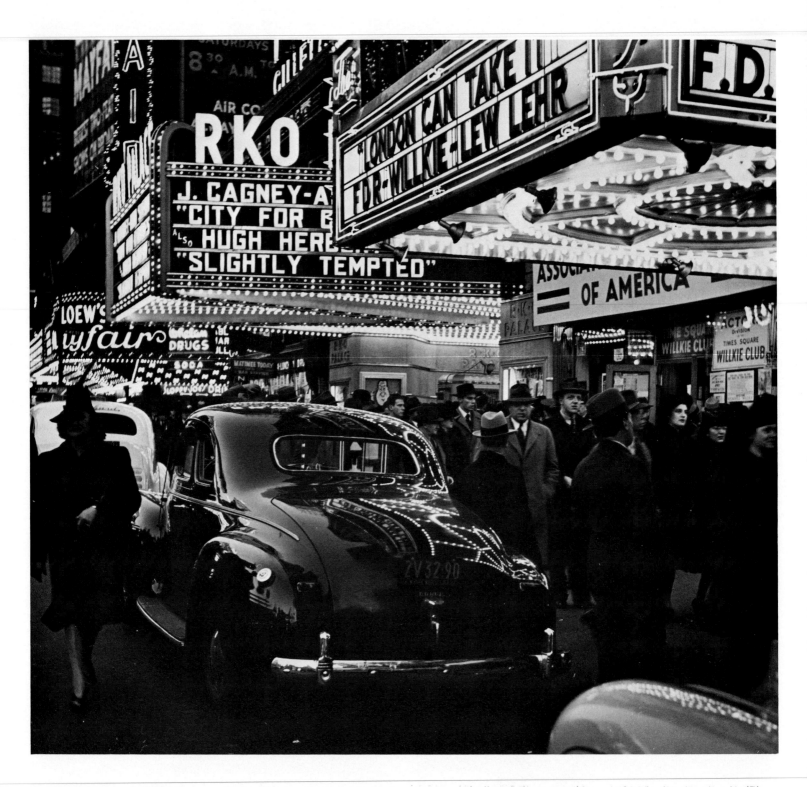

Two views of Times Square. Times Square was a restrained carnival that supplied mass entertainment both day and night. While movie stars like John Wayne and James Cagney dominated the screen, the larger theaters drew extra patrons through stage shows headlined by such popular names from the big band era as Jimmie Lunceford (opposite). Even in the dazzle of this glittering world, however, the American love of politics was not forgotten. The Times Square Willkie Club displayed its dogged support for the 1940 Republican presidential candidate (above).

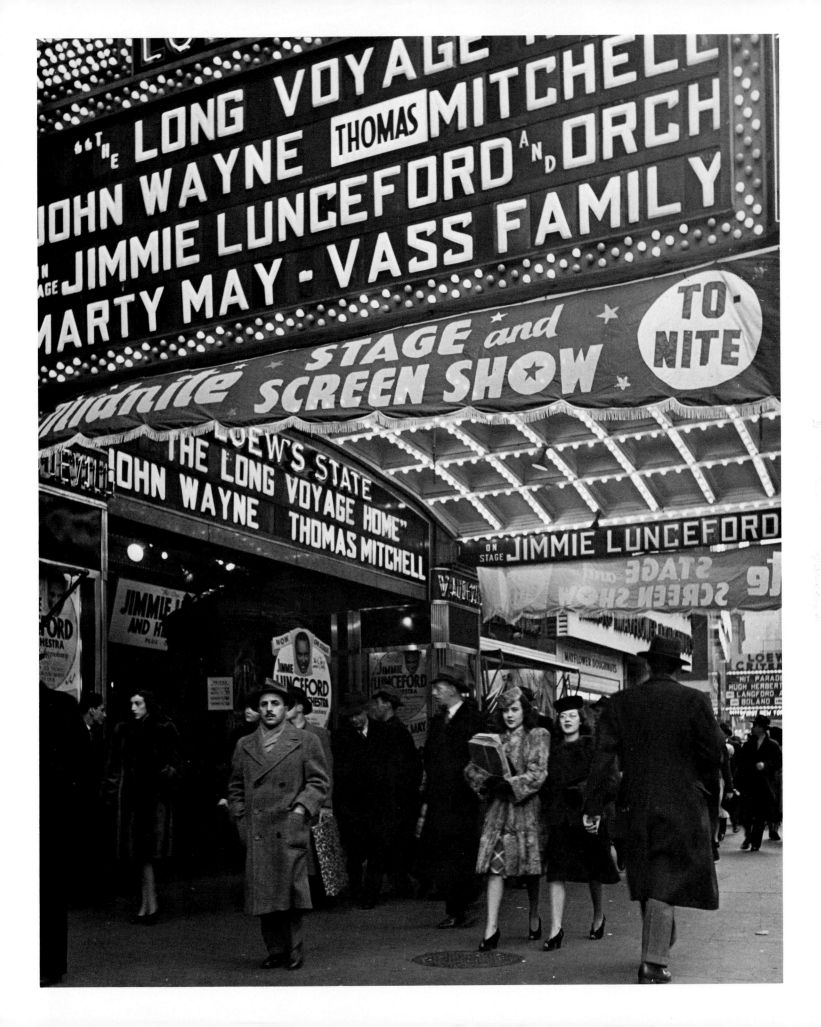

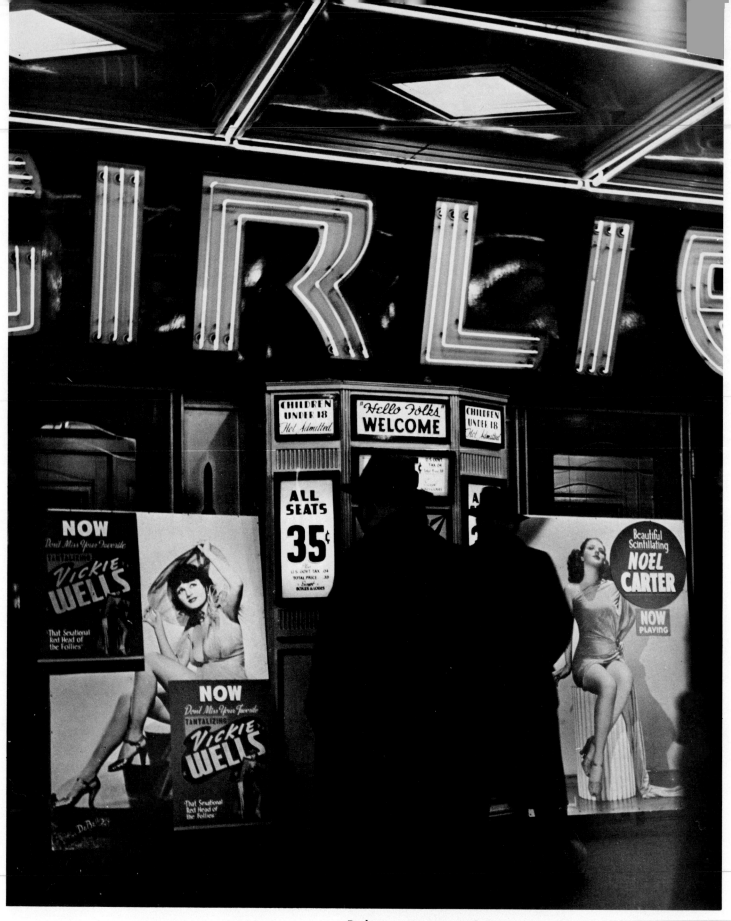

Burlesque House, 42nd Street between Seventh and Eighth Avenues [above]. Movie theater on 42nd Street [opposite]. New York was not without its gamy entertainment, even in the relatively puritan age of the 40s. The burlesque house lured patrons with posters of scantily clad women in gossamer wraps

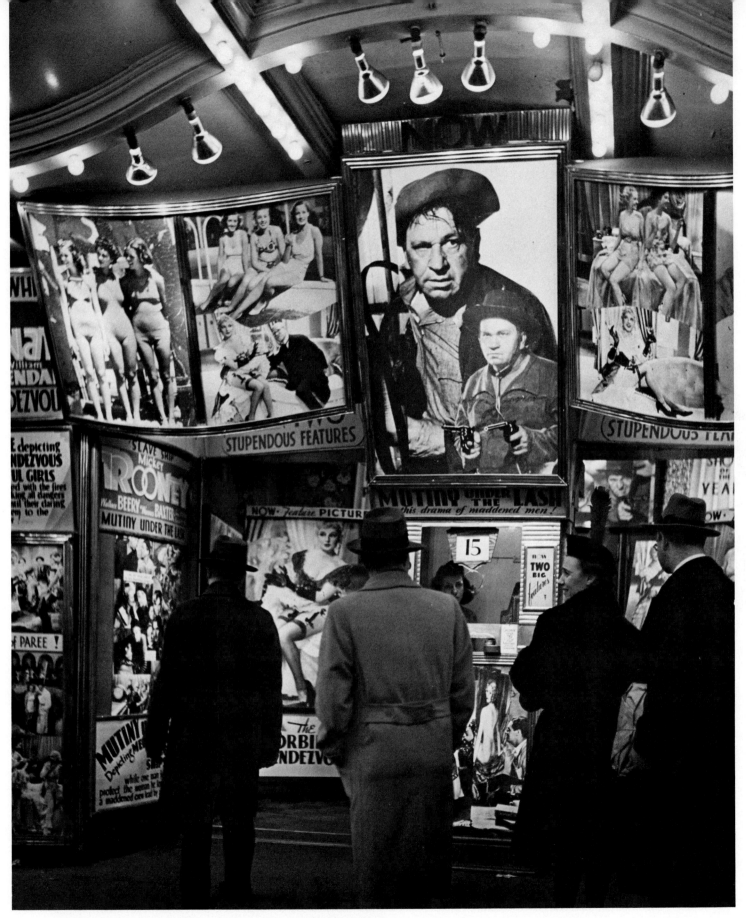

and high-heeled shoes. This risqué display seems restrained by present standards, with its "welcome" sign over the ticket booth and demure poses of the stars. Even movies proclaiming violence (*Slave Ship* with Wallace Beery) and promising a saucy French rendezvous seem innocent.

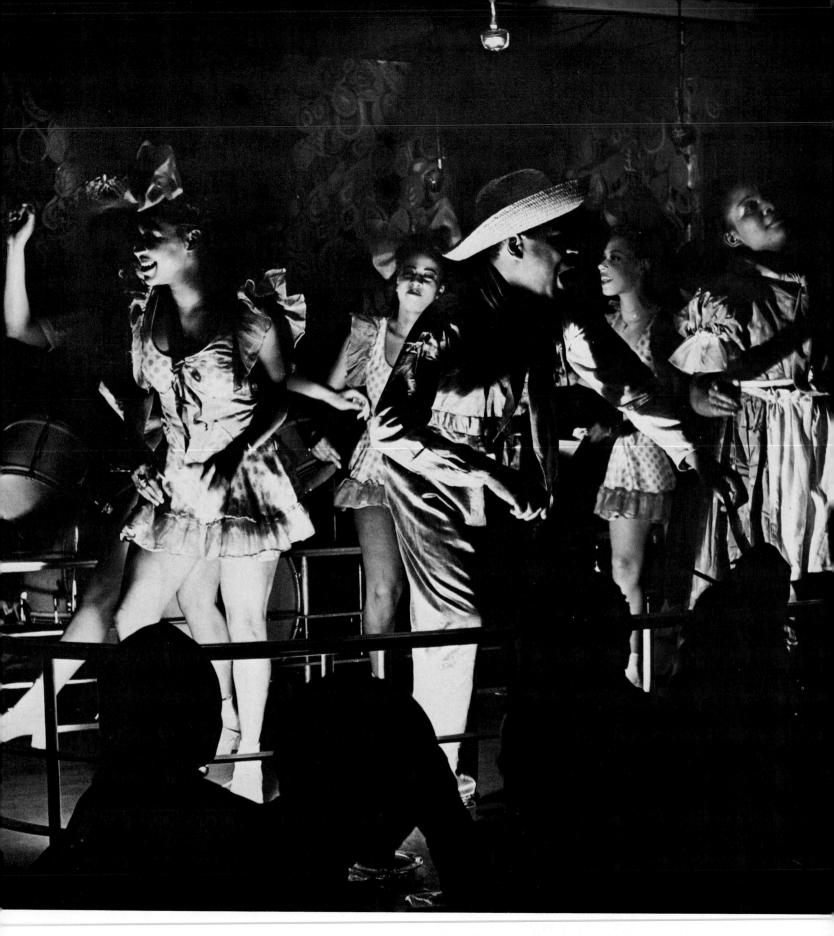

Floor show in a Harlem nightclub. Harlem had some of the most famous and popular night spots in the city, including the Elks Rendezvous at 133rd Street and Lenox Avenue, shown here. Patrons of all races arrived and departed at all hours of the

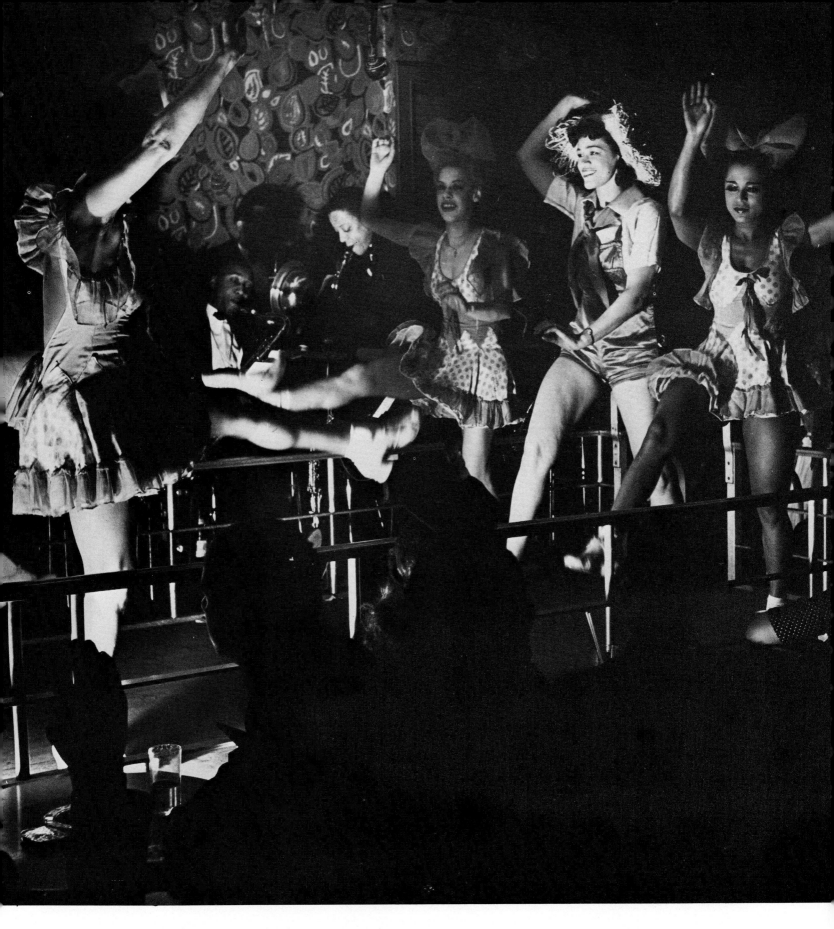

night at these clubs, which were the showcases for the great
jazz players of the time. The Harlem nightclubs were the birth-
places of the dances adopted by the entire nation—the jitter-
bug, Suzy Q and Lindy Hop.

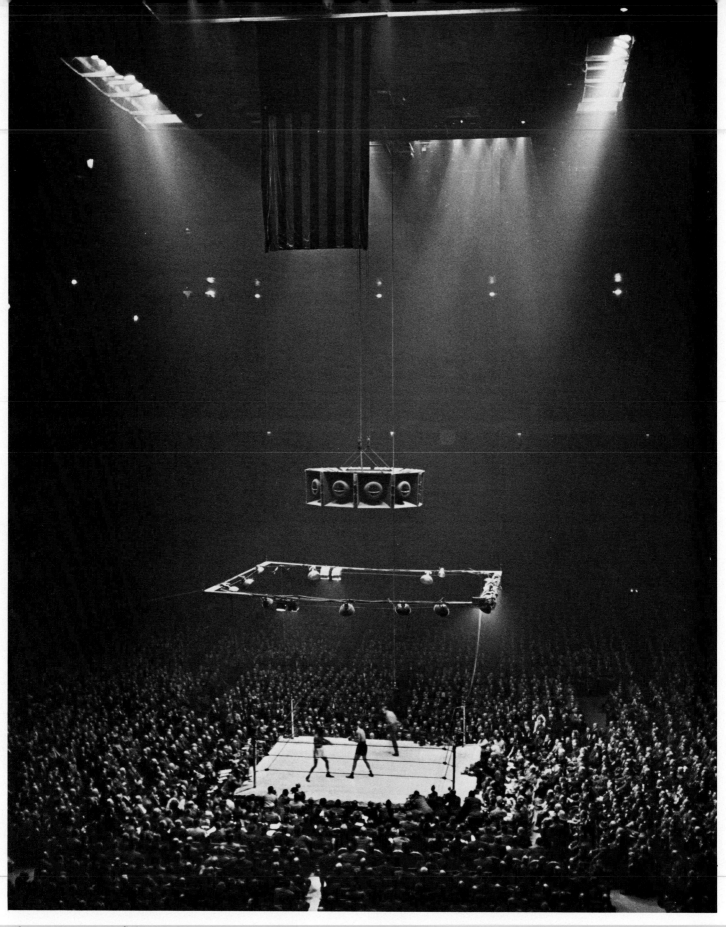

The Louis-Walcott fight, Madison Square Garden, 1947. A sports arena famous around the world, Madison Square Garden was in its third incarnation, this time at 8th Avenue and 50th Street. (The two earlier Gardens had stood near Madison Square at 26th Street.) In 1947, some 18,000 boxing fans filled the Garden to watch heavyweight champion Joe Louis outpoint Jersey Joe Walcott to retain his crown.

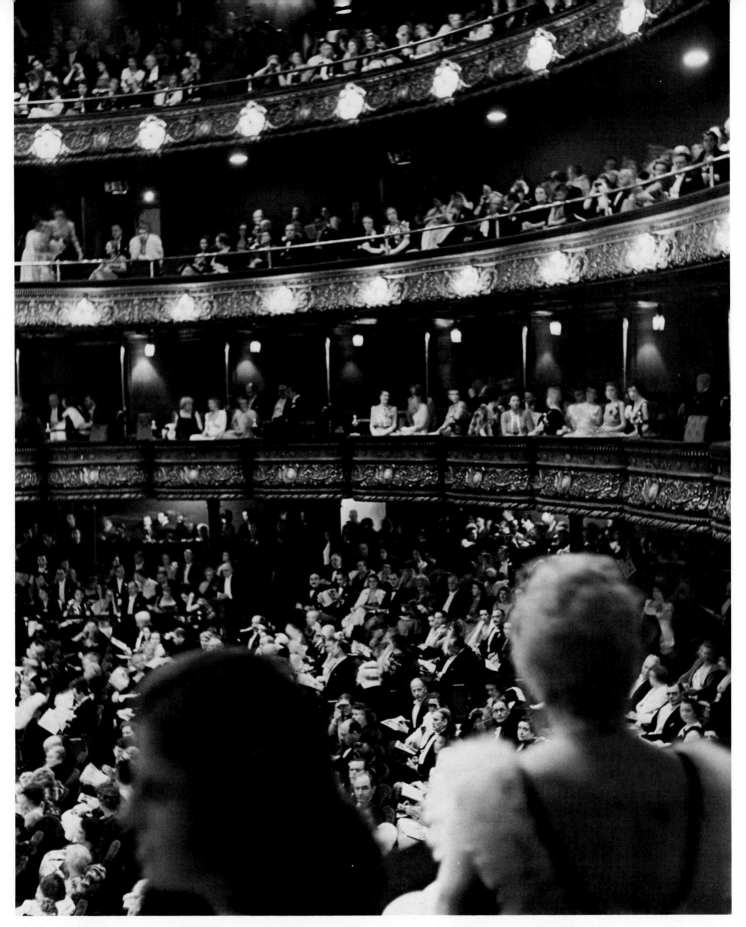

The Diamond Horseshoe of the Metropolitan Opera House.
The Metropolitan was a different type of arena than Madison
Square Garden, although equally as famous. Here, the wealth-
iest people of the age came to hear the finest musical artists.

Although the opera was the drawing card, the occasion was a
golden opportunity for the rich to preen in their finery. With
the demolition of the old Metropolitan Opera House in 1966,
this opulent display came to an end.

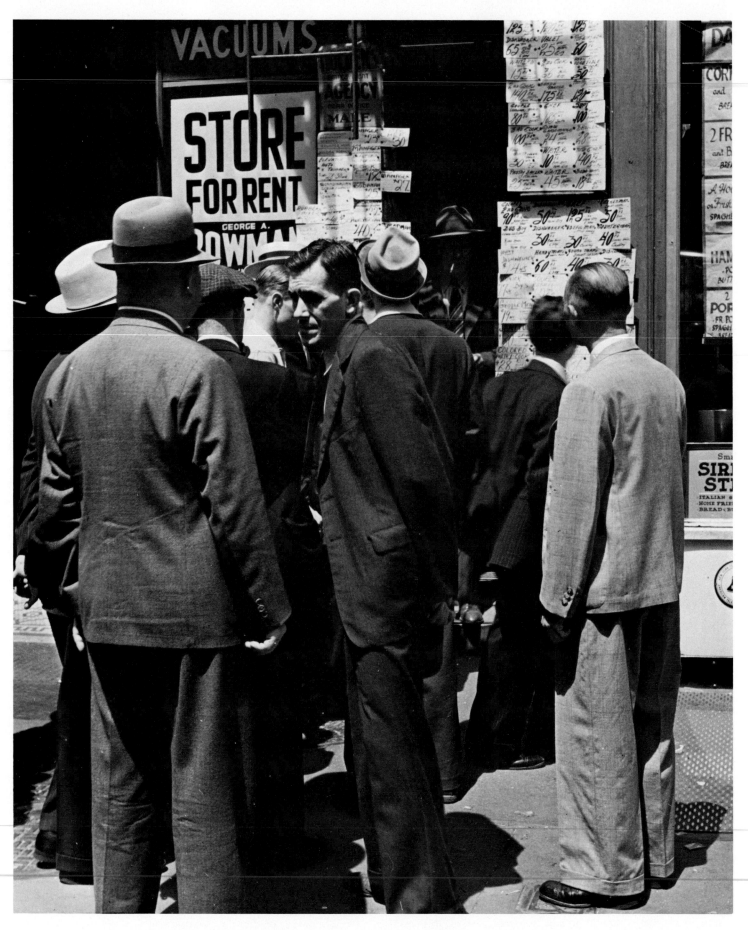

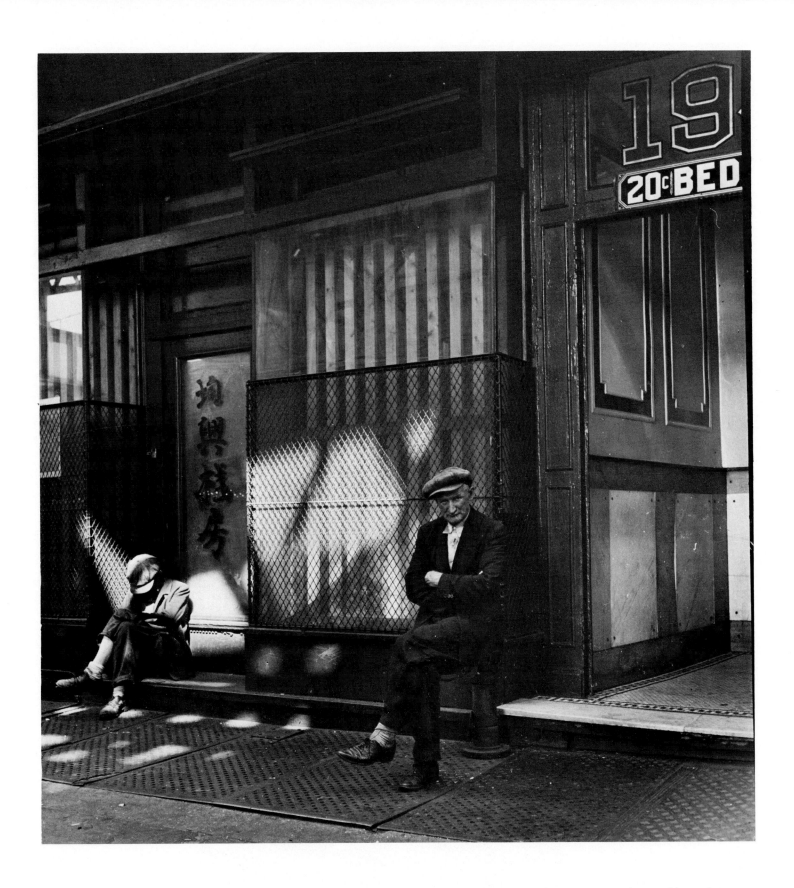

Bowery flophouse [above]. Employment agency on Sixth Avenue [opposite]. Like the rest of the country, New York in the early 40s still hurt from the economic depression of the previous decade. Behind the sparkling facade of opulence lurked the spector of men temporarily out of work and those who had given up entirely on the American dream. Unemployment agencies, like the one opposite, offered some hope for would-be countermen, dishwashers and elevator operators. But the Bowery flophouse with its beds for 20 cents were the last stop for those who were no longer looking.

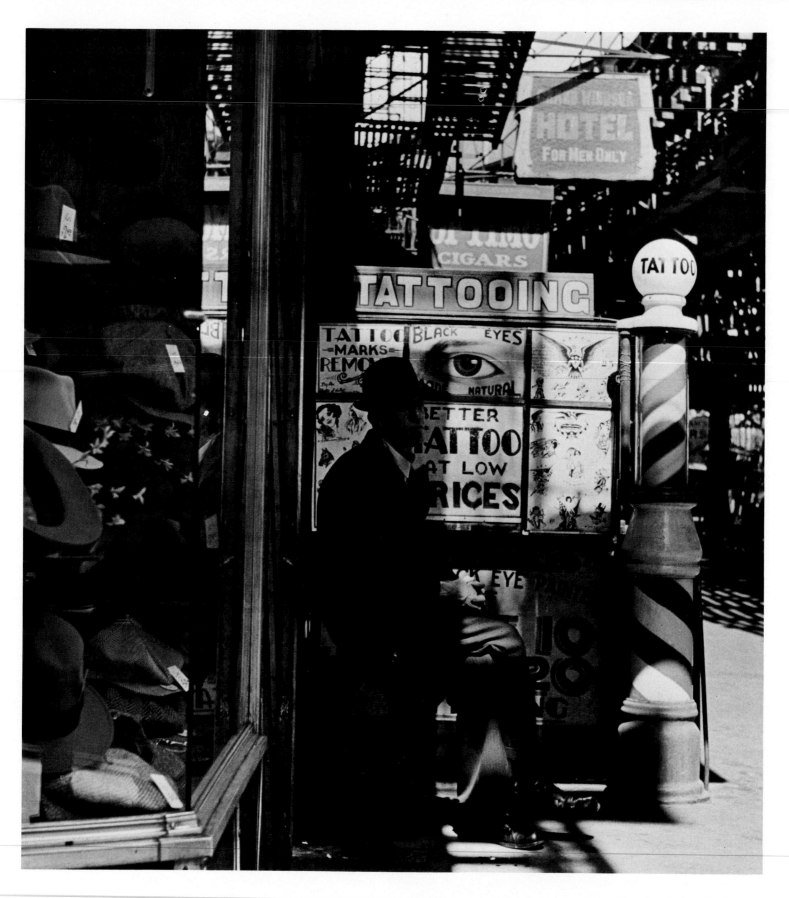

Two Bowery scenes. Darkened by the gridwork of the Third Avenue elevated, the Bowery was a shadowy boulevard of netherworld appeals. Tattoo parlors dotted the avenue, the signs and display windows assuring potential customers what

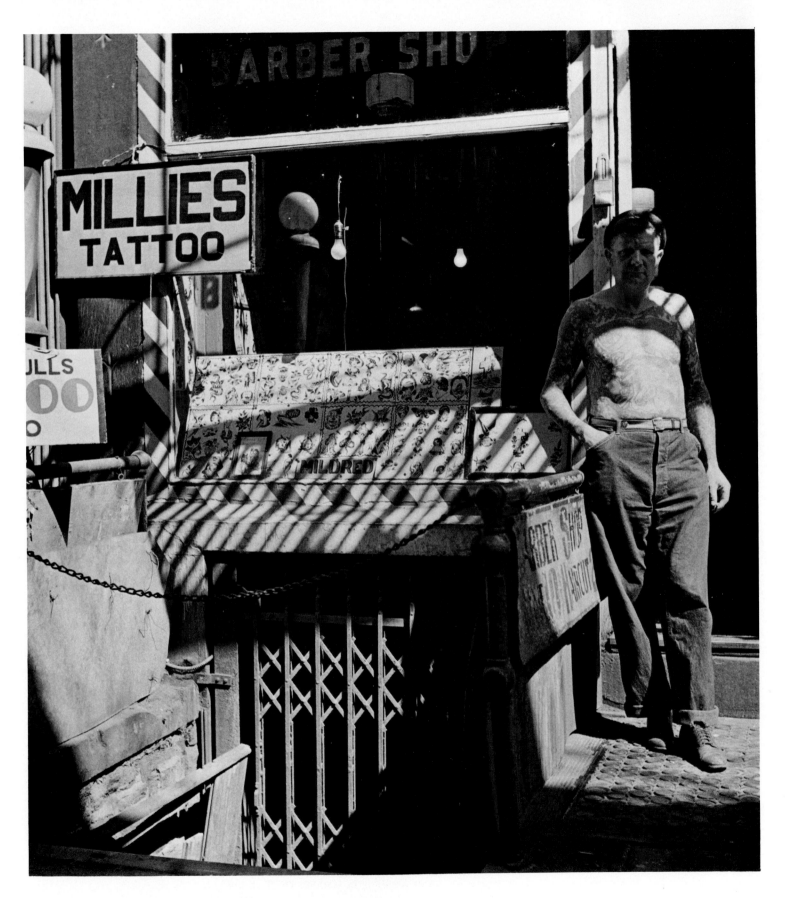

they could expect. With its shady reputation and inexpensive services, the Bowery was the Fifth Avenue of day laborers, itinerant seamen, drifters and drunks—men who could get a black eye repainted to look natural for as little as a dime.

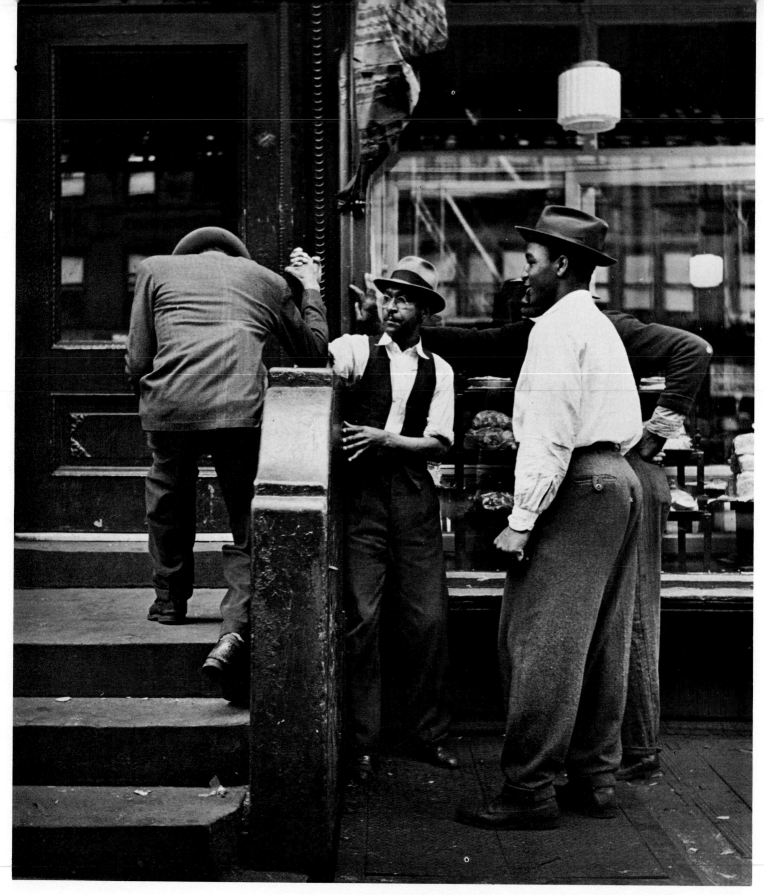

Arm wrestling in Harlem. Physical strength wins respect in almost any community. But in Harlem, where men were accustomed to taking on the city's toughest physical work, a strong man earned a special place. One way to test strength was through arm wrestling, a game in which the winner owned the bragging rights to his stoop—and maybe even his block.

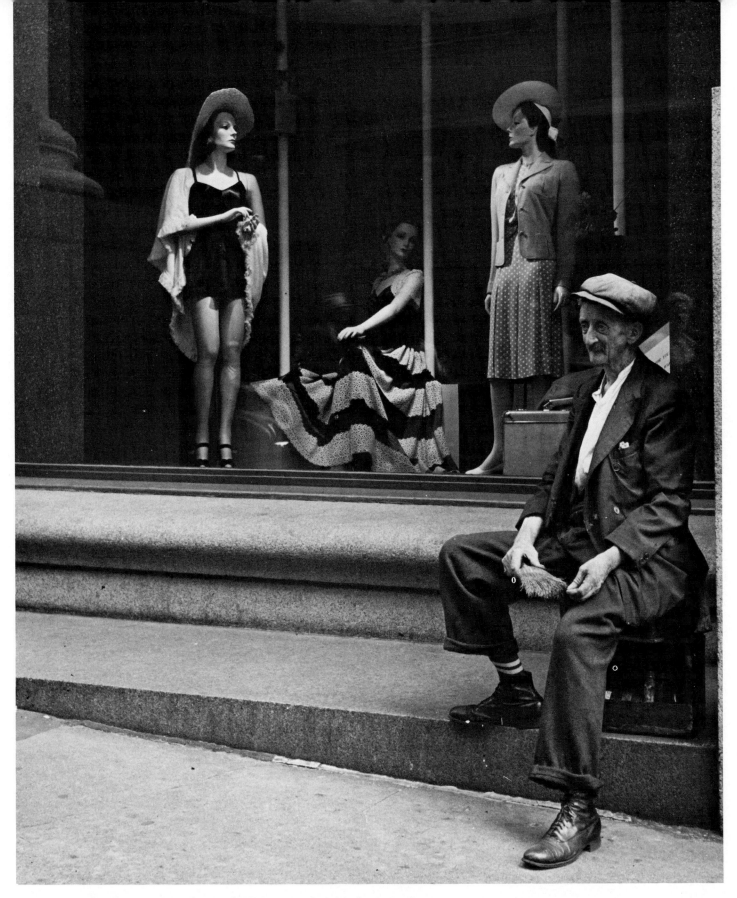

Shoeshine man in front of Altman's. A bootblack awaits his next customer in front of a fashionable Fifth Avenue store. Dressed in the vestiges of gentility of those broken by the Great Depression, he wears a cap, white shirt, suit and high shoes. The whisk broom is to spruce up the suit of his patron.

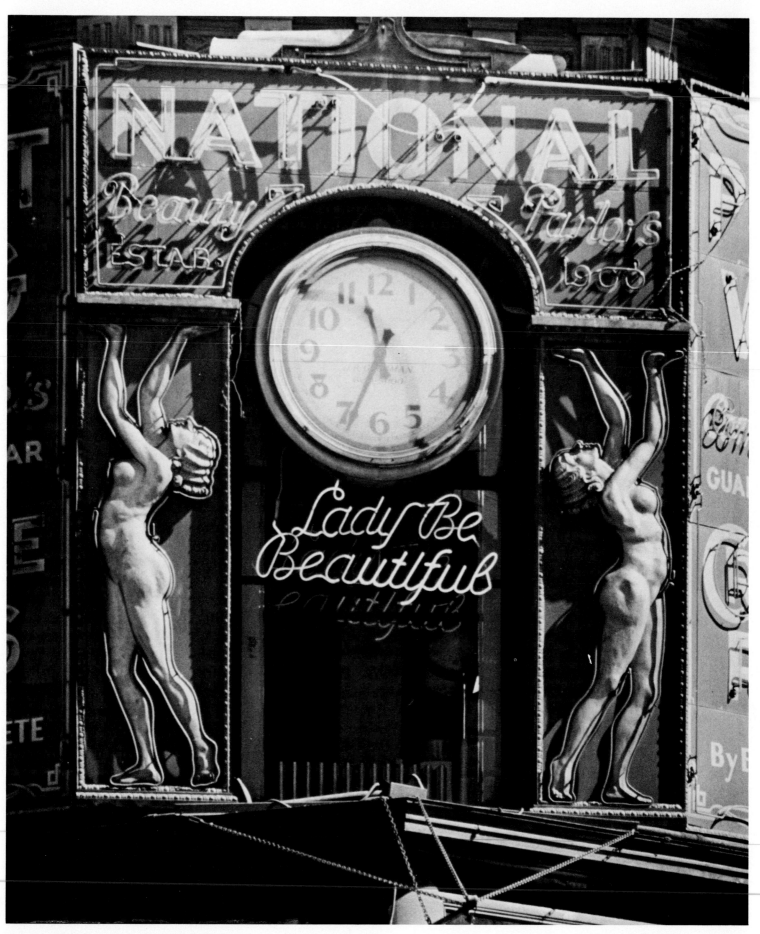

Beauty parlor at 43rd Street and Broadway.

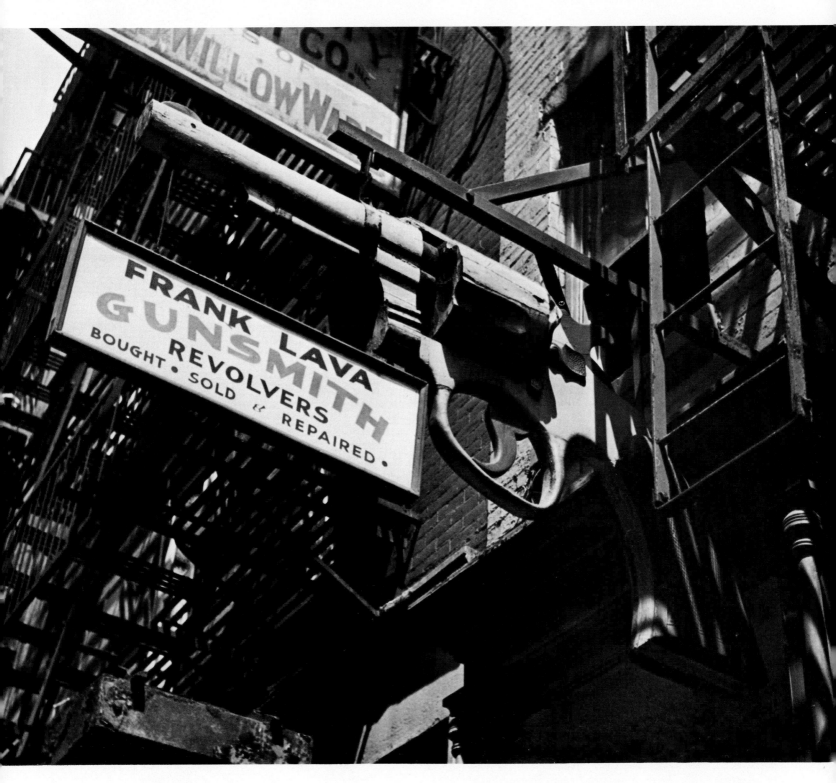

Gunsmith near central police headquarters on Grand Street.

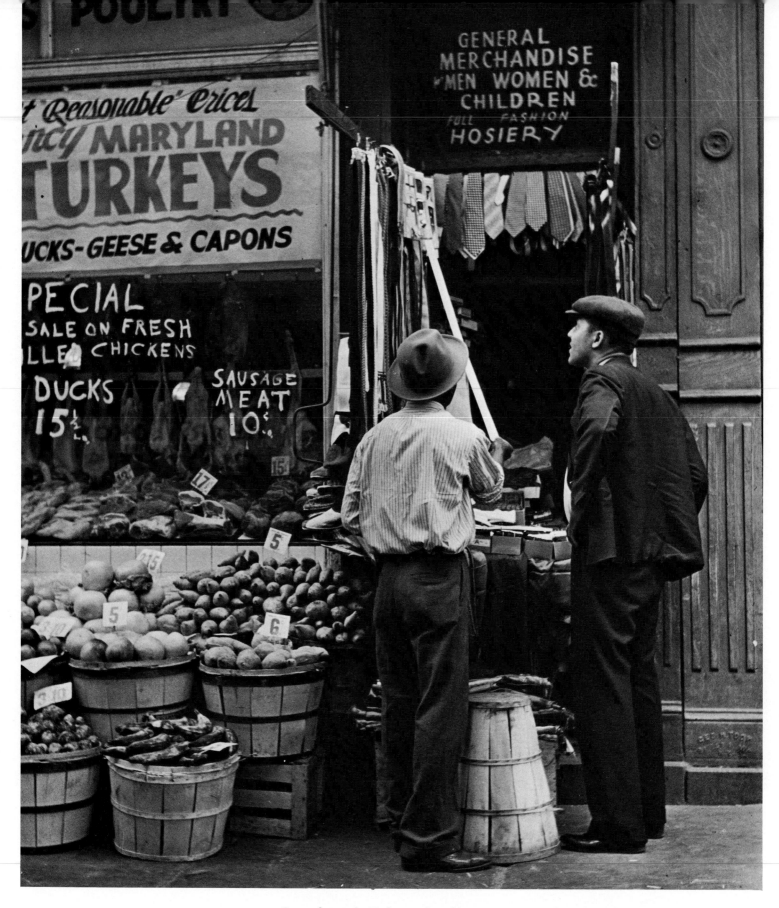

General store in Harlem. A lot of business was conducted on the sidewalks of New York. Thousands of stores like the one above spilled their goods onto the sidewalks to enlarge their display area.

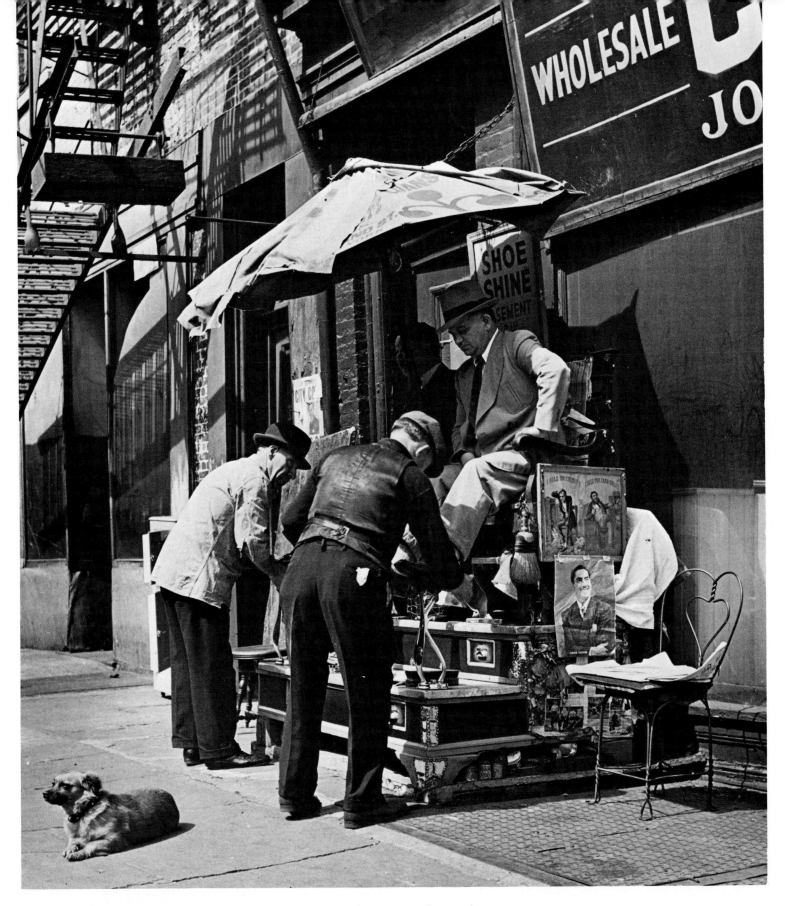

Downtown shoeshine stand. The shoeshine stand was more than a place to have dull leather renewed. It was a male hangout, like the barber shop, where the latest rumors and gossip were exchanged. The marble and brass-trimmed stand held comfortably-dilapidated armchairs for its patrons. In this relaxed ambience, the men were free to discuss matters of local and national importance.

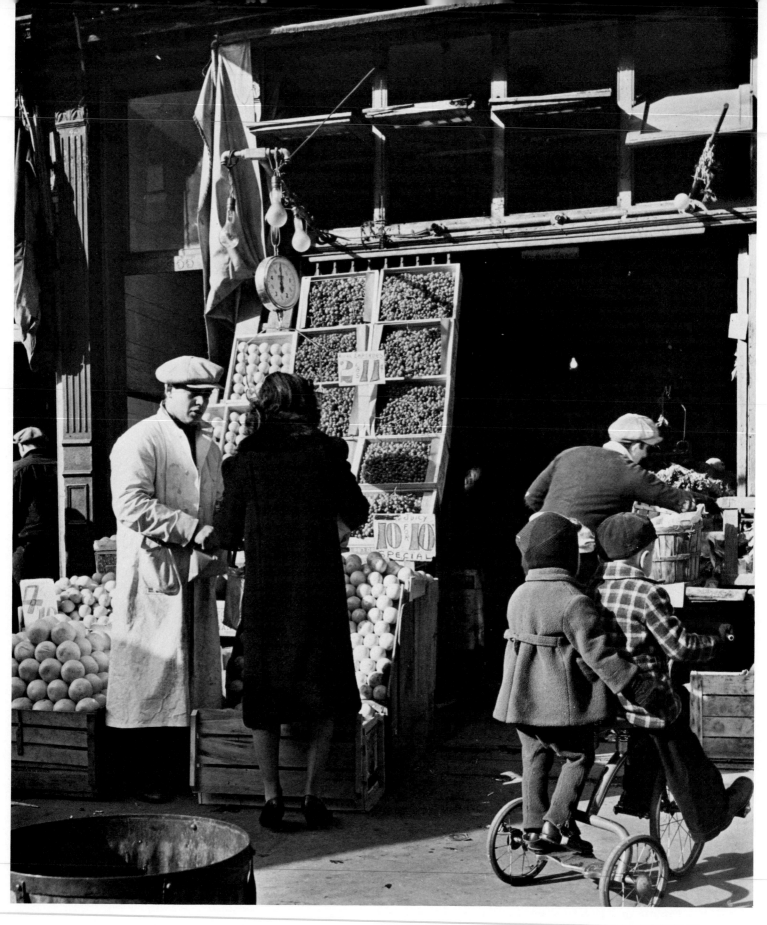

Third Avenue grocer.

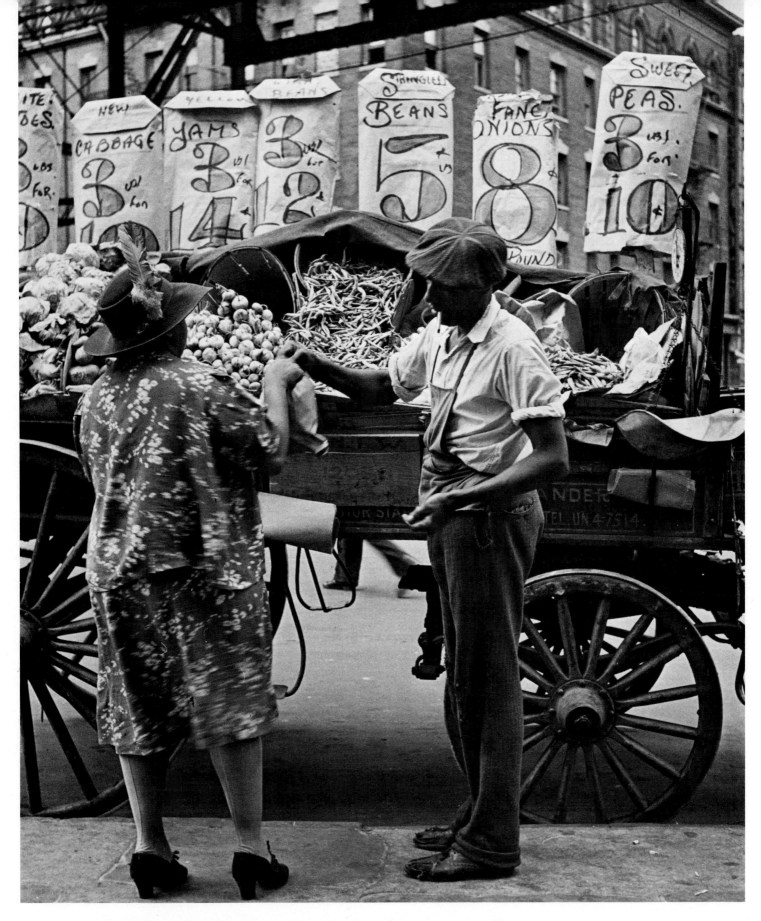

Harlem street vendor. The street vendor and his horse-drawn cart are usually considered part of an older epoch, but they were still fairly common in New York during the 1940s. The vendor above sells his vegetables in the shadow of the Ninth Avenue elevated.

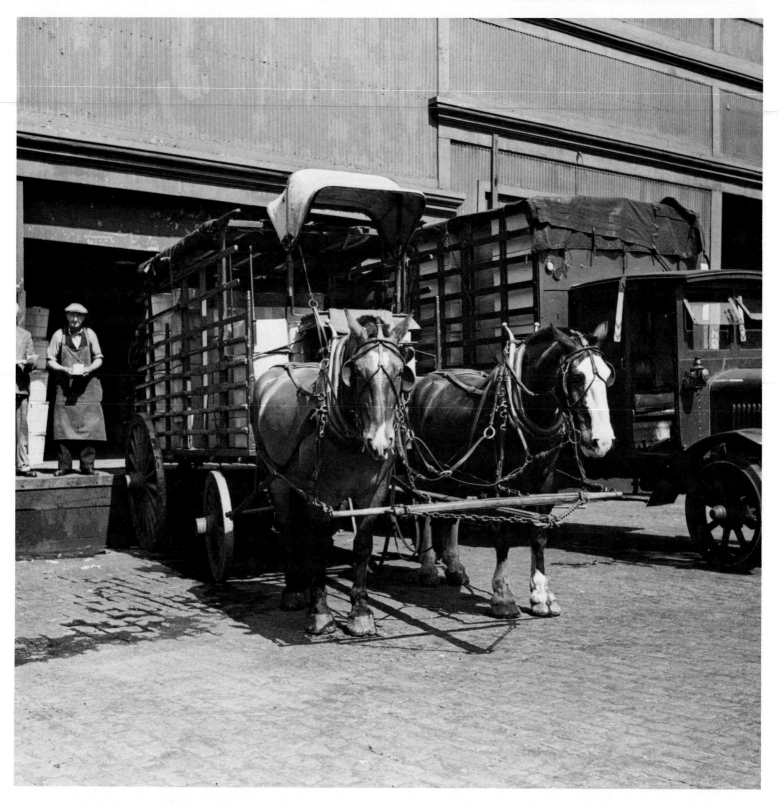

West Street [above]. West 18th Street, coal truck [opposite].
Although the 1940s witnessed the advent of the jet engine and
other advances in motorized transportation, delivery work in
New York often fell to vehicles from an earlier time. It was not
rare to see teams of horses pulling rattling carts full of goods
over the paving blocks of the city's streets to the loading plat-
forms of suppliers, such as the one at West Street above. And

many of the commercial vehicles were little more than drays
with engines instead of horses. The coal truck at right did have
the modern advantage of dumping its cargo without hard labor.
But it still rolled as roughly as a horse cart on spoked wheels
with solid rubber tires. Even the coal it carried speaks of an age
when furnaces and boilers were stoked by hand and automatic
oil burners for many were still machines of the future.

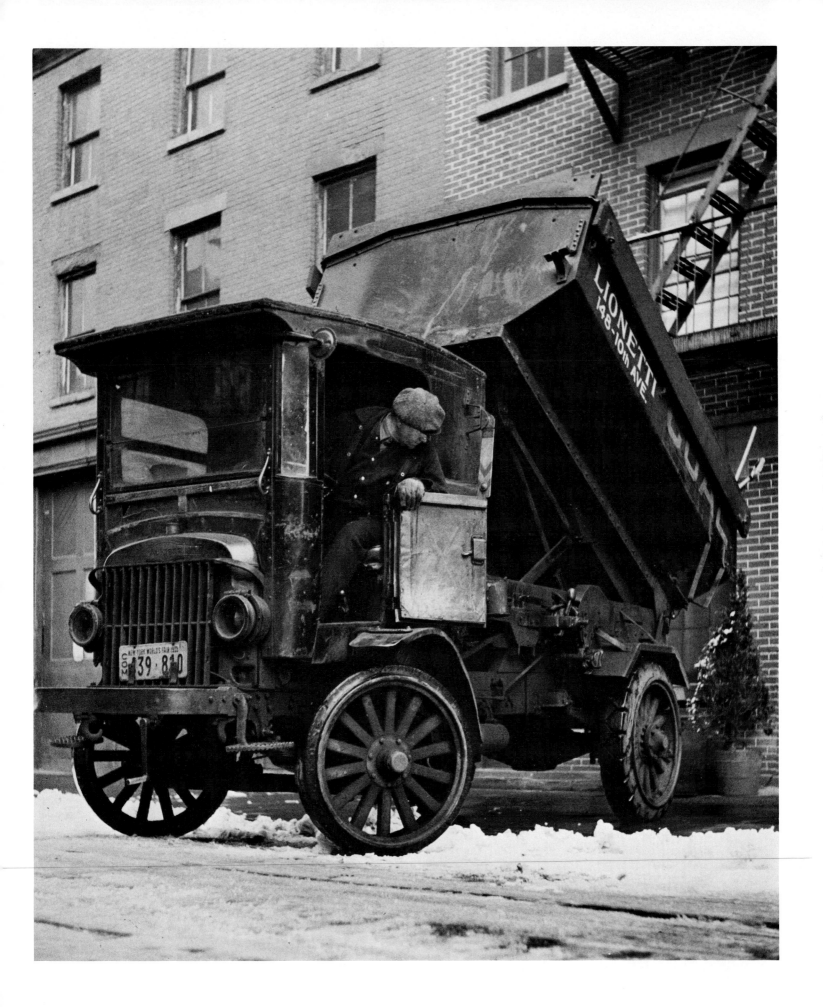

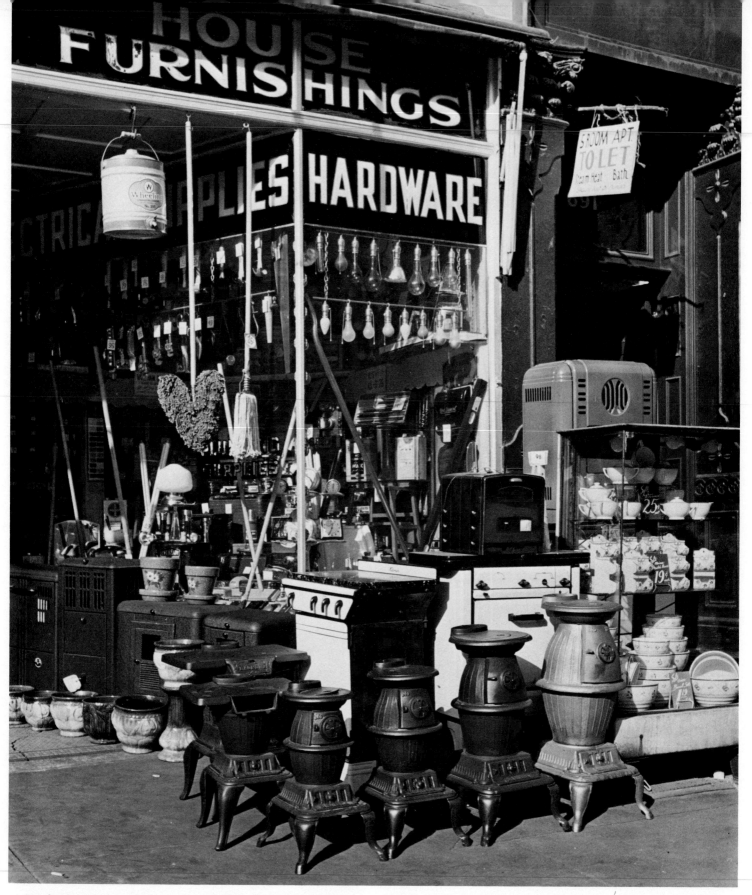

Hardware store on Ninth Avenue [above]. Fourth Avenue bookstore [opposite]. New York in the 40s was poised on the brink of many technological and marketing advancements. Soon, almost every apartment and office building would be centrally heated. Publications produced in the city would be mass-marketed through large printings and shrill promotions. In certain niches of the city, however, there was little awareness of these new concepts. A west side hardware store (above) still found a brisk market for potbellied stoves bought by local residents in cold-water flats. And secondhand bookstores on that avenue of bookstores—Fourth Avenue—still specialized in their own quiet form of marketing; they recycled books from reader to reader for a nickel each.

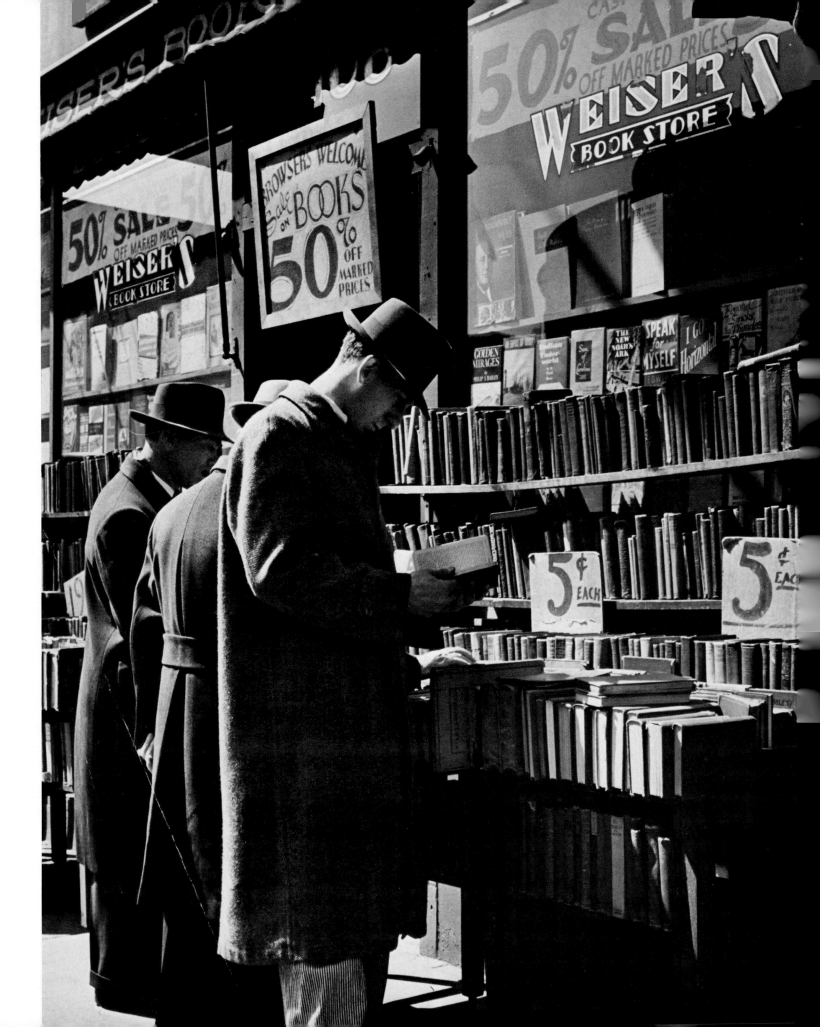

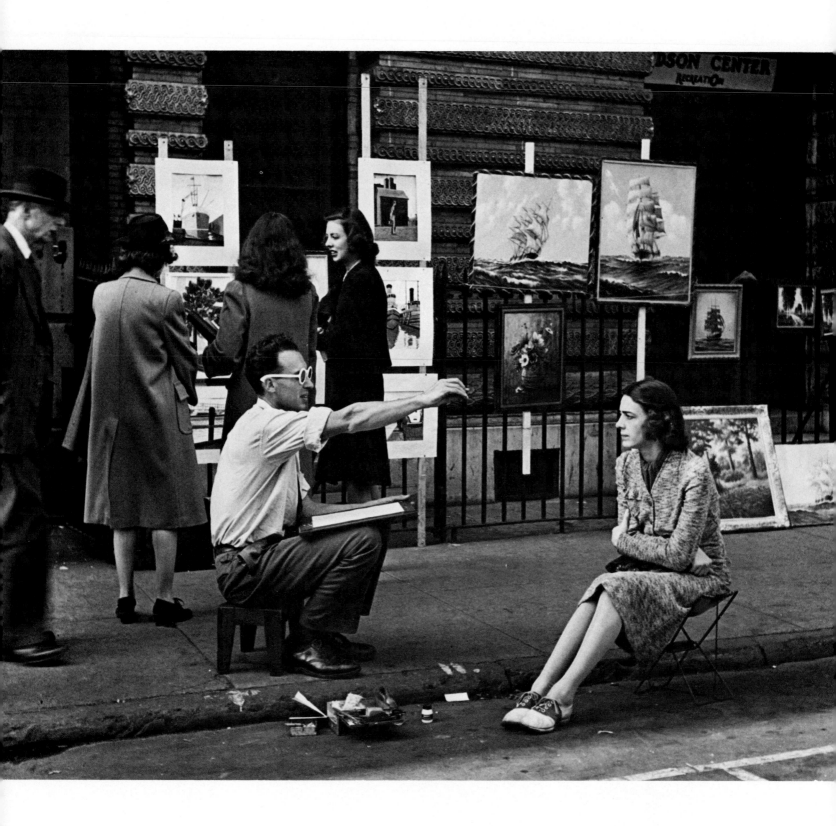

Sidewalk portraitist at work [above]. Artist awaiting a customer [opposite]. The Washington Square art show opened in 1931 and by the 1940s was an established hit in New York. In the spring and autumn artists would hang their work on fences or prop them against parked cars to display them to sidewalk patrons. Usually the works were the result of months at beaches, country retreats and drafty studios. Art was often executed on the spot, however, as caricaturists and portraitists made quick studies for a fee.

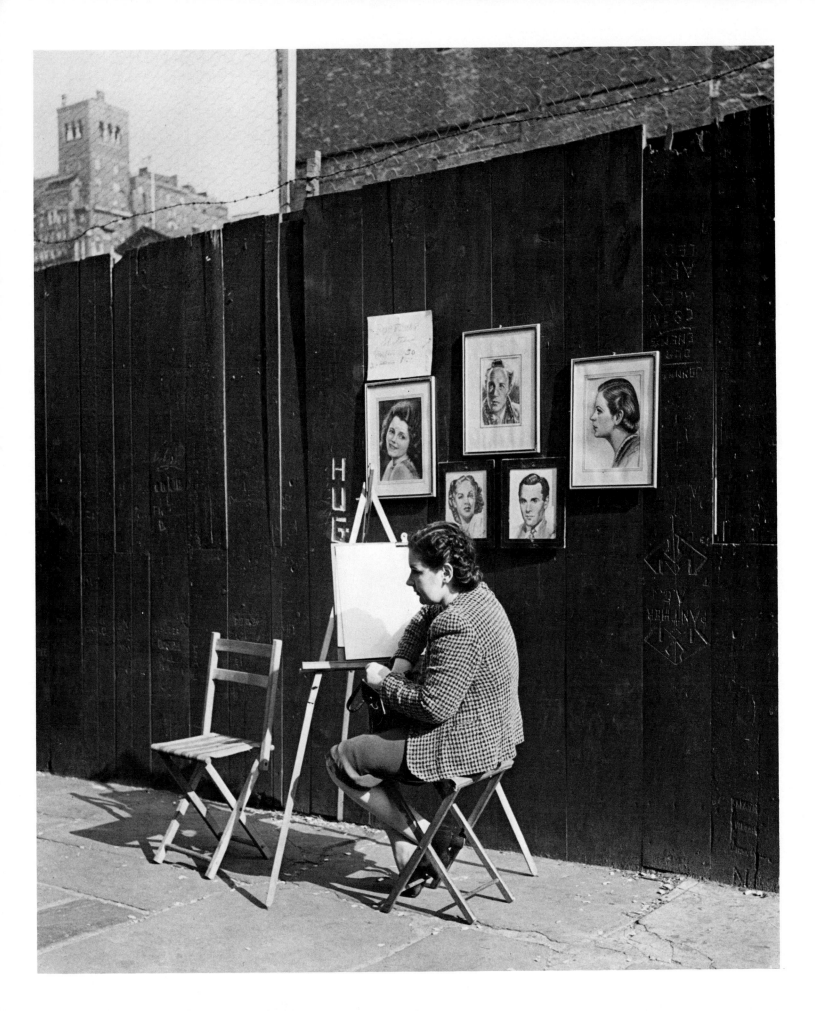

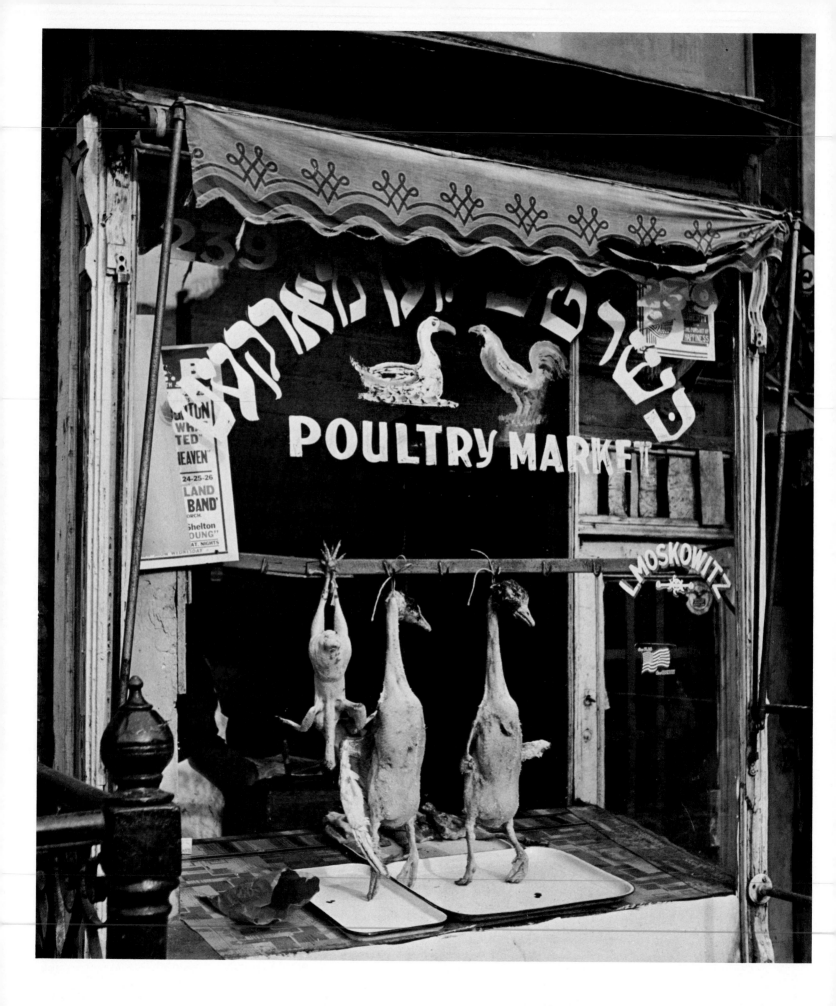

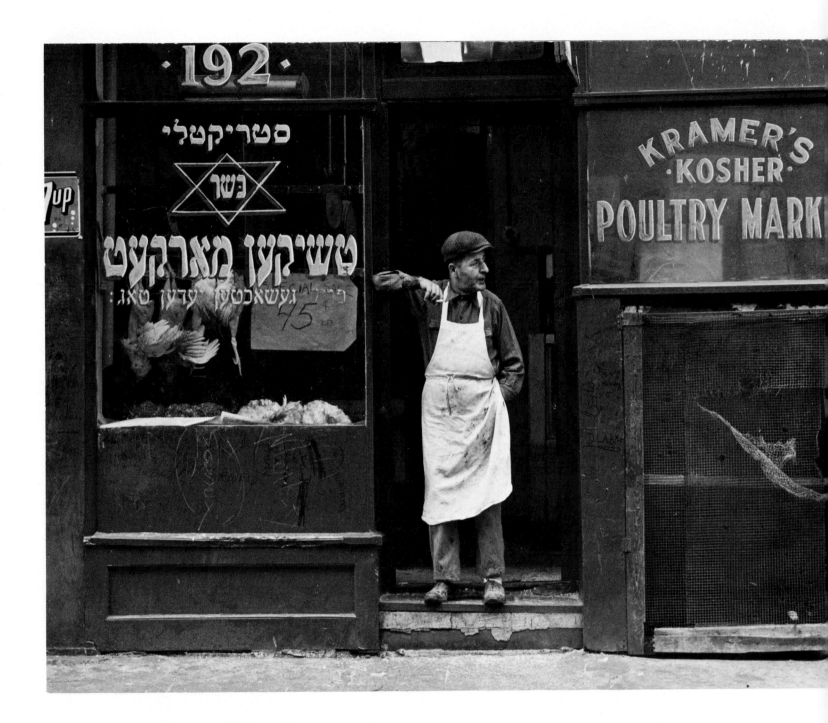

Two Lower East Side poultry markets. By the 1940s, many families of immigrants had lived in the city for several generations. Yet the customs, language and life styles were often remarkably unaltered from the Old World. The Lower East Side particularly was a rugged patch of real estate where the traditional customs and styles died hard. The hardy perennial plants of the Old World grew unmolested in the rocky garden of the Lower East Side, sprouting and flowering unchanged through the generations. While the Lower East Side was exemplary, other neighborhoods in New York retained their ethnic qualities too.

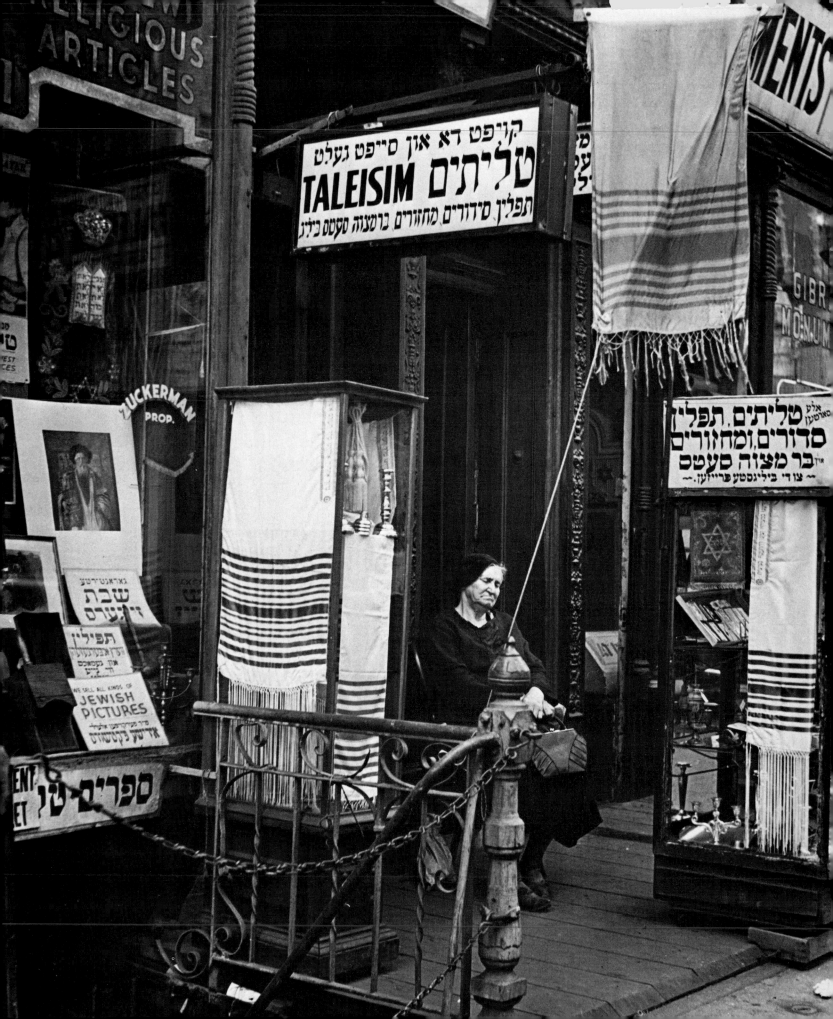

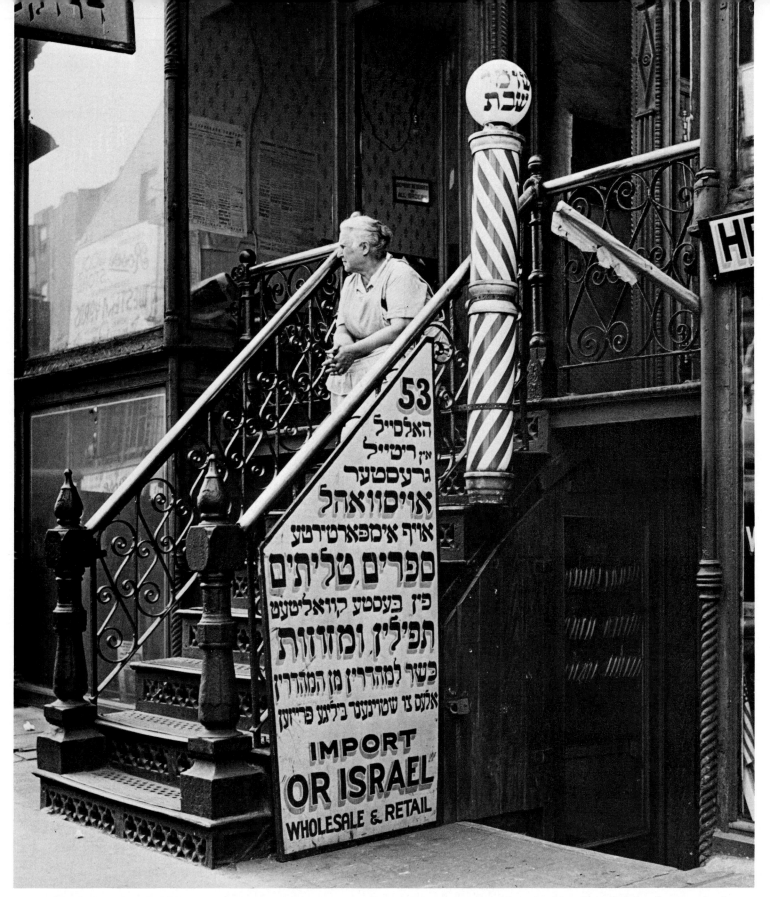

Jewish shops on Orchard Street. No group was more associated with the Lower East Side than the Jews, most of them immigrants from Eastern Europe and Russia who arrived at the end of the 19th century. Many Lower East Side neighborhoods became solidly Jewish as shops catered to their religious and dietary needs, newspapers were printed in Yiddish and success- ful Jewish merchants invested heavily in local real estate. In the 1940s, the Jewish Lower East Side was still intact. Physically, it was little changed from its most crowded period at the turn of the century. The store at left sold taleisim, prayer shawls, as well as other religious articles.

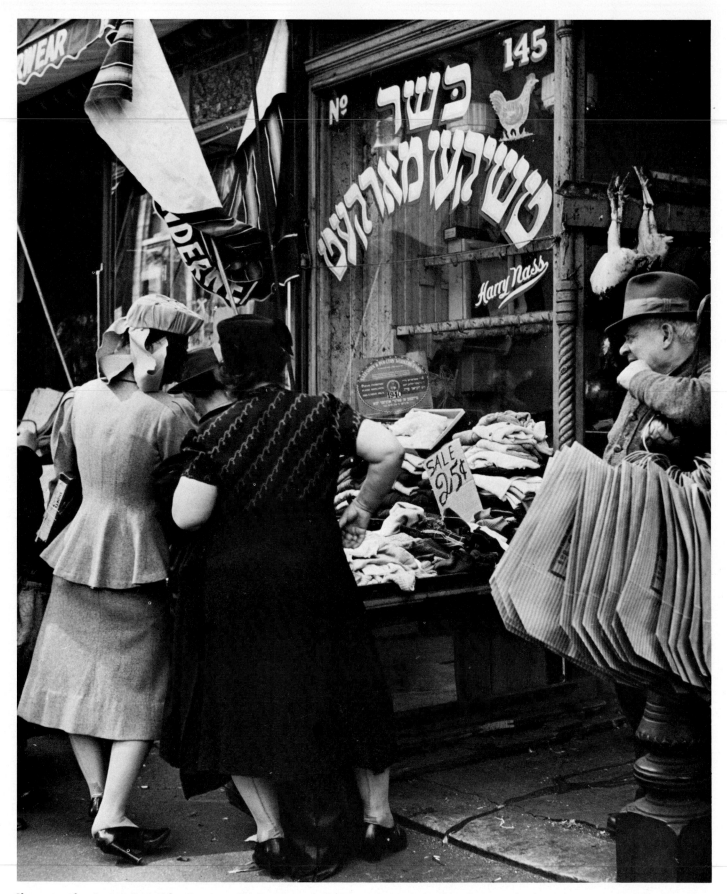

Shops on the Lower East Side. Every available square inch of space was used by merchants to attract the bargain-conscious shoppers of the Lower East Side. The poultry market at right housed a used-clothing store in its basement, probably run by a merchant who rented the space for a few dollars and stored the clothes in the cellar at the end of the selling day. The shoppers in the photograph above are typical of the true professionals of their era. While one of the women jealously guards her shopping bag by placing it between her feet, the other gives one tired foot a rest by twisting it free from its confining high-heel shoe. The merchant stands at a respectful distance wondering if he has browsers or buyers.

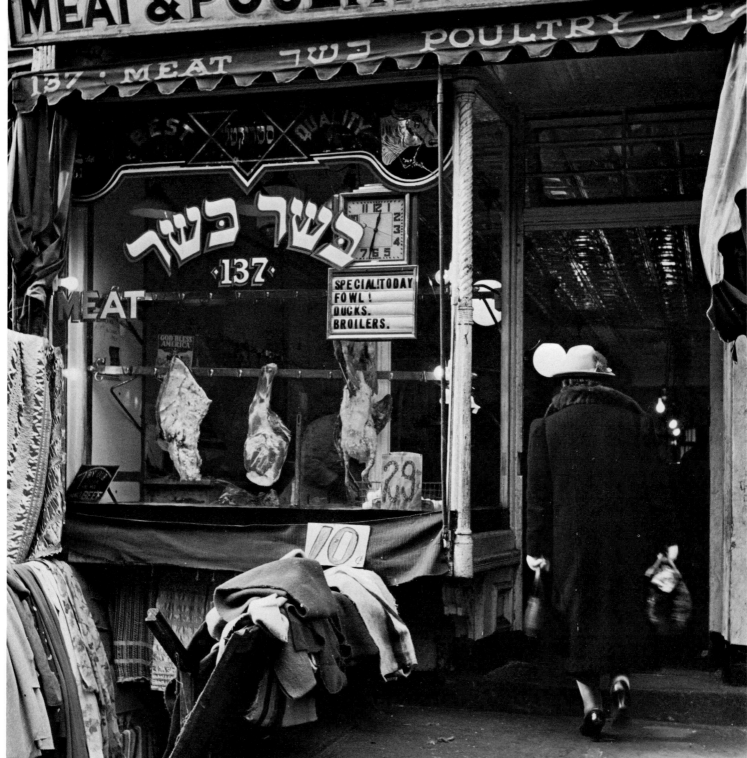

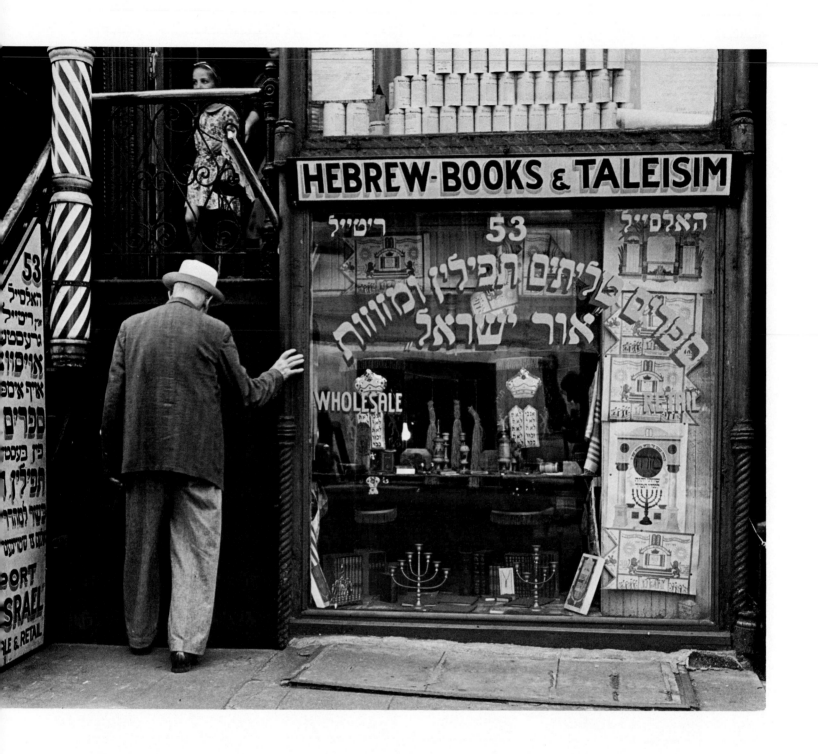

Two Lower East Side Jewish shops. The area was crowded with stores that sold books in Yiddish and Hebrew and all sorts of religious articles including torah, or holy scripts; yarmulkes, or skull caps; mezuzahs, the religious amulet mounted on the doorway of the home.

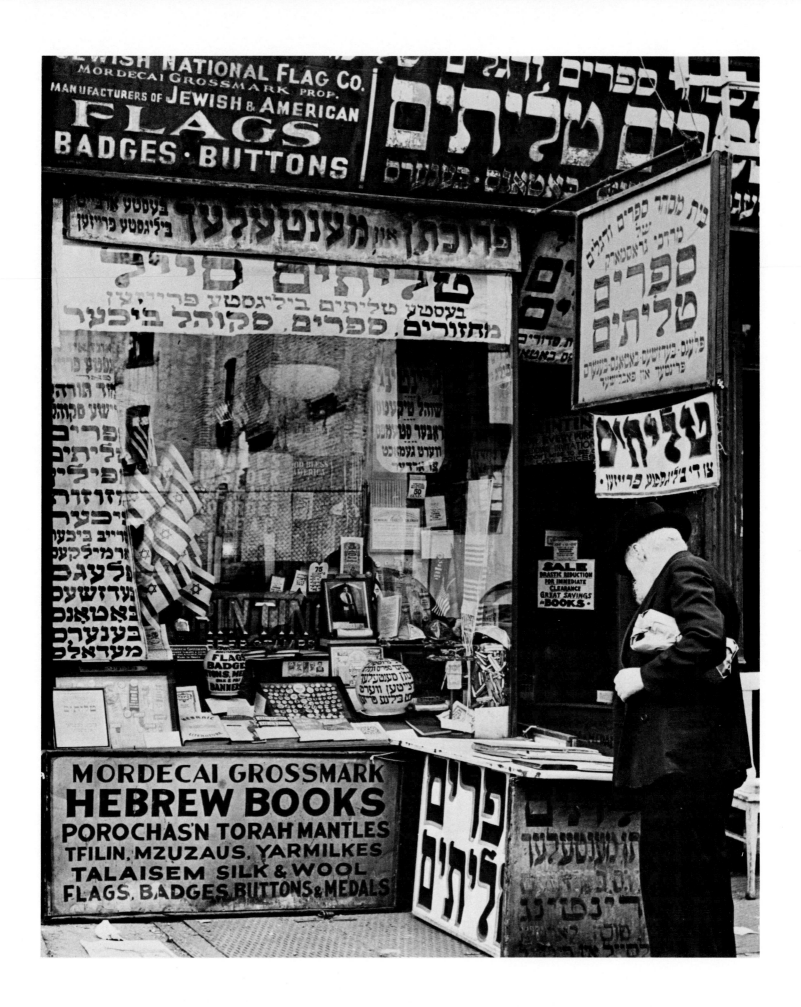

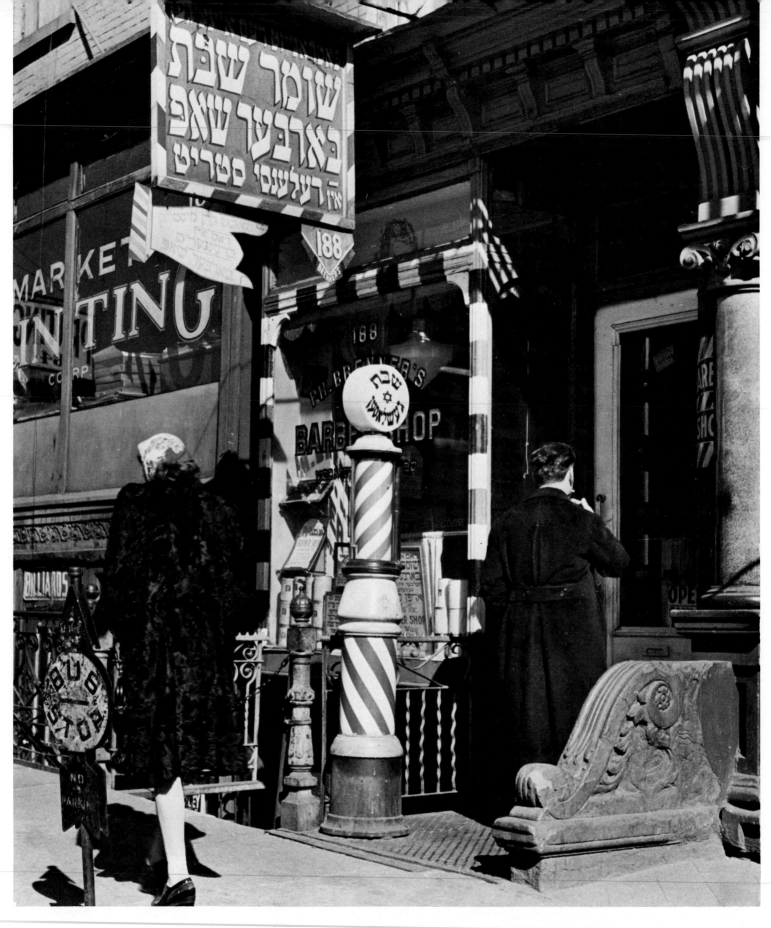

Two Lower East Side shops. The Hebrew letters on the sign in the photograph above are a transliteration of "barber shop."

NEW YORK
ARTISTIC
DARNERS
& WEAVERS

נ"יארק
קונסט
שטאפ׳ערס
ד"עבערס
·212·

WEAVING
DONE WHILE YOU WAIT

ווער געמאכט
וו"ל א"הר ווארט

RK WEAVERS

NEW YORK
ARTISTIC
WEAVERS

Miller
HIGH LIFE

WEAVING & STOTTING

DARNING
and
WEAVING

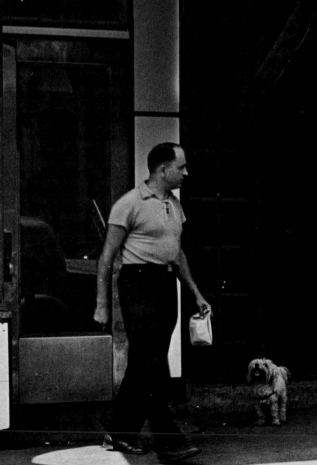

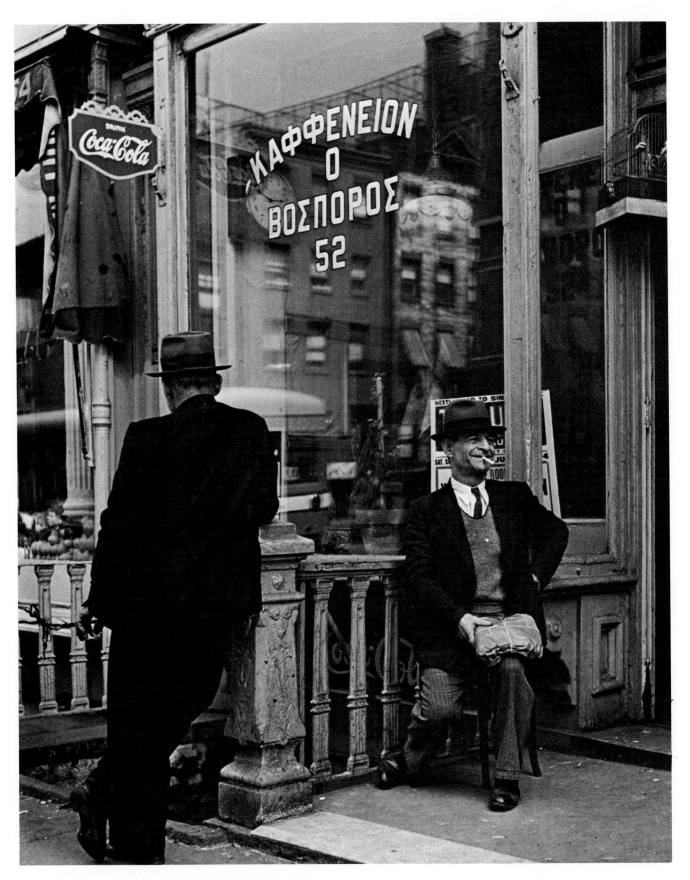

Greek coffee house on Mulberry Street [above]. Yorkville delicatessen [opposite]. Each of the city's neighborhoods seemed to have its own ethnic flavor. Generations of German immigrants made Yorkville in the east 80s around Third Avenue their own. Here, delicatessens perpetuated the favorites of the fatherland—the aromas of the treats being carried home are not lost on the dog in the photograph opposite. The Greeks, too, had their places. One, the Bosporus Coffee House (above) was a local gathering place for Greeks who lived in the Mulberry Street area downtown.

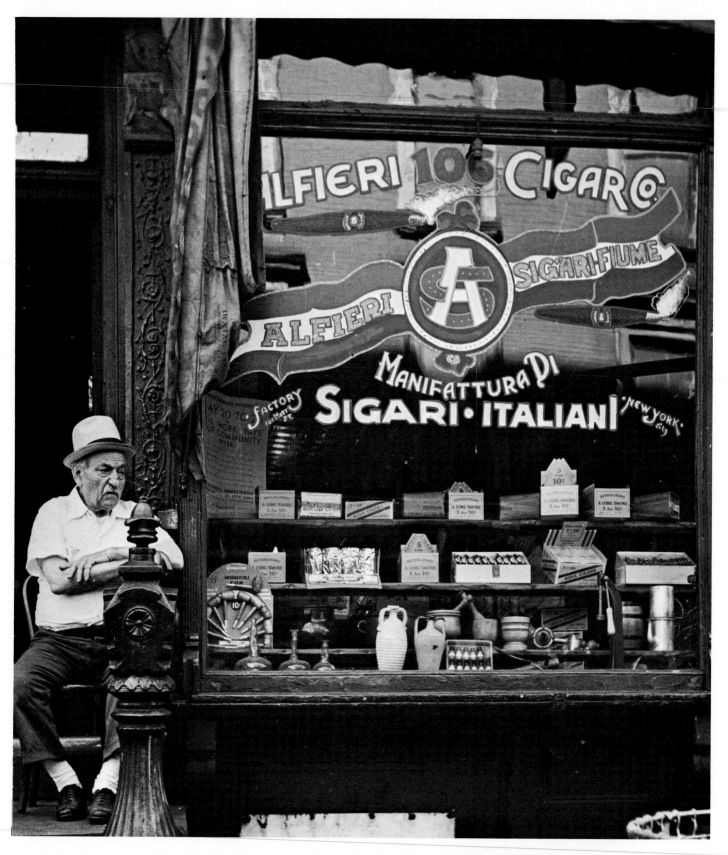

Two Italian stores on Mulberry Street. New York City had several neighborhoods called "Little Italy." The one on Mulberry Street was perhaps the best known, a Lower East Side community packed with colorful stores, grocers, bocce courts and fine restaurants. But sizeable populations of Italian-Americans also lived in Greenwich Village with Bleecker Street as a main thoroughfare and in a pocket of East Harlem uptown.

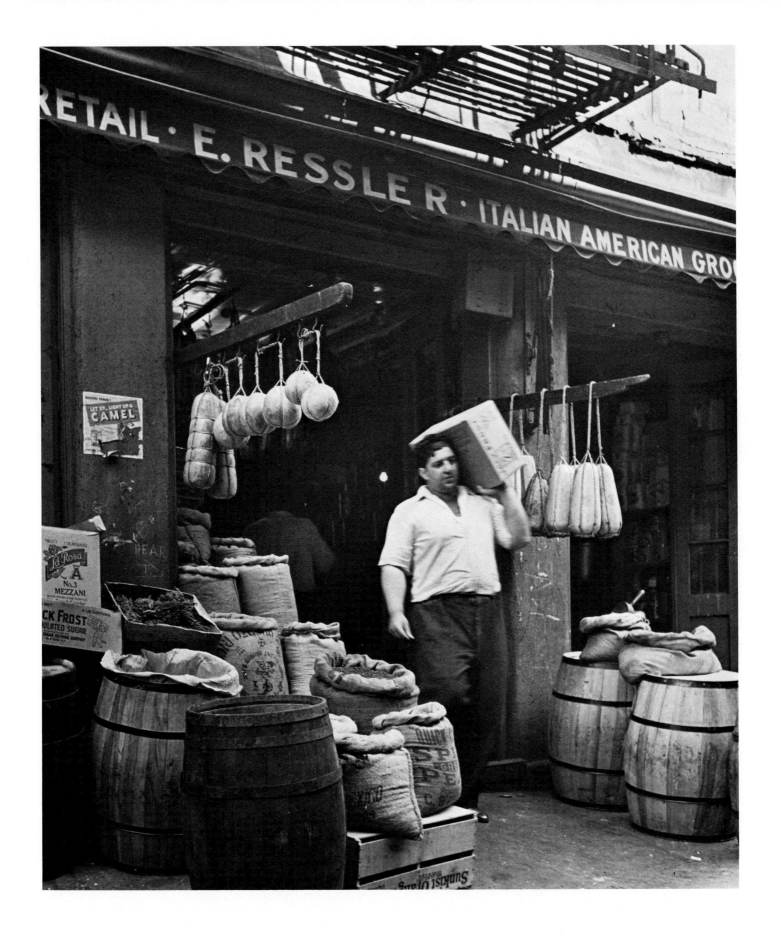

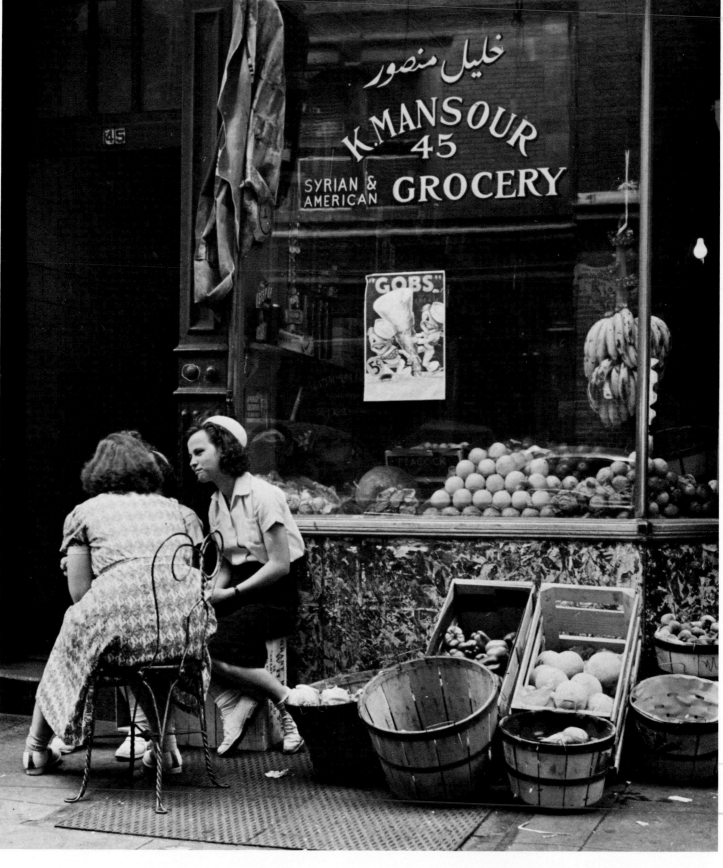

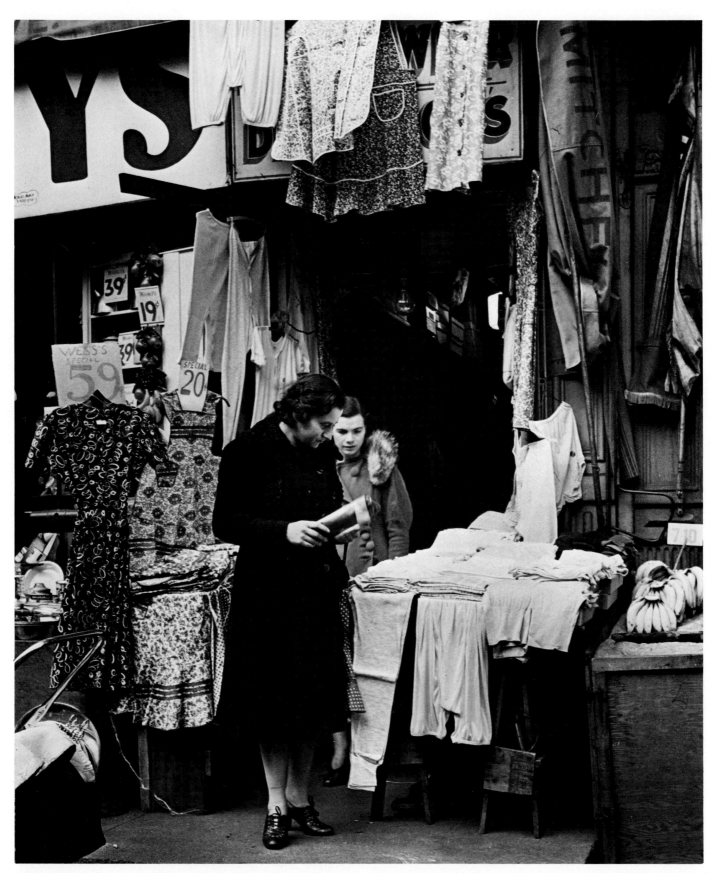

Syrian grocer along Washington Street [opposite]. A central marketplace for the city was Washington Street on Manhattan's Lower West Side. Trucks rolled down the streets in the predawn darkness to unload produce for distribution to the city's major markets. Most of the business was wholesale, but some retail stores, like the Syrian grocery, kept going.

Women's apparel shop on First Avenue and 11th Street [above]. Lower First Avenue was popular with bargain hunters for decades, a tradition continued in the 40s. The area had a mixture of Italians, Jews, Poles and Slavs.

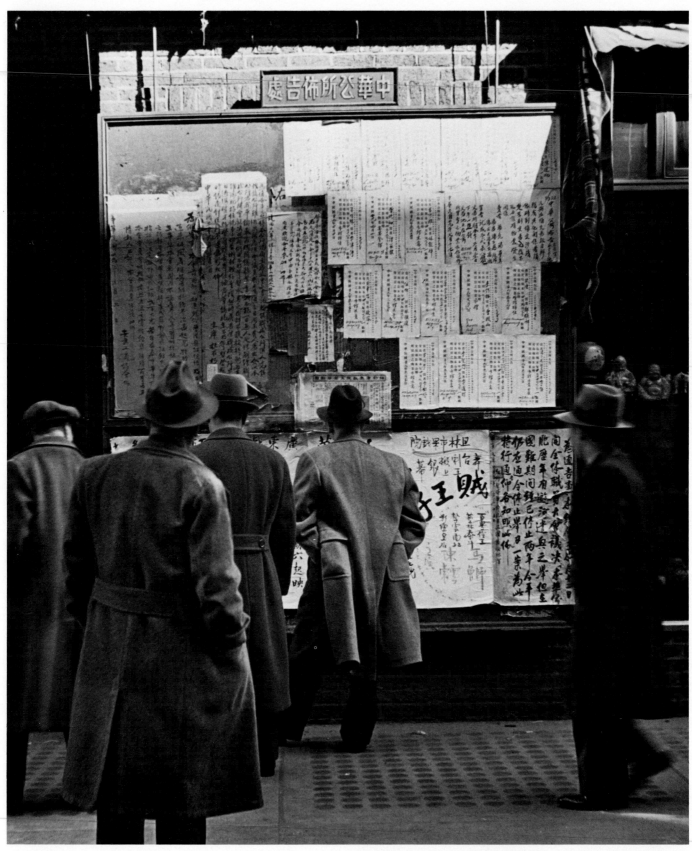

Newspaper office in Chinatown. The Chinese newspapers in Chinatown had a special system for keeping their readers apprised of the latest developments during World War II. Bulletins handwritten in red characters on orange paper were posted in the newspaper office windows. These poster-bulletins told of the fortunes—and misfortunes—of Japan, the hated enemy of China.

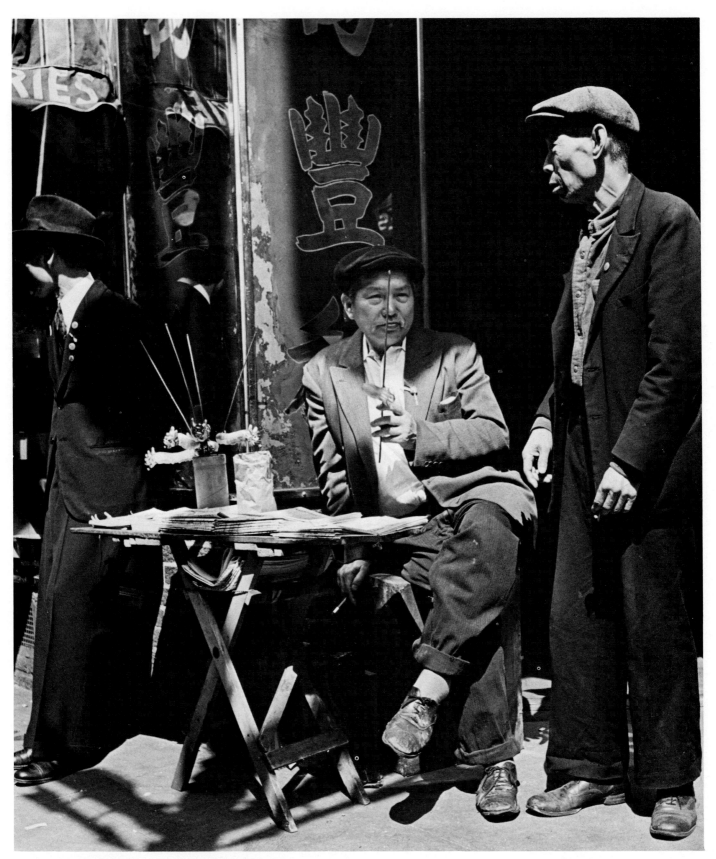

Vendor on Mott Street. The newspapers themselves were sold to the Chinese by sidewalk salesmen like the one above. While the papers were for Chinese-Americans, the vendor carried as a sideline some paper tigers, which were suspended from sticks on strings. The paper tiger is a traditional Chinese toy, but most were probably bought by tourists visiting the inexpensive restaurants and stores in Chinatown.

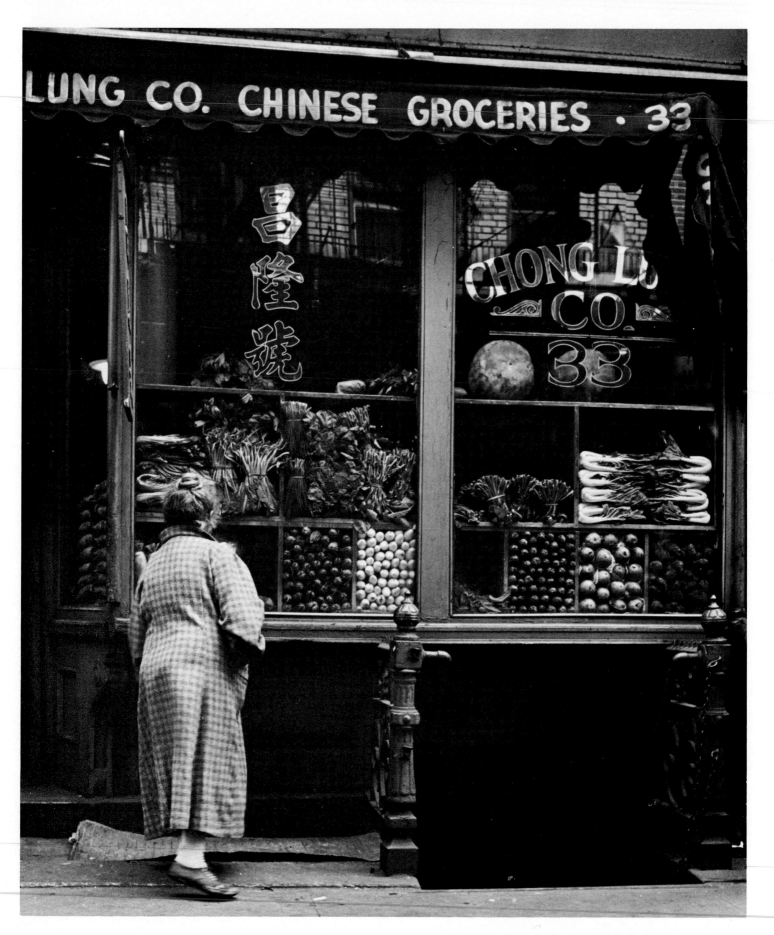

Chinese grocer.

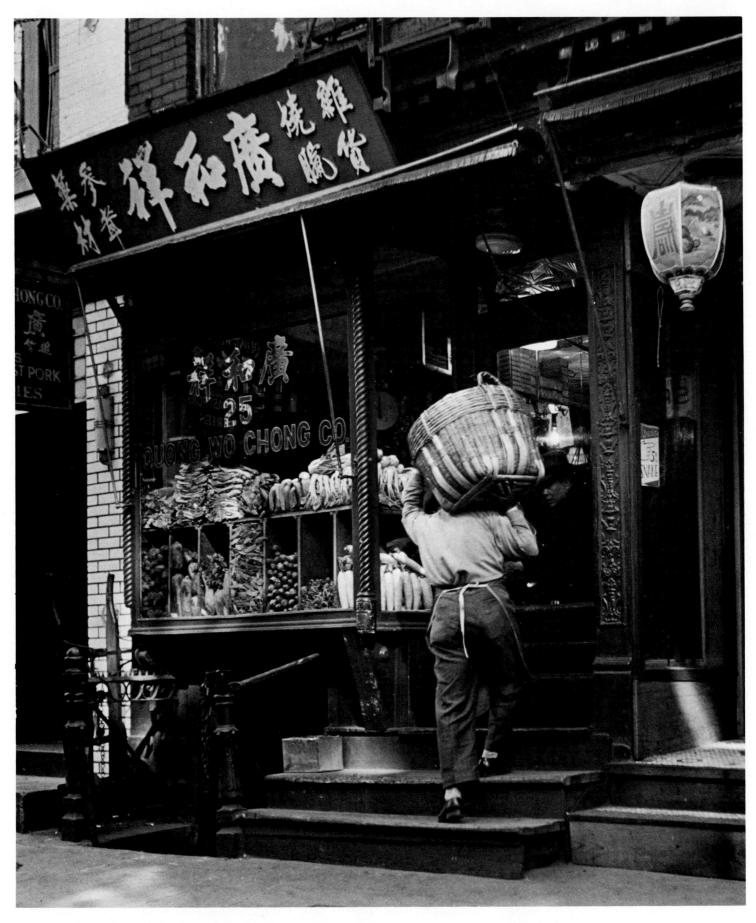

Supplies arriving at a Pell Street Chinese grocery store.

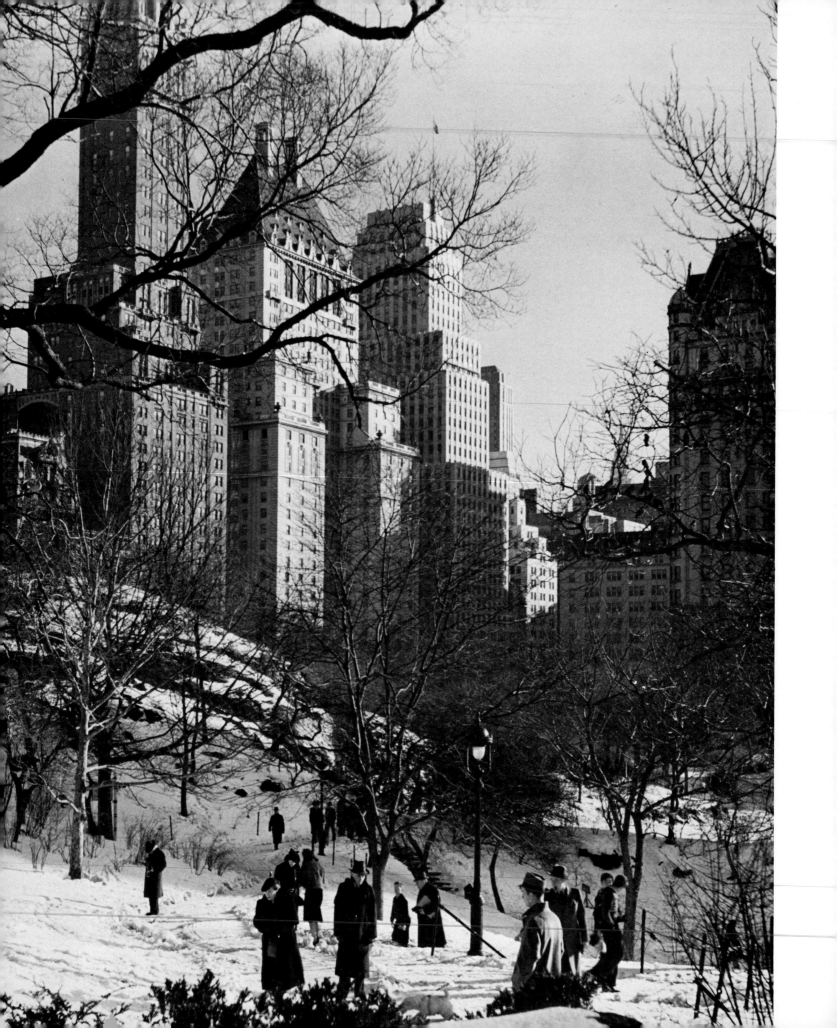

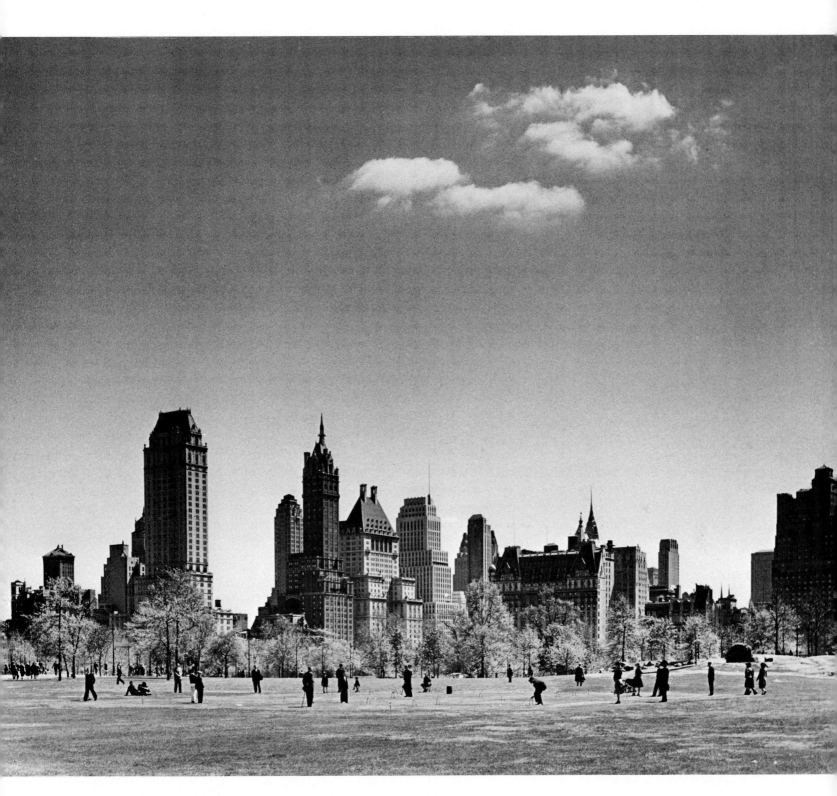

Sheep Meadow, Central Park, in summer [above]. Winter in Central Park [opposite]. These two photographs show the southeastern corner of Central Park in winter and summer. In the winter, the corner was the site of snowy walks. In the background at left is the Sherry-Netherland Hotel and to its right, the Savoy-Plaza Hotel, since torn down to make room for the General Motors Building. The Plaza Hotel is at right. In summer, the Sheep Meadow held spirited games of croquet. The spire of the Sherry-Netherland rises at left-center and the Plaza Hotel with its distinctive squared gables is at right-center. Both pictures show New Yorkers dressed with typical 1940s formality— even while in the park—a style that has long since vanished.

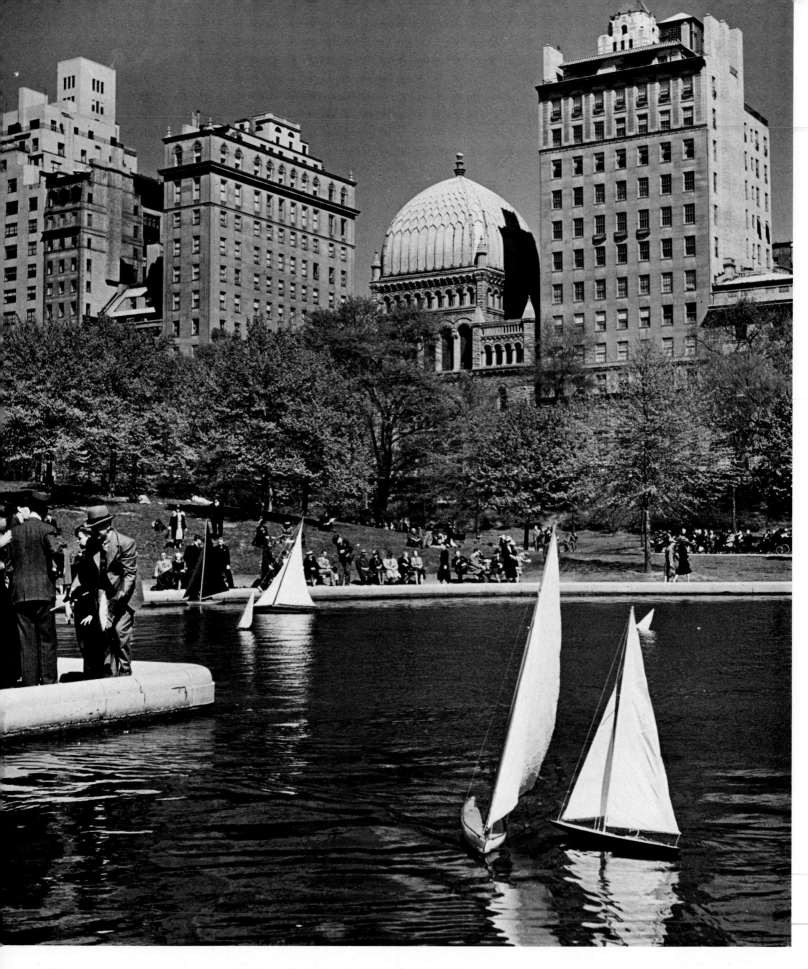

140　　Model yacht basin, Central Park near Fifth Avenue, with Temple Beth El in background.

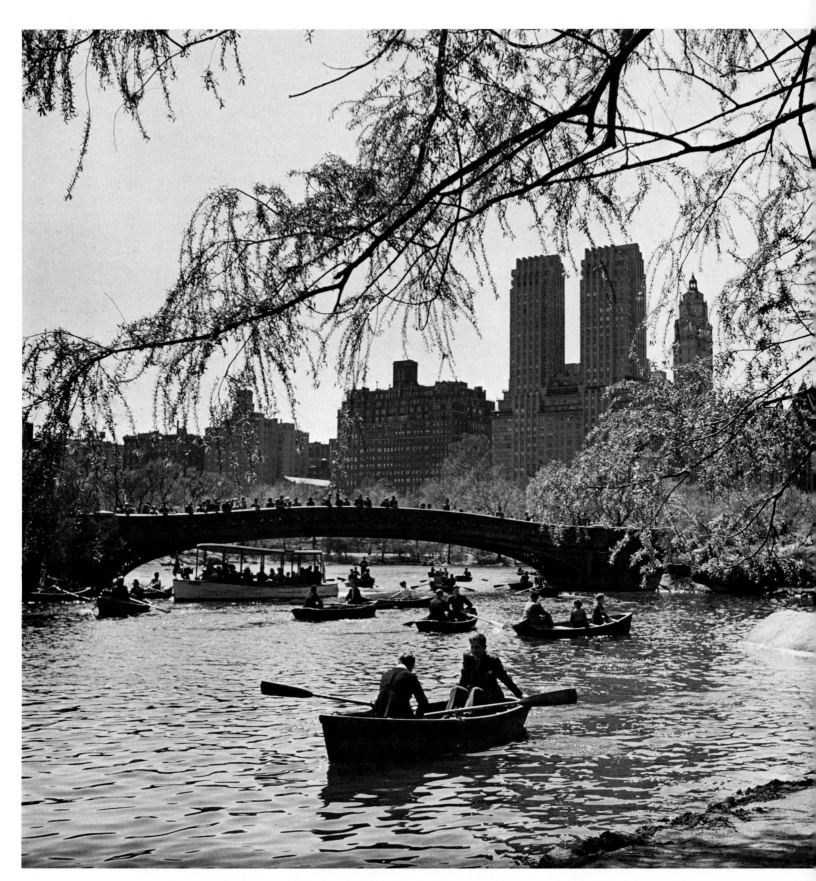

Central Park lake and Bow Bridge, looking toward Central Park West.

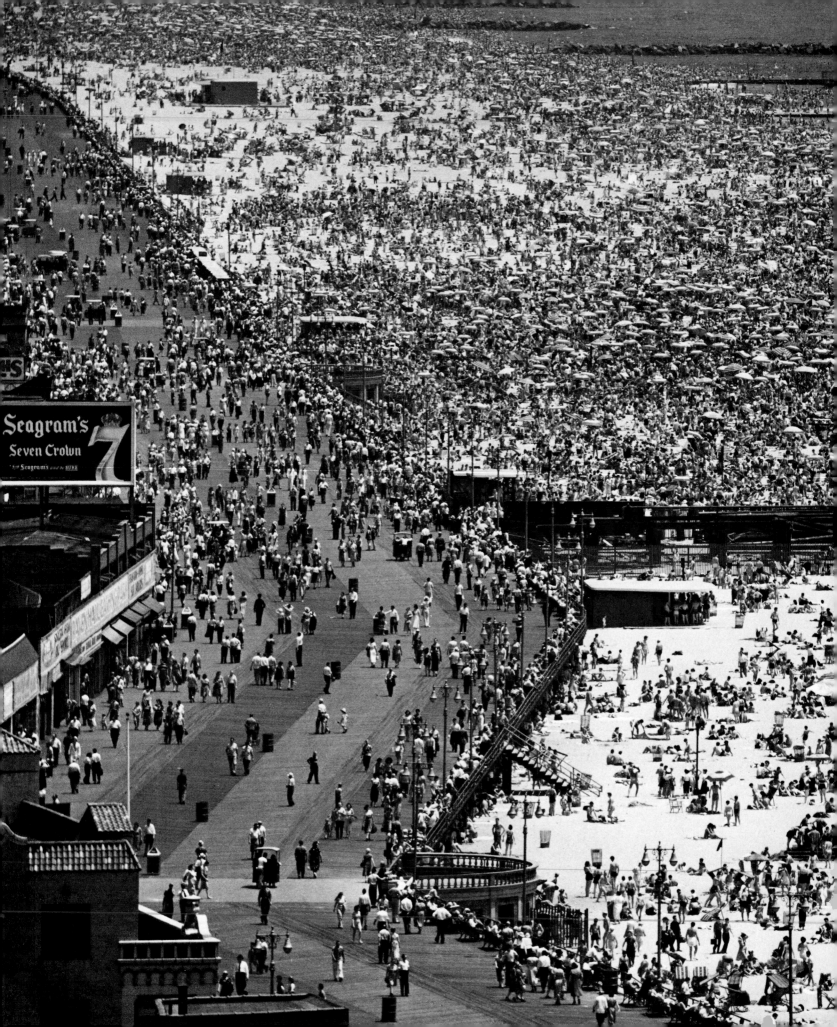

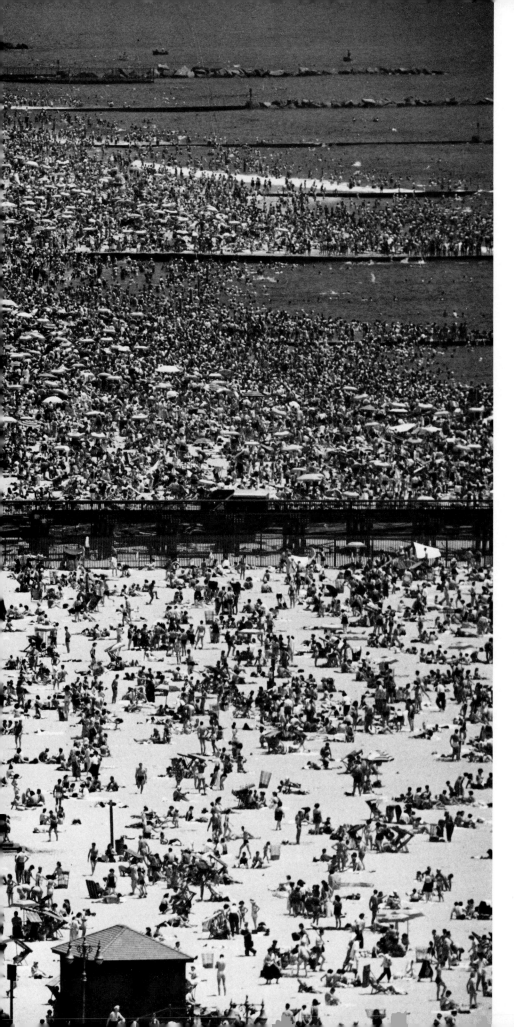

Coney Island, July 4, 1949. The biggest pressure-relief valve for New Yorkers broiling under the summer sun was Coney Island. Actually a huge sandbar between Lower New York Bay and the Atlantic, Coney Island is believed to have derived its name from the Dutch settlers who called the area *Konijn Eiland*, or Rabbit Island, for the large populations of rabbits that roamed there. In the 19th century, stately hotels with bathhouses catered to New York's wealthiest families while paddlewheelers made the trip over water from Manhattan with loads of day-visitors. Some politically-suspect land grants awarded to developers in the 1870s inaugurated Coney's first period of popular expansion. Railroads and boulevards were built to the island and racetracks opened in Brighton Beach and nearby Sheepshead Bay. The big names of the gay 90s—"Diamond Jim" Brady, Lillian Russell—frequented the casinos and restaurants but the area soon disintigrated into a tawdry showcase for prostitutes and peep shows.

Coney Island's next rejuvenation began in 1920 when completion of subway lines opened the beaches to any rider with a dime for the round trip. The boardwalk was built the following year and immediately Coney gained a fresh reputation as the playground for the millions.

The 40s for Coney Island meant a lush period of unrivaled popularity. The boardwalk drew throngs to its bathhouses, games of chance, sideshows, fortune-tellers, inexpensive restaurants and snack bars with their tempting foods. The tangy sea air was rent with screams and squeals as riders were voluntarily terrified by rollercoasters and other tests of will and sanity—the Cyclone, Thunderbolt, Mile-High-Chaser, Rough Rider, Shoot-the-Chutes and Parachute Jump. Carousel organs pumped into the night competing with honky-tonk dance halls and jazz bands to win the ears of the dizzied patrons.

Coney Island was a perpetual carnival, a celebration that delivered on almost every promise. Only one thing seemed unattainable on that sandy city spit by the sea—a secluded section of beach.

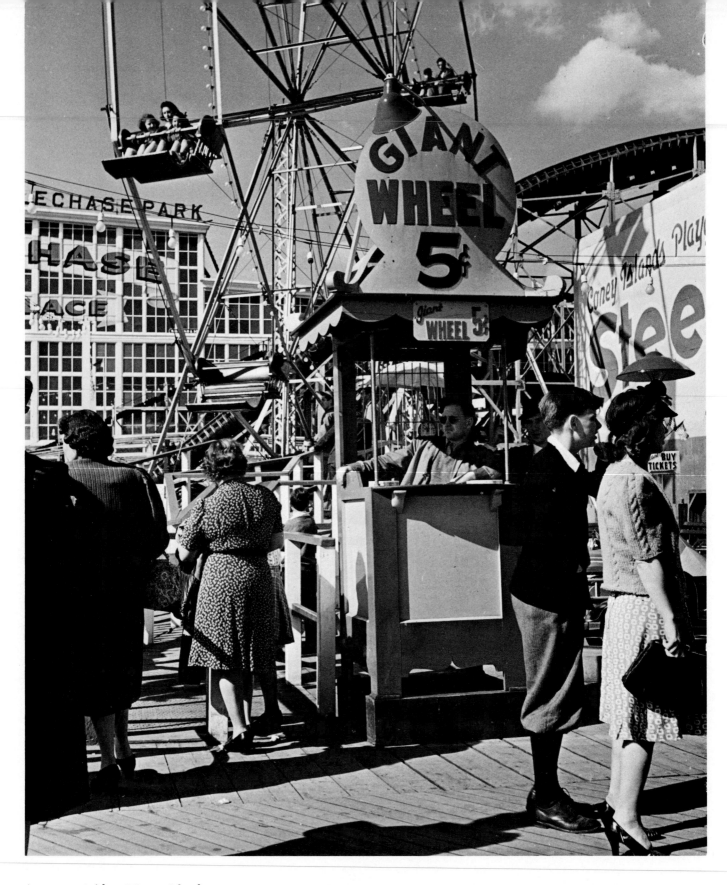

Amusement rides at Coney Island.

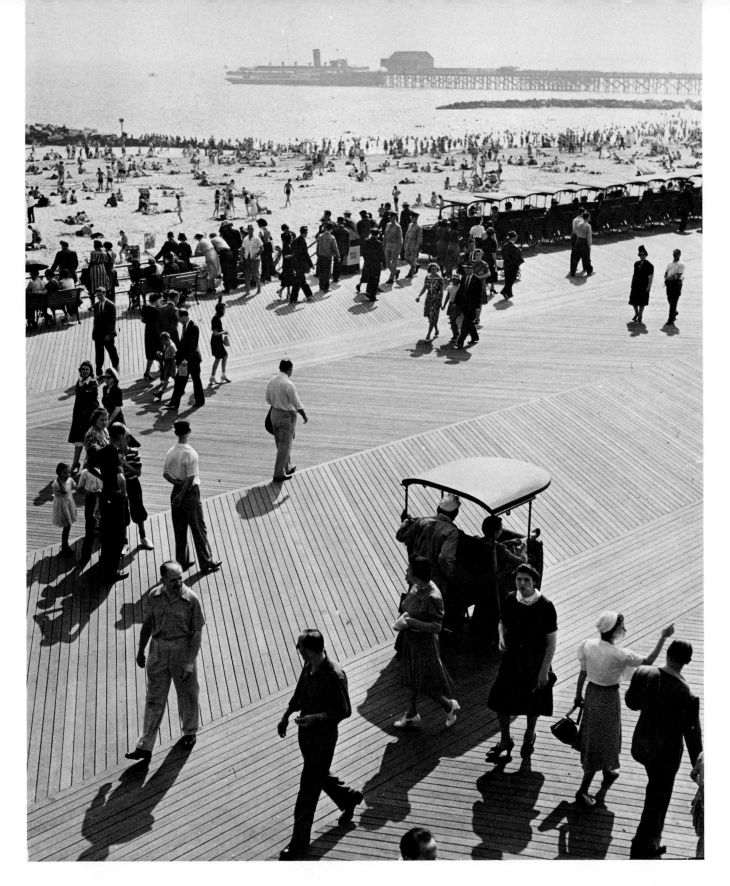

Coney's boardwalk with an excursion boat tied up at the pier. Coney Island enjoyed its last period of grace during the 1940s. Excursion boats still set sail from the Battery to tie up at its imposing pier. And visitors disinclined to stroll the boardwalk could cruise it in roofed wheeled carts pushed by hand. Coney Island was swept by urban decay in the decades following the 40s. Recently, however, the resilient old area has shown signs of revival as New Yorkers are rediscovering the pleasures of its seaside on a pleasant day.

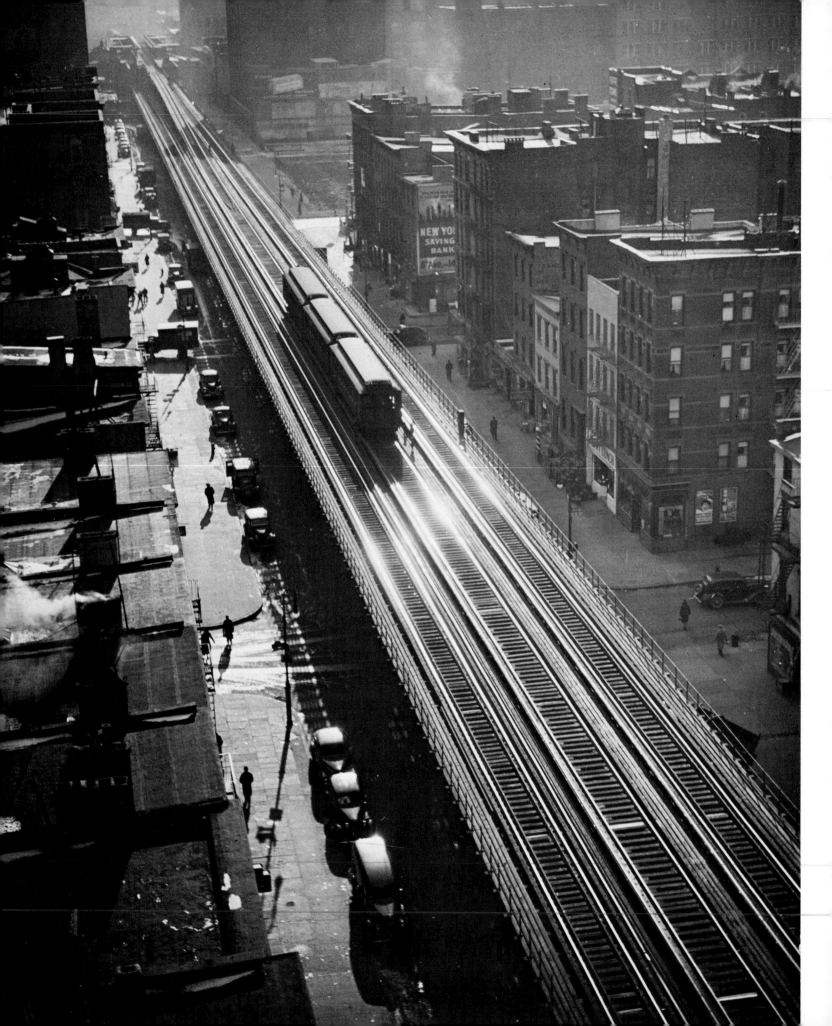

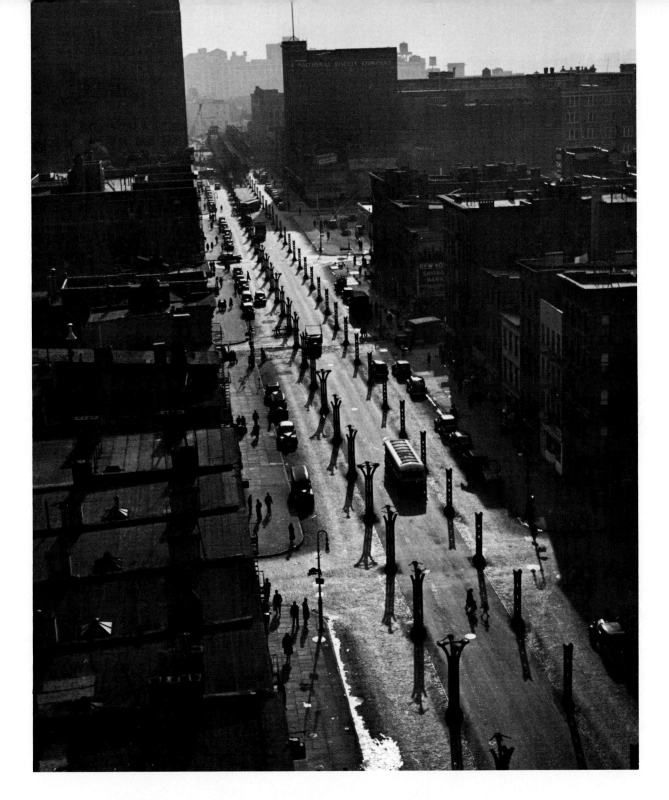

The Ninth Avenue elevated as seen from West 20th Street [opposite]. The same view as the el is dismantled in 1940 [above]. Rapid transportation through the congested city has tantalized New York's planners and politicians for centuries. Most of officialdom felt the answer had been found in the late 19th century with the construction of the elevated railroad lines. Supported above the city's traffic on steel girders, these elevated trains rattled up and downtown, sometimes tempting the fates and testing the laws of gravity with curves that seemed suicidal to uneasy riders. By the 40s, however, the elevated railroad, or el, was regarded as a mixed blessing. The el did provide rapid transit, but its heavy laticework of steel cast the avenues beneath them in dark shadows. And the rocketing trains left a wake of noise and disruption. The streets where the els ran were murky, clattering breeding places for slums. As a result, in the 40s the demolition of many elevated lines began in earnest.

The photographer found the el an ideal subject for studies of light and shadow. Its antique stations also provided historic views of vintage railroad architecture. The photographs on the following pages catch the el (and the West Side elevated highway) as a series of visual delights. And for the record, the photographs here show the dismemberment of the Ninth Avenue el as seen from the window of the photographer's apartment. It is an unusual before-and-after essay on the transformation of a thoroughfare.

147

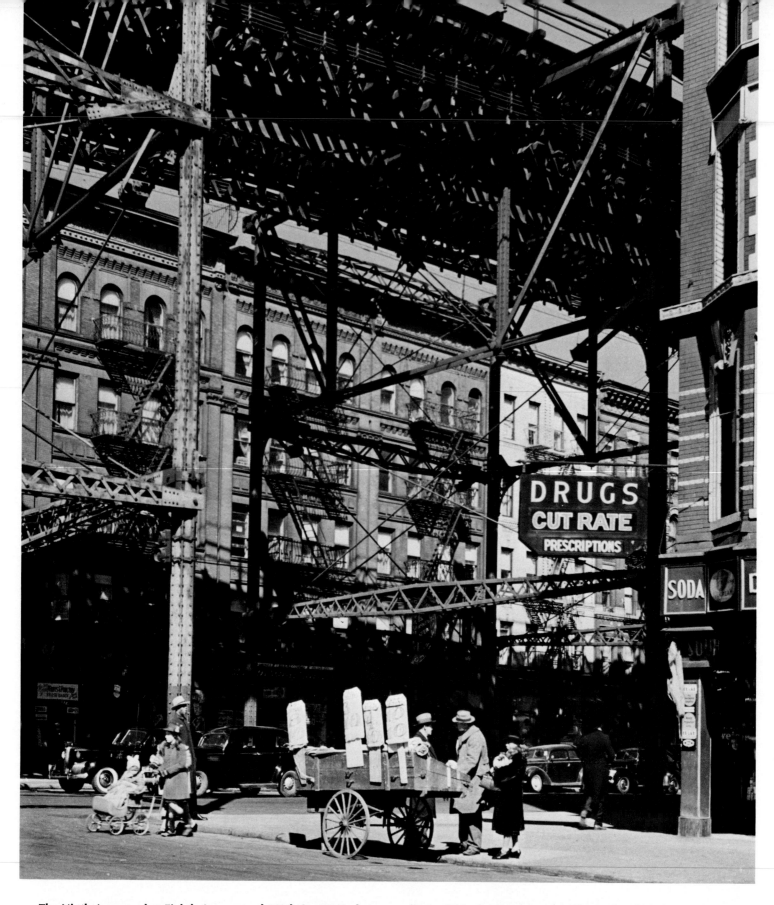

The Ninth Avenue el at Eighth Avenue and 110th Street, Harlem [above]. The Ninth Avenue el at Eighth Avenue near 127th Street, Harlem [opposite]. Normally the elevated tracks went along at about the level of the third floor. Due to the hills and valleys of Manhattan, however, the gridwork for the elevated sometimes was higher in places to keep the tracks free from steep grades. In the photographs here, the supporting grids rise to the rooftops, a response to a dip in the cityscape.

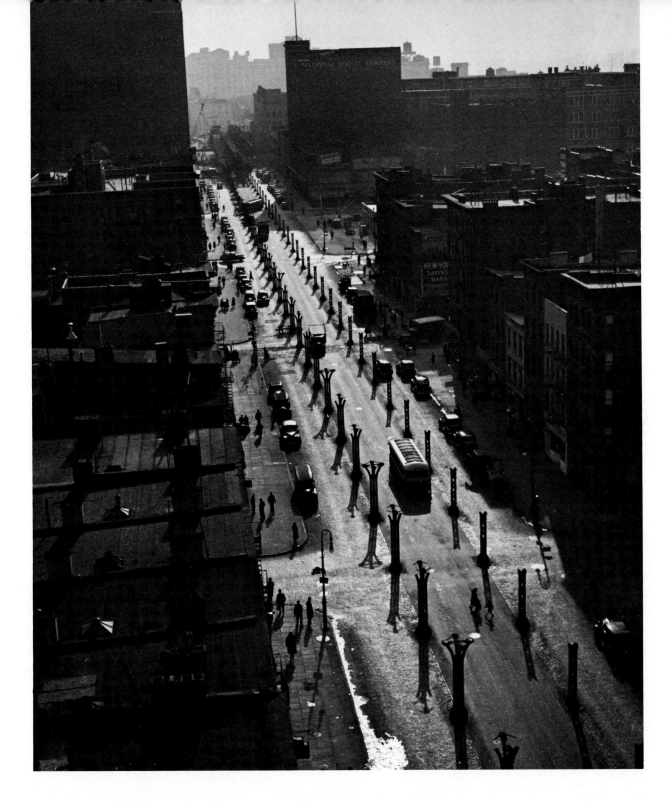

The Ninth Avenue elevated as seen from West 20th Street [opposite]. The same view as the el is dismantled in 1940 [above]. Rapid transportation through the congested city has tantalized New York's planners and politicians for centuries. Most of officialdom felt the answer had been found in the late 19th century with the construction of the elevated railroad lines. Supported above the city's traffic on steel girders, these elevated trains rattled up and downtown, sometimes tempting the fates and testing the laws of gravity with curves that seemed suicidal to uneasy riders. By the 40s, however, the elevated railroad, or el, was regarded as a mixed blessing. The el did provide rapid transit, but its heavy laticework of steel cast the avenues beneath them in dark shadows. And the rocketing trains left a wake of noise and disruption. The streets where the els ran were murky, clattering breeding places for slums. As a result, in the 40s the demolition of many elevated lines began in earnest.

The photographer found the el an ideal subject for studies of light and shadow. Its antique stations also provided historic views of vintage railroad architecture. The photographs on the following pages catch the el (and the West Side elevated highway) as a series of visual delights. And for the record, the photographs here show the dismemberment of the Ninth Avenue el as seen from the window of the photographer's apartment. It is an unusual before-and-after essay on the transformation of a thoroughfare.

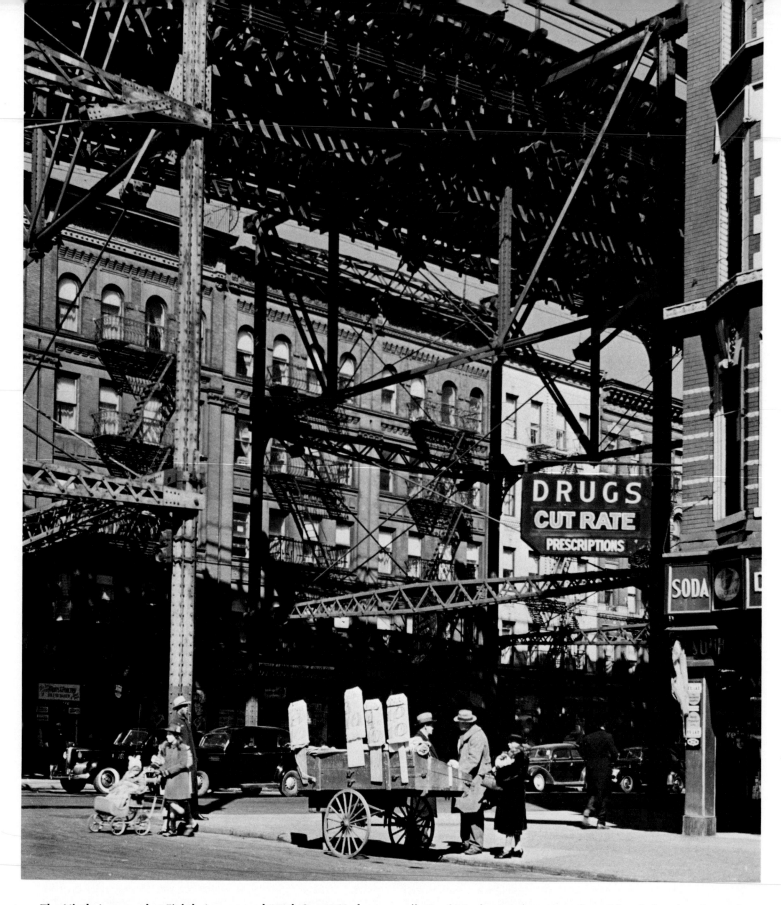

The Ninth Avenue el at Eighth Avenue and 110th Street, Harlem [above]. The Ninth Avenue el at Eighth Avenue near 127th Street, Harlem [opposite]. Normally the elevated tracks went along at about the level of the third floor. Due to the hills and valleys of Manhattan, however, the gridwork for the elevated sometimes was higher in places to keep the tracks free from steep grades. In the photographs here, the supporting grids rise to the rooftops, a response to a dip in the cityscape.

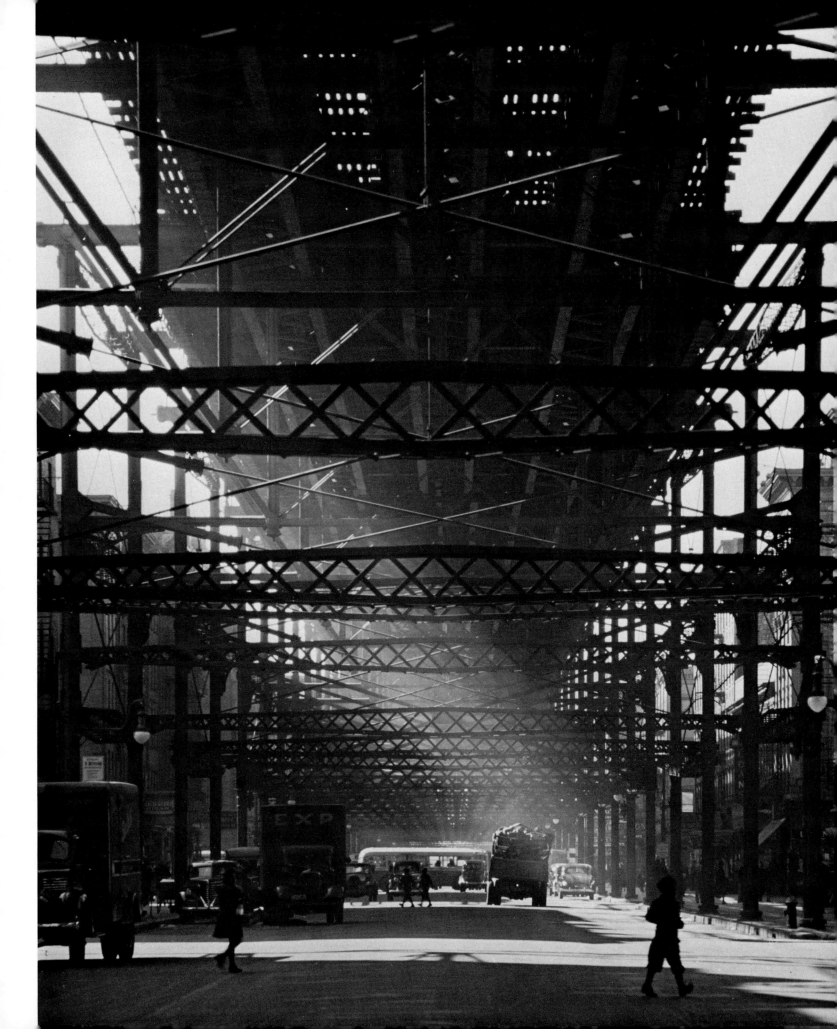

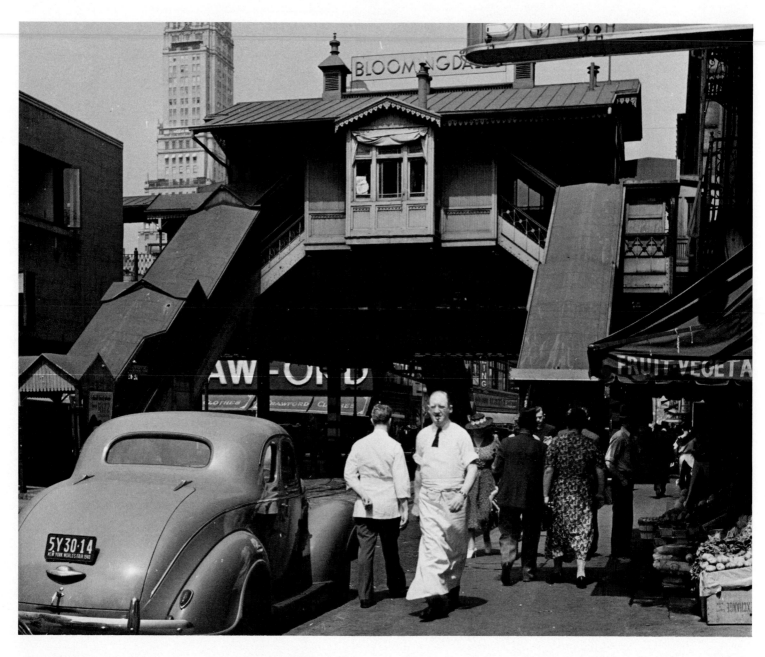

The 59th Street station of the Third Avenue el [above]. The
Warren Street station of the Ninth Avenue el [opposite].

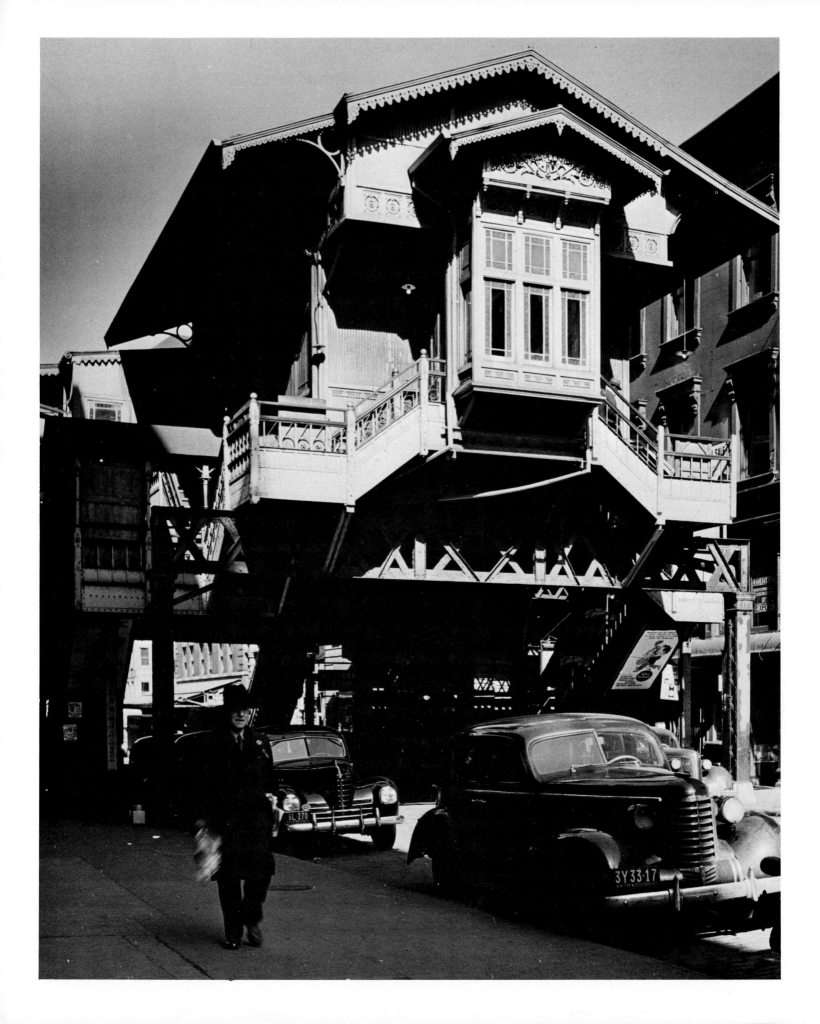

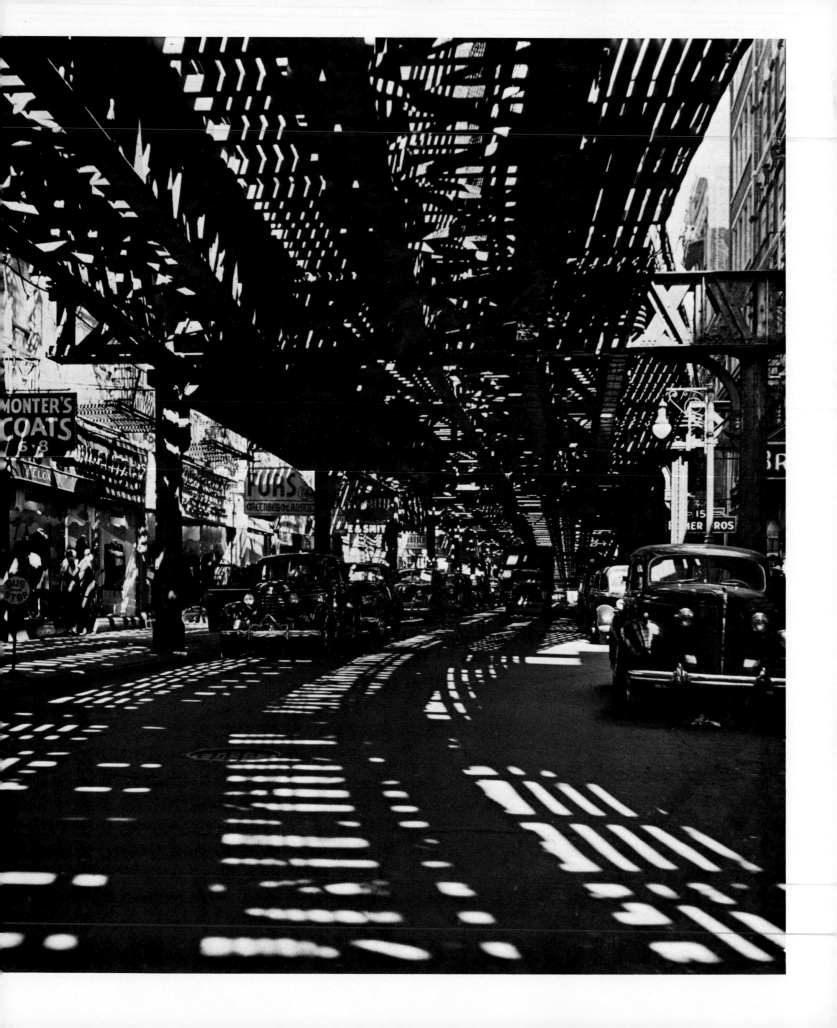

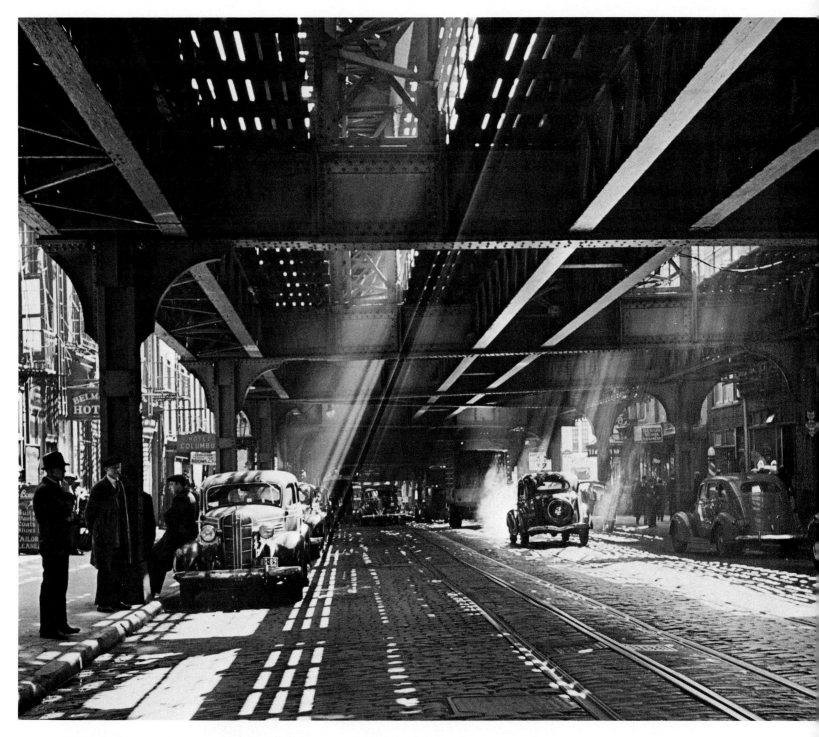

The Bowery under the shadows of the Third Avenue el [above].
The el as it runs above Division Street [opposite].

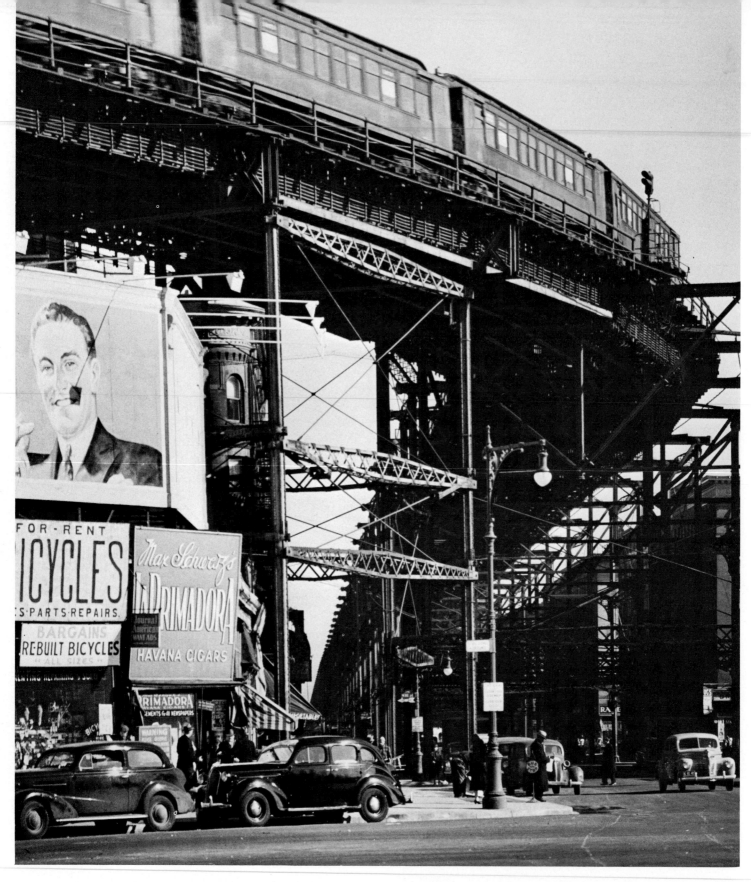

The Eighth Avenue el as it swings around 110th Street [above].
The arching girders of the Westside Highway near 125 Street
[opposite].

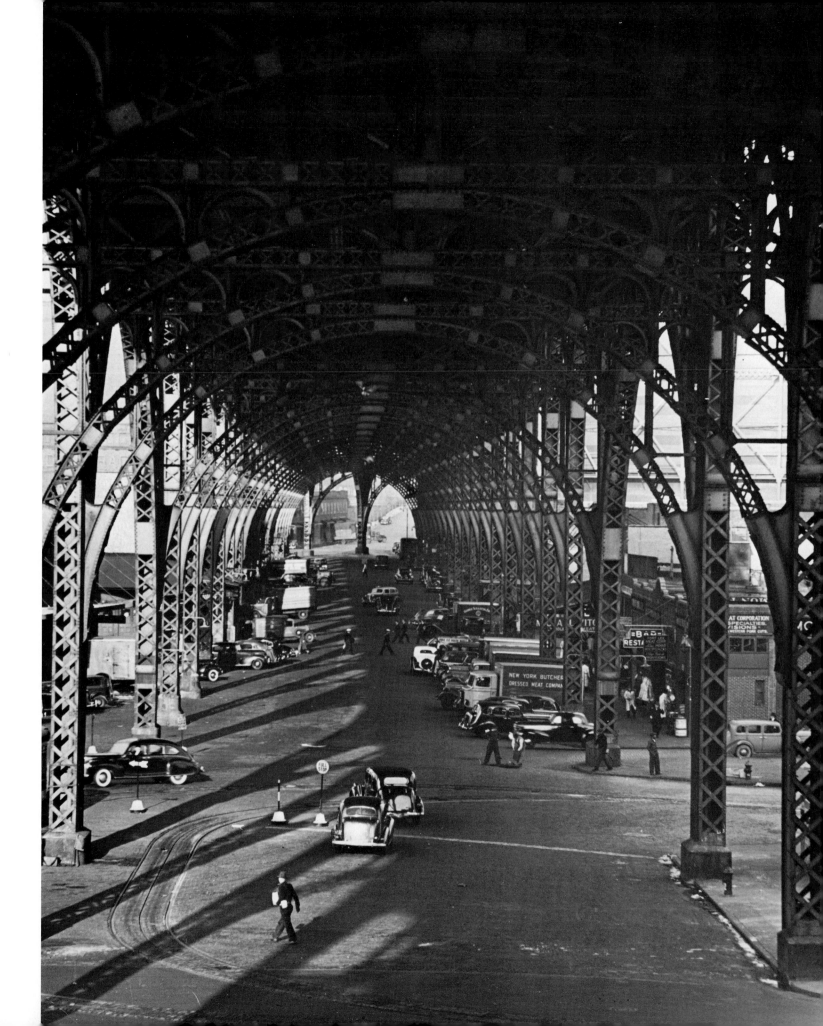

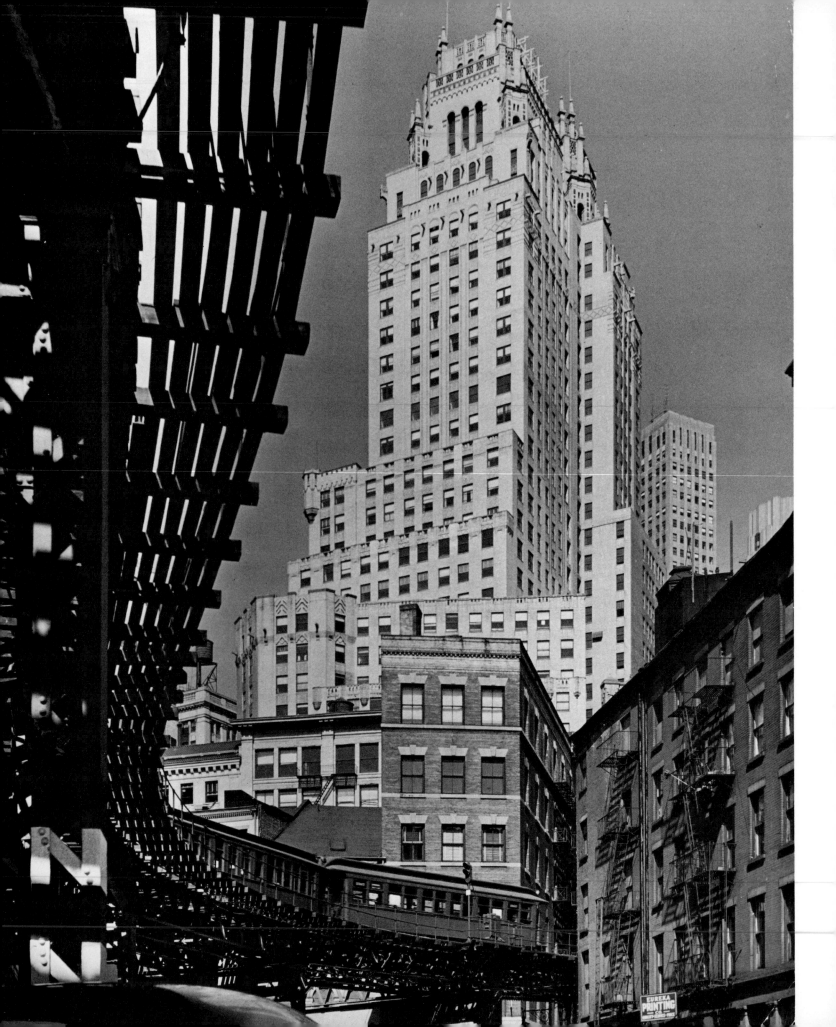

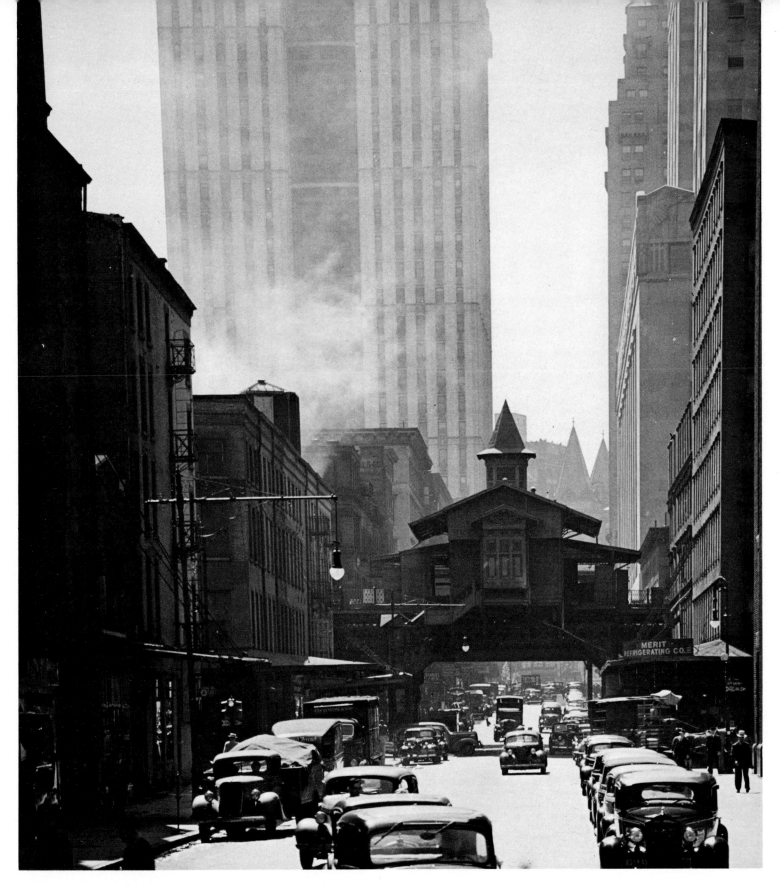

The Barclay Street station of the Ninth Avenue el [above].
The S-curve of the Second Avenue el at Coenties Slip [opposite].

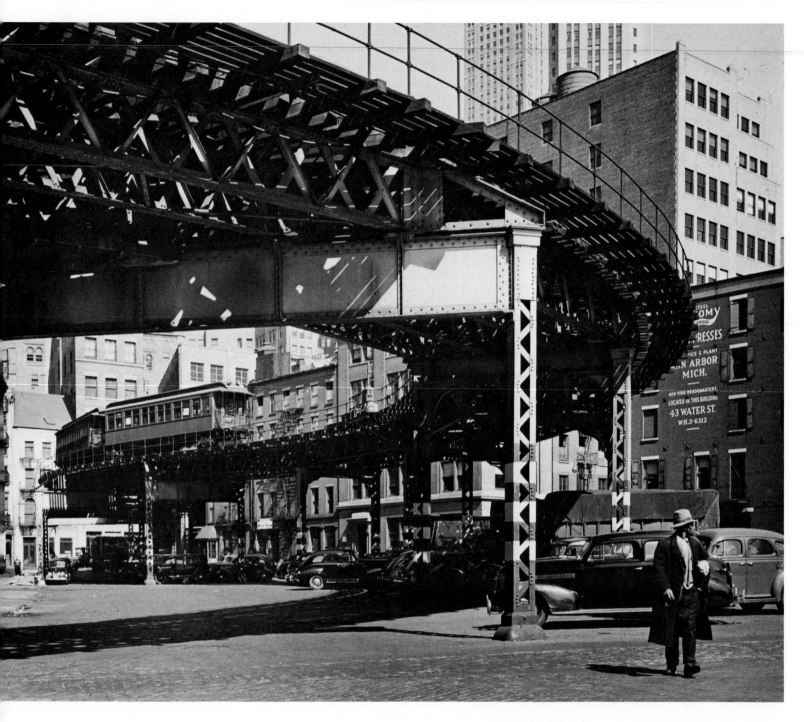

Another view of the S-curve at Coenties Slip [above]. The station at Chatham Square, downtown [opposite]. In the Chatham Square station photograph, the tower on the left, crowned by a dome, is the old *World* Building, erected by Joseph Pulitzer. Behind it to the left is the old *Tribune* Building. The massive structure dominating the right of the photograph is the Municipal Building.

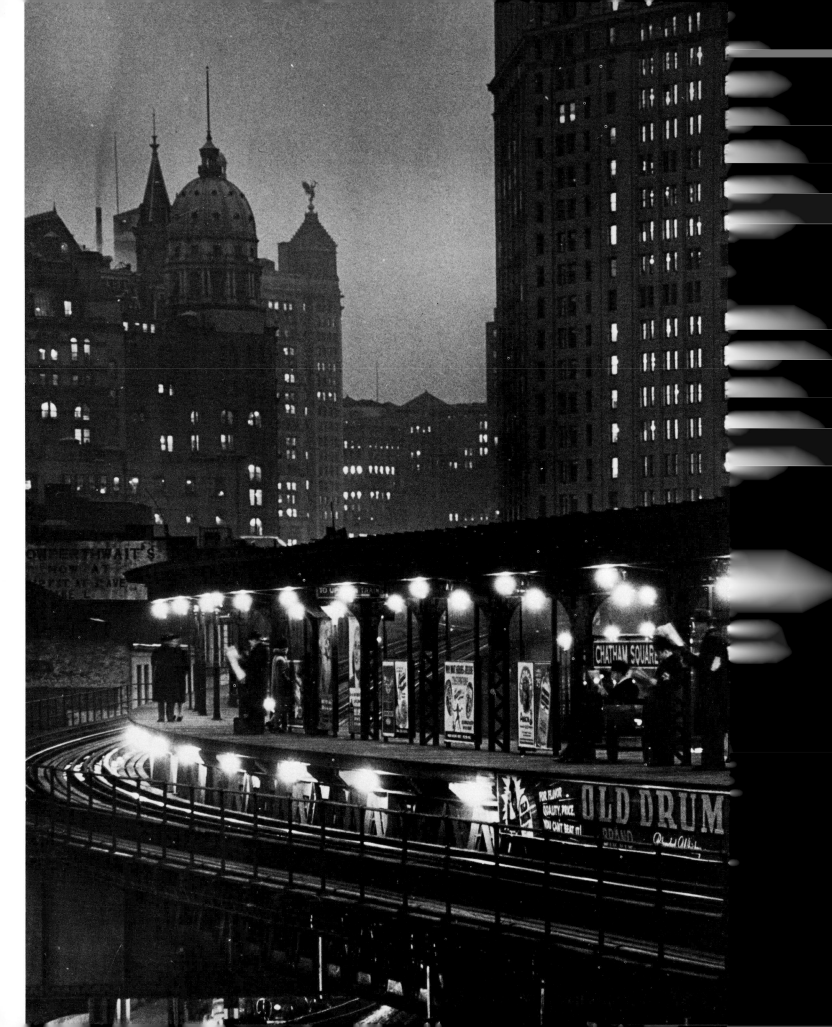

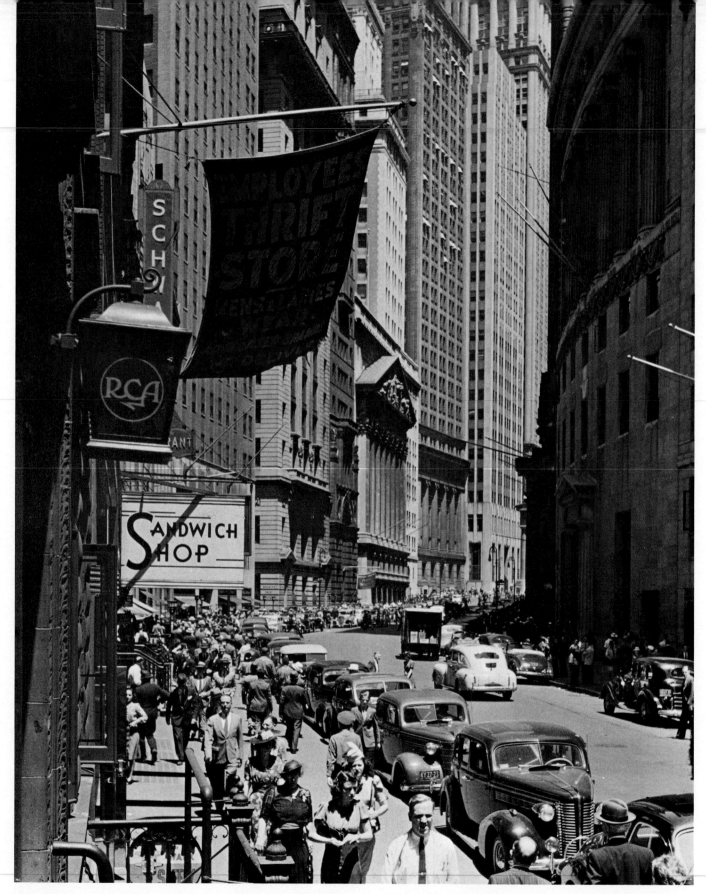

Broad Street at lunchtime [above]. A tickertape parade on Lower Broadway [opposite]. The Financial District in Lower Manhattan was known in the 40s as the site of two American institutions—the stock exchange and the tickertape parade. The New York Stock Exchange is the building with the classical facade and pediment in the photograph above. The tickertape parade was bestowed on a person whose feats captured the fancy of the city. This one opposite has more loose paper floating in the air than tickertape. The tape was the byproduct of a machine that transmitted stock market quotations and had been phased out by the 40s.

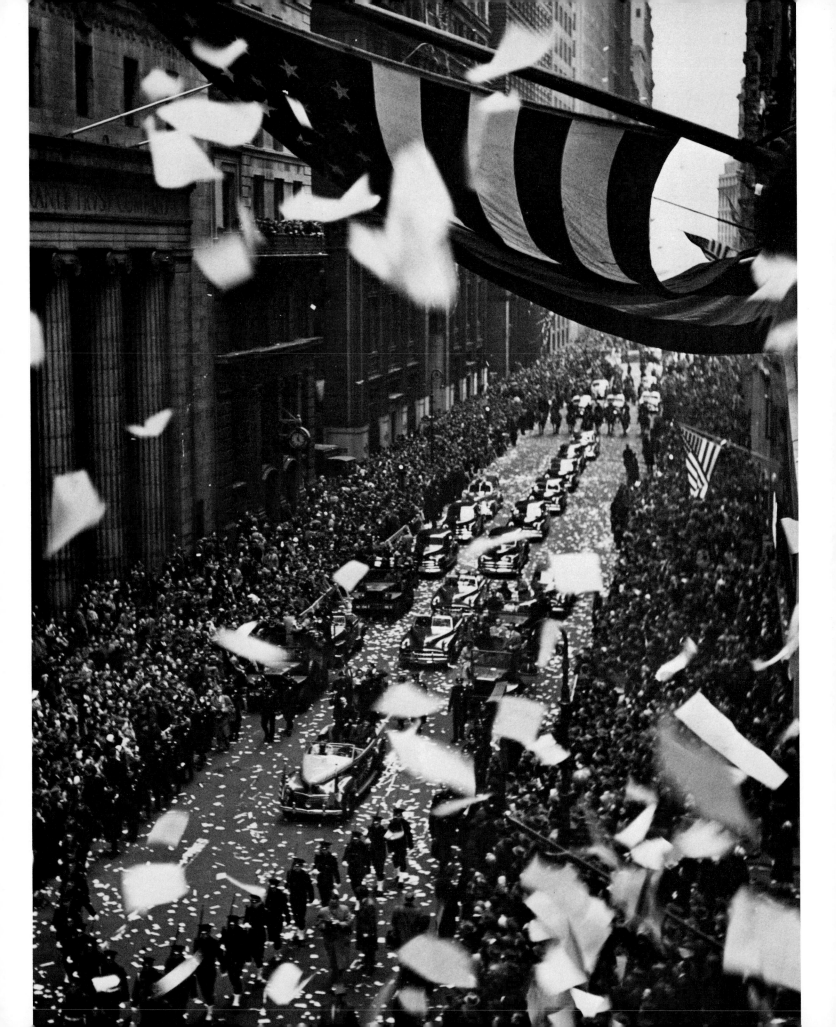

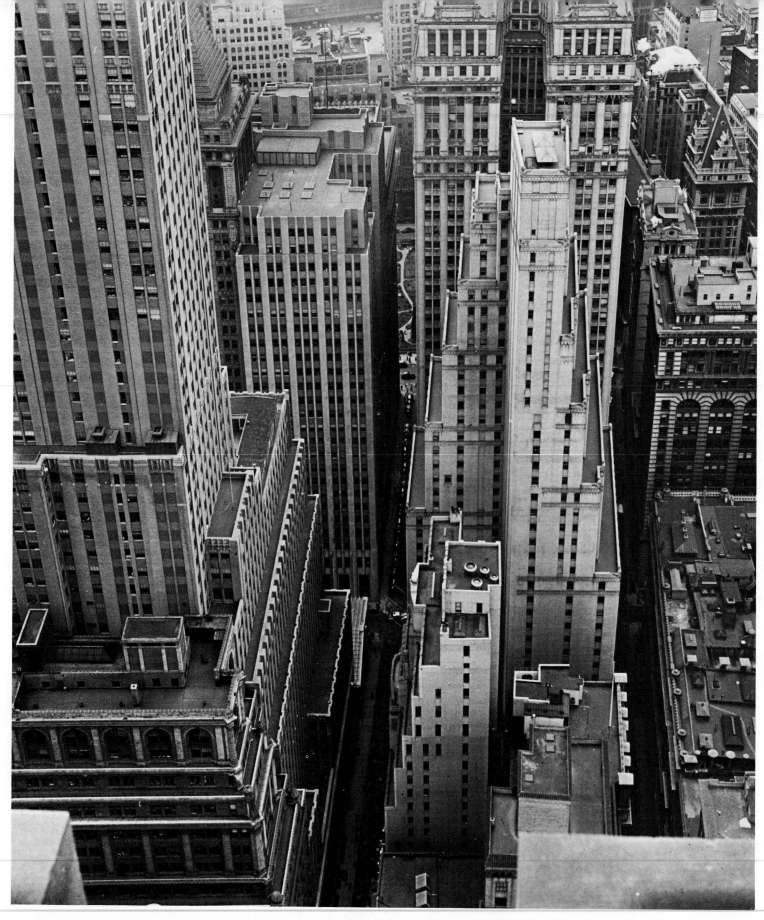

The Financial District: Pine Street at left, Cedar Street at right [above]. Buildings at Lower Broadway and Rector Street [opposite]. After the U-shaped Equitable Life Building in the upper-right background was completed in 1914, city planners were shocked by the massive bulk that dominated the neighborhood. A new law was passed in 1916 requiring all future skyscrapers be built with stepped-back construction to allow suitable light and air space.

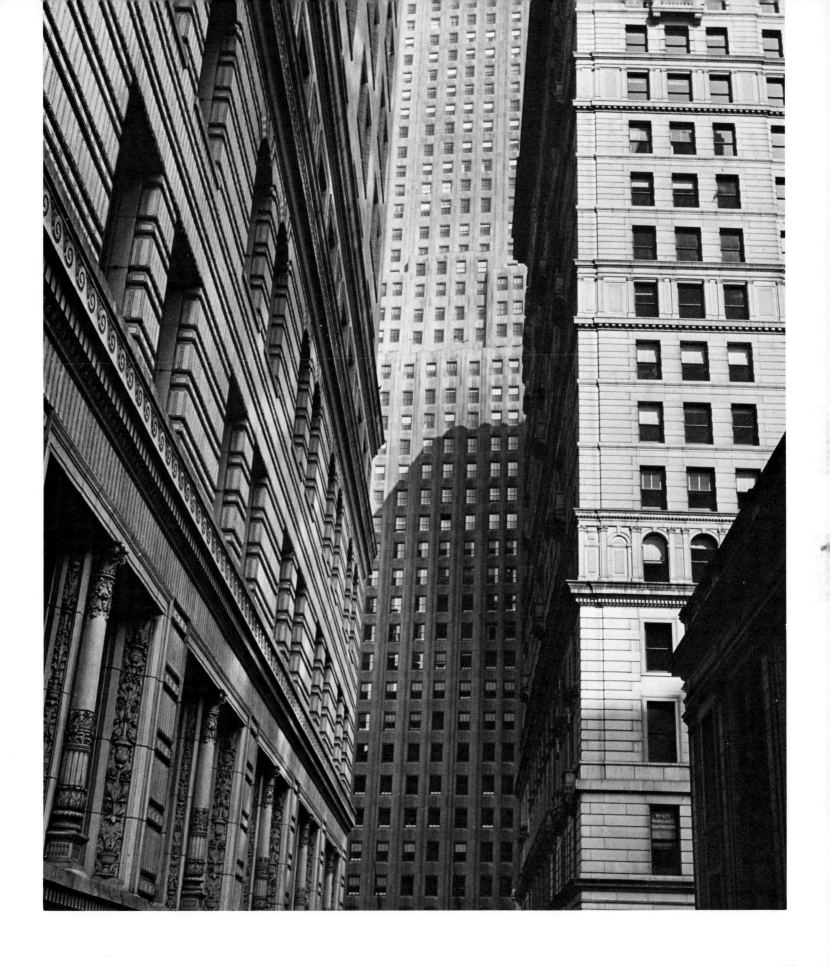

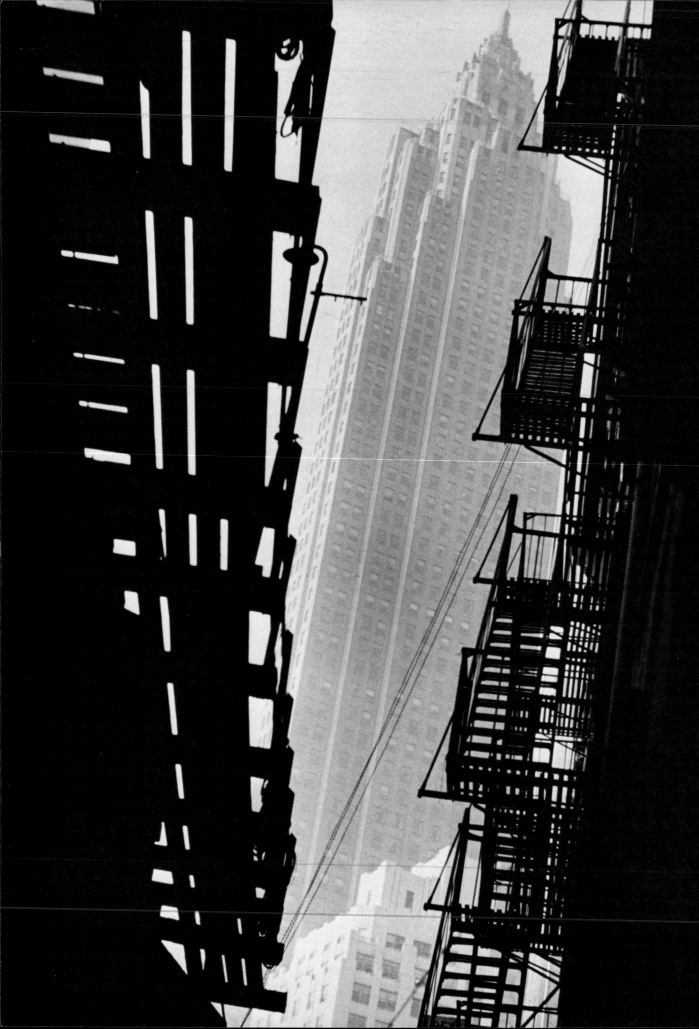

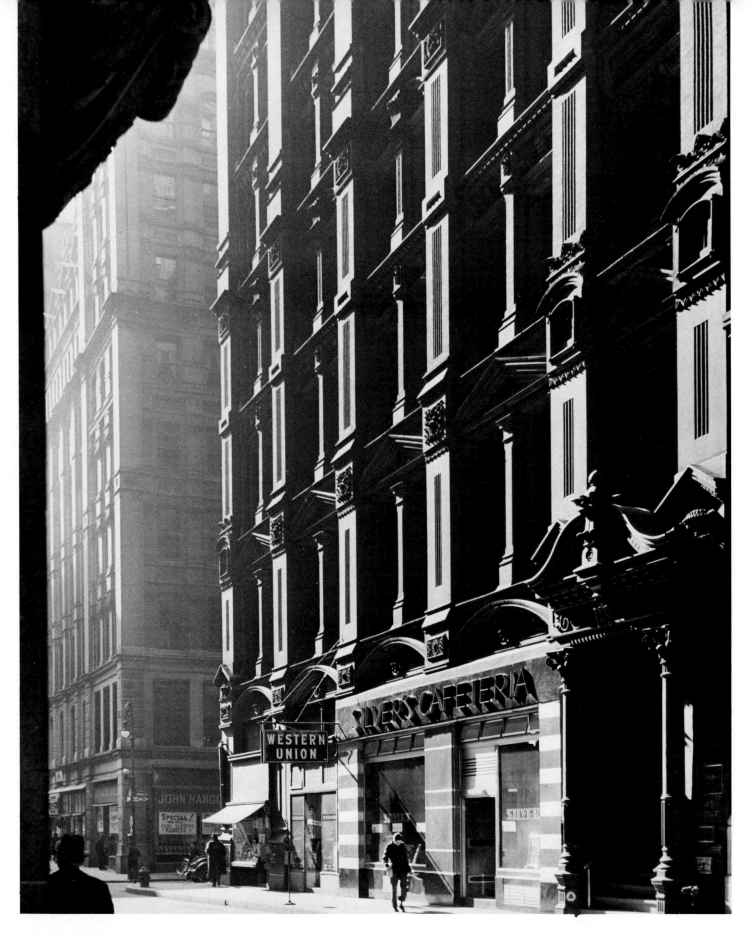

The cast-iron facade of the Potter Building, Nassau Street [above]. The Cities Service Building at 70 Pine Street with the Second Avenue el at left [opposite].

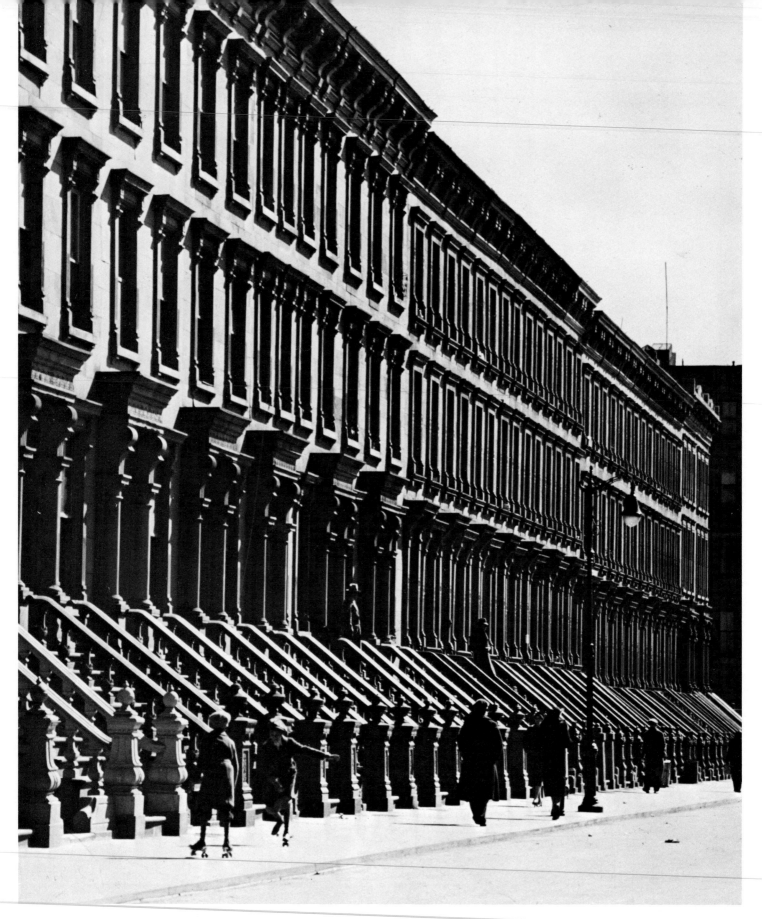

Brownstone houses on West 46th Street [above]. Cast-iron fronts [opposite]. Two distinct types of building facades—the brownstone and cast-iron—continued to be well-represented in the New York of the 40s. Brownstones like those above lingered from the last half of the 19th century when whole neighborhoods were constructed as speculative housing. Cast-iron fronts date from 1848 when James Bogardus designed one for a building at Center and Duane Streets downtown. Elaborate details were possible with cast iron and its generous proportion of glass to frame ranks these facades as precursors of the modern steel-and-glass buildings.

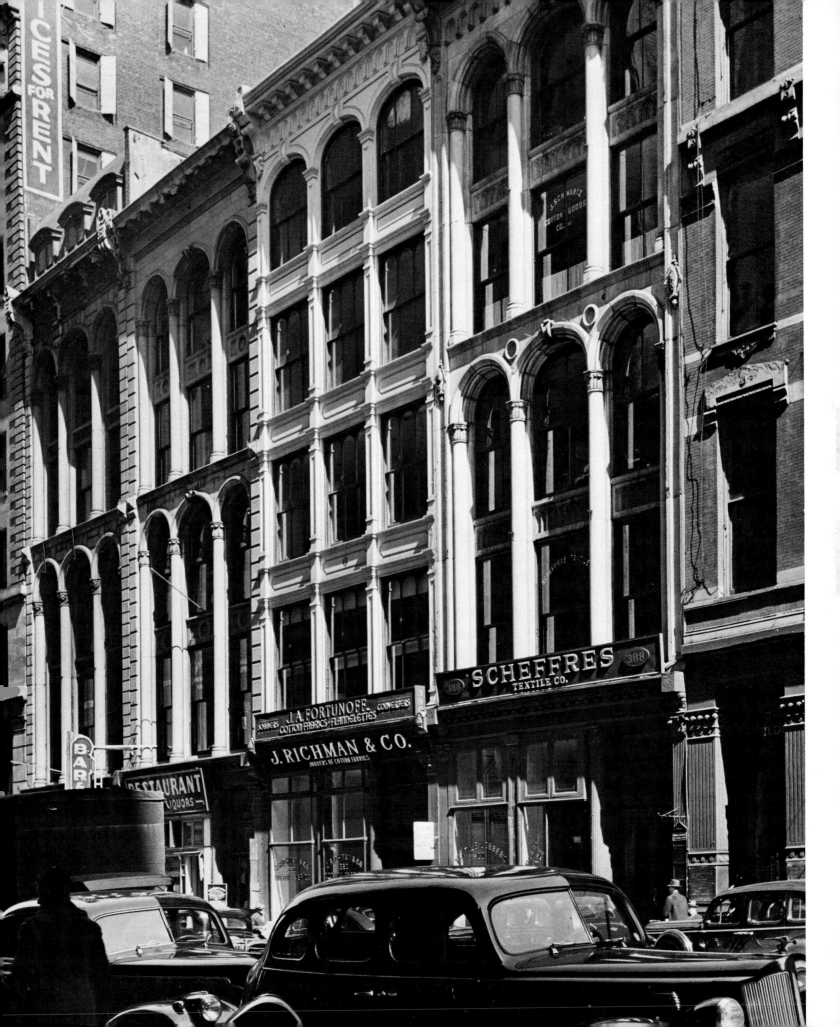

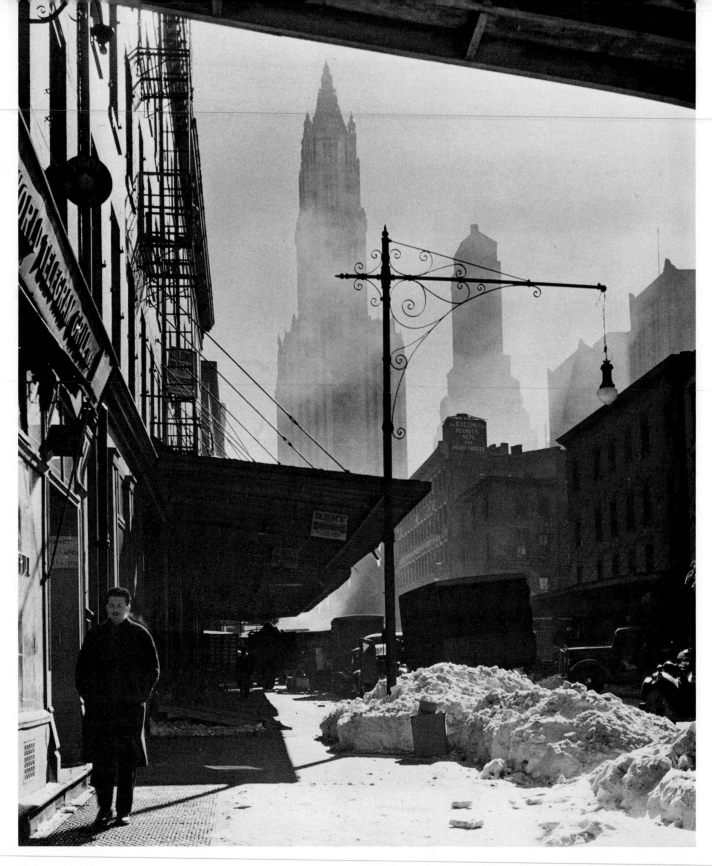

**Park Place after a snowfall [above]. Lower Broadway looking
north [opposite].** Downtown had many faces depending on the
season. The carefully shoveled snow, light steam forming in the
frosty air, trucks arranged around the drifts and the dignified
tower of the Woolworth Building all combine to create a
sharply etched study of a winter's day. By contrast, the cluttered
stretch of Broadway on a busy sunny afternoon shows the city
at its hectic, good-weather pace.

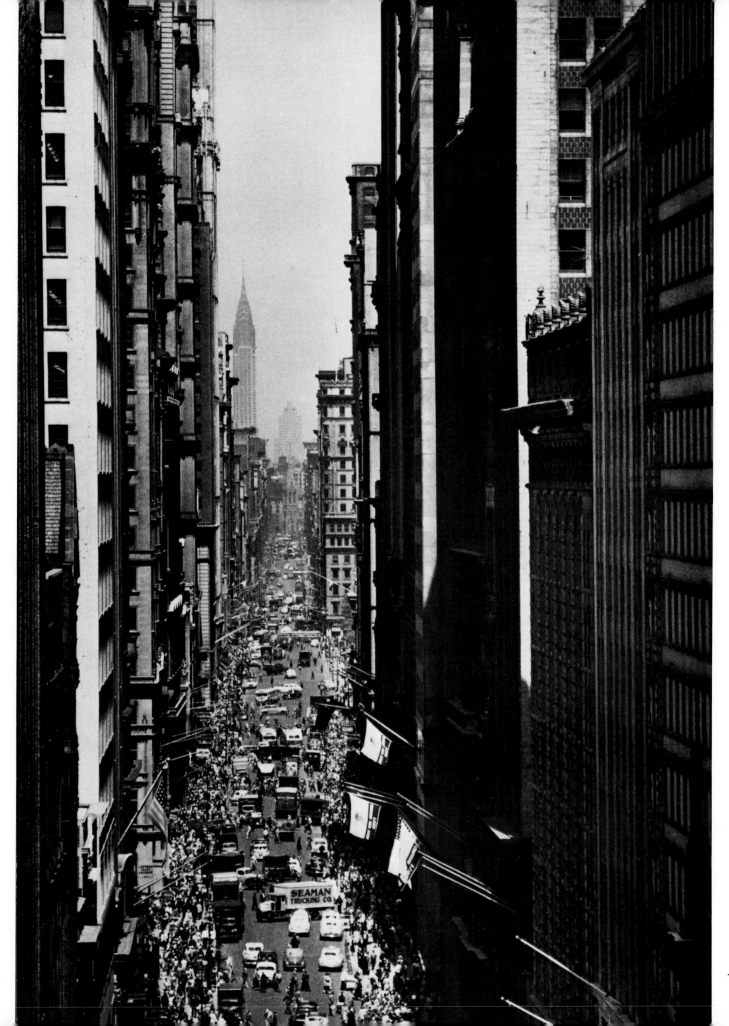

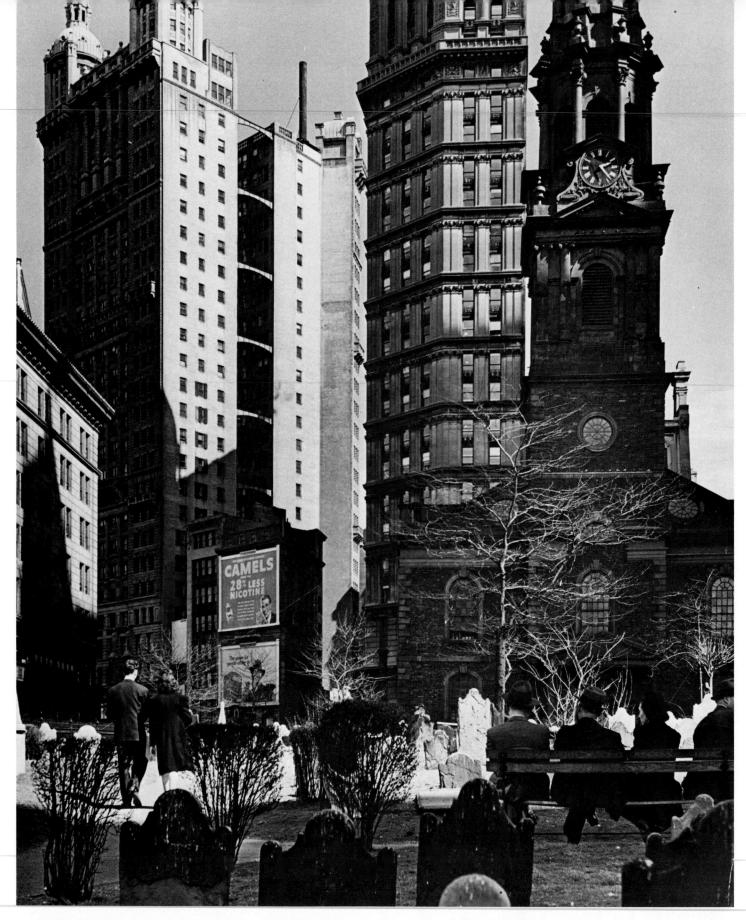

St. Paul's Chapel and cemetery. The oldest church building in Manhattan, St. Paul's was built in 1764–66 and enlarged in the 1790s after the American Revolution. A classic example of colonial church architecture, St. Paul's is practically unchanged since Washington worshiped there when New York served as the capital of the United States. In the 1940s, the grounds were still favored for strolling or bench-sitting—a sanctuary from the surrounding financial district.

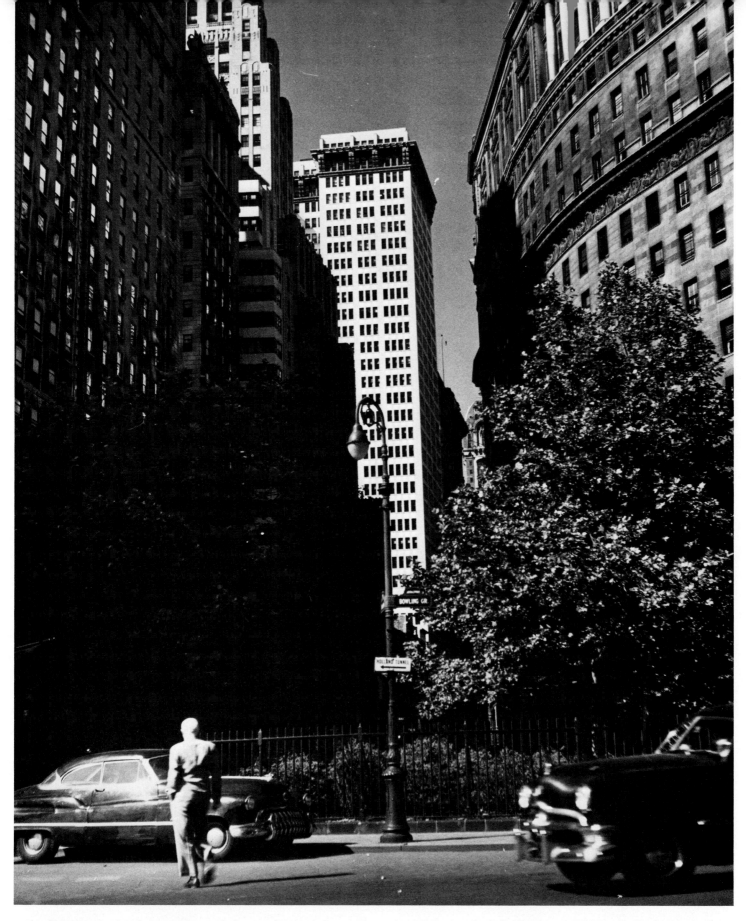

Bowling Green. A sylvan patch amid the crushing presence of the edifices of Lower Manhattan, Bowling Green is virtually untouched since colonial days. Originally used for bowling, as the name indicates, the greensward was a popular park in the 40s. It also marked the beginning of Broadway, that legendary avenue that was laid out over a well-worn Indian trail leading north.

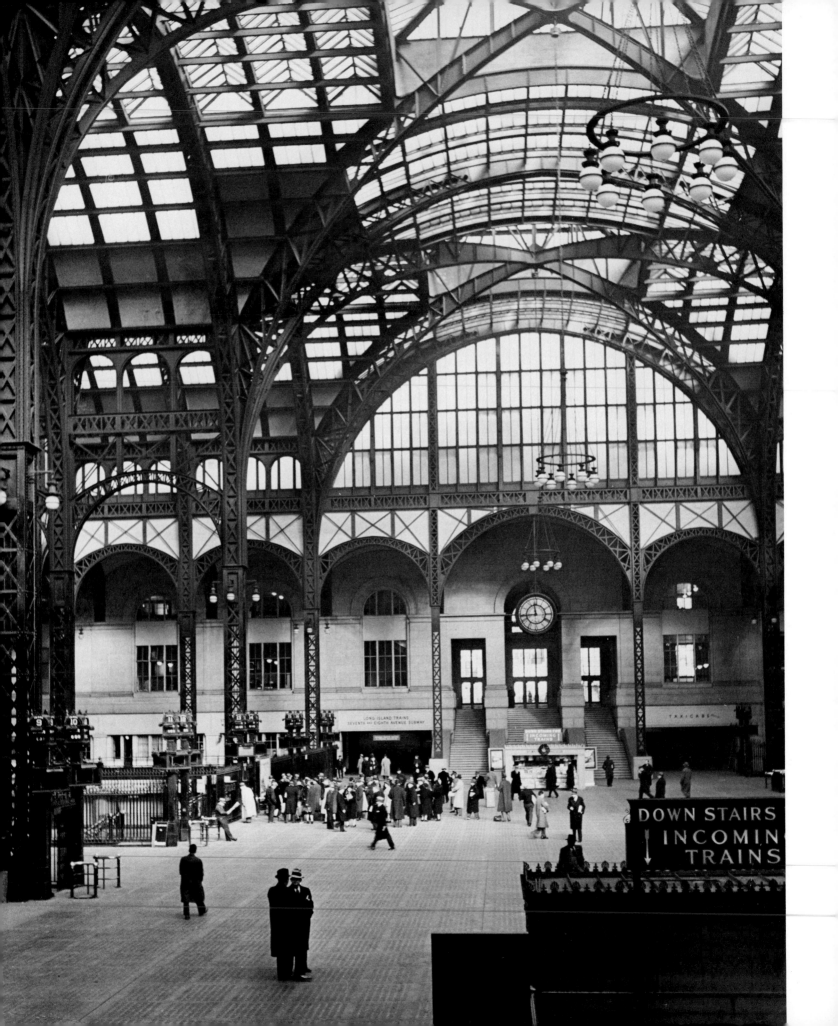

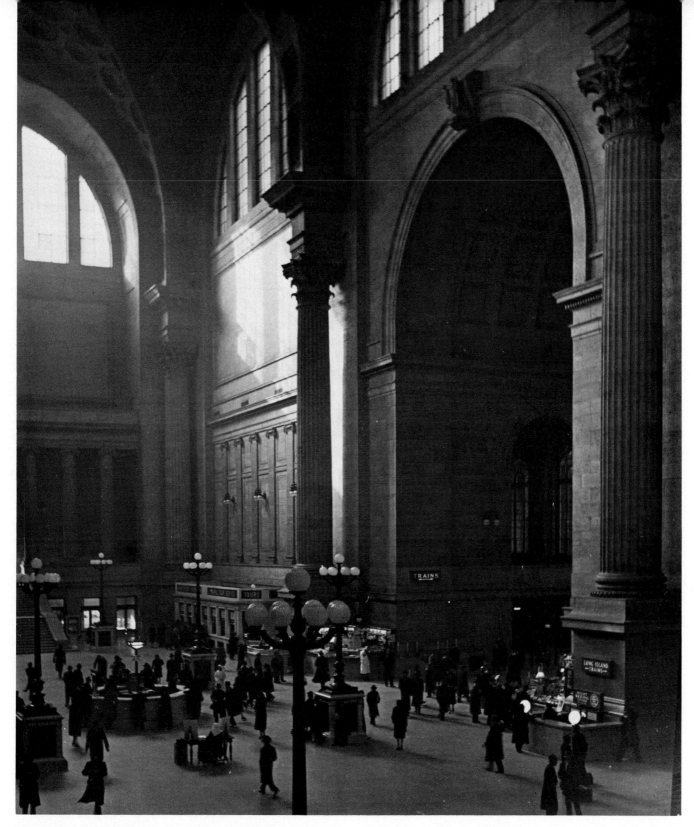

Main waiting room, Pennsylvania Station [above]. Concourse, Pennsylvania Station [opposite]. Marble columns and archs rising in Roman splendor provided a triumphal entrance for a traveler stepping into the main waiting room of Penn Station. The ticket booths, information stand and even the imposing stanchions of globular lights were dwarfed in the 15-story-high room that sprawled over two square city blocks. Designed by McKim, Mead and White, who drew inspiration from the Baths of Caracalla of Rome, the station was inaugurated in 1910 and built for the ages. The marble columns in the waiting room (above) were four-and-a-half feet in diameter and rose to a height of 35 feet. The vast concourse spread a magnificent umbrella of glass 138 feet high over an area large enough to encompass a football field. The concourse was built to handle masses; in 1945 alone some 110 million passengers passed under the glass roof. Underground are.27 tracks on 28-acres of land—four times the size of the station. These tracks, connected to tunnels under the Hudson and East Rivers, reached their zenith of activity in the 1940s when a train arrived or departed every 46 seconds. The venerable station was torn down in 1966.

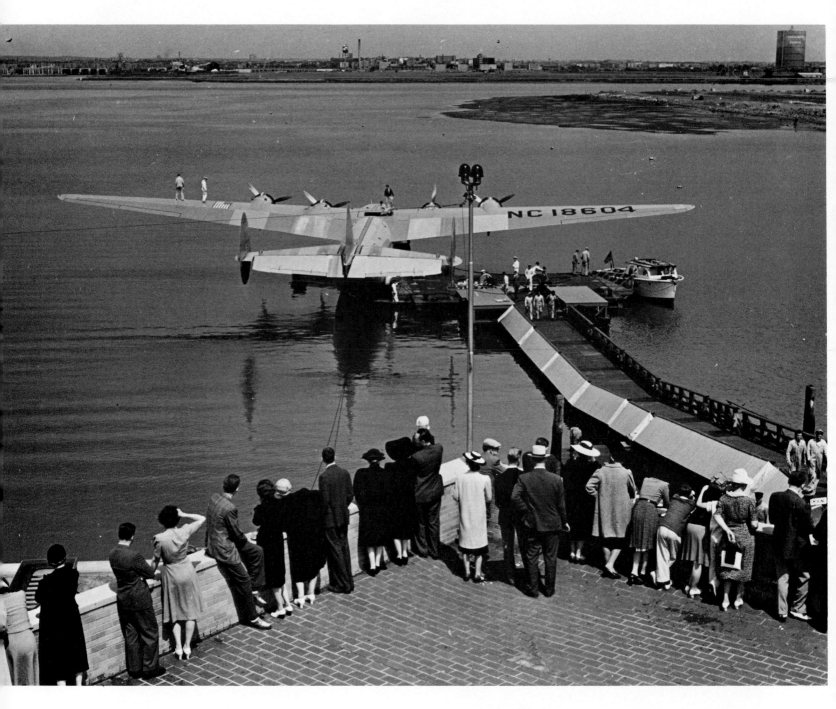

An Atlantic clipper at Marine Terminal [above]. LaGuardia Airport [opposite]. In 1940, when both these photographs were taken, New York stood at the dawn of the air age. The prestigious trans-Atlantic aircraft were still associated with the sea: they were called "clippers" and were seaplanes that could land on the ocean in case of emergency. In New York they came in and debarked from a back bay at Marine Terminal near La-Guardia Airport.

LaGuardia itself, opened as North Beach Municipal Airport, was little more than a few asphalt runways laid down over man-made land. The airport had been built in 1935–39 with

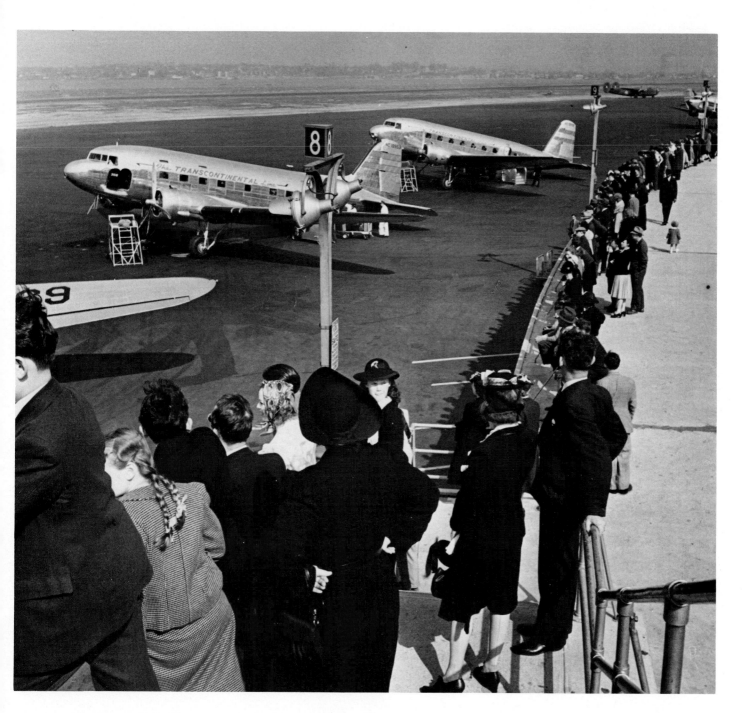

landfill—debris and ashes hauled from the old dump at Riker's Island just across the western neck of Long Island Sound. (Riker's then became the site of a new penitentiary constructed in 1935.)

Finished in time for the World's Fair of 1939, LaGuardia in the early 40s remained a playground for the well-to-do and adventurous. Ticket prices were expensive and flights limited in number. The closest most families came to air travel was a ride to LaGuardia on a pleasant Sunday afternoon to watch the planes take off and land—or just to stare at them parked on the runway.

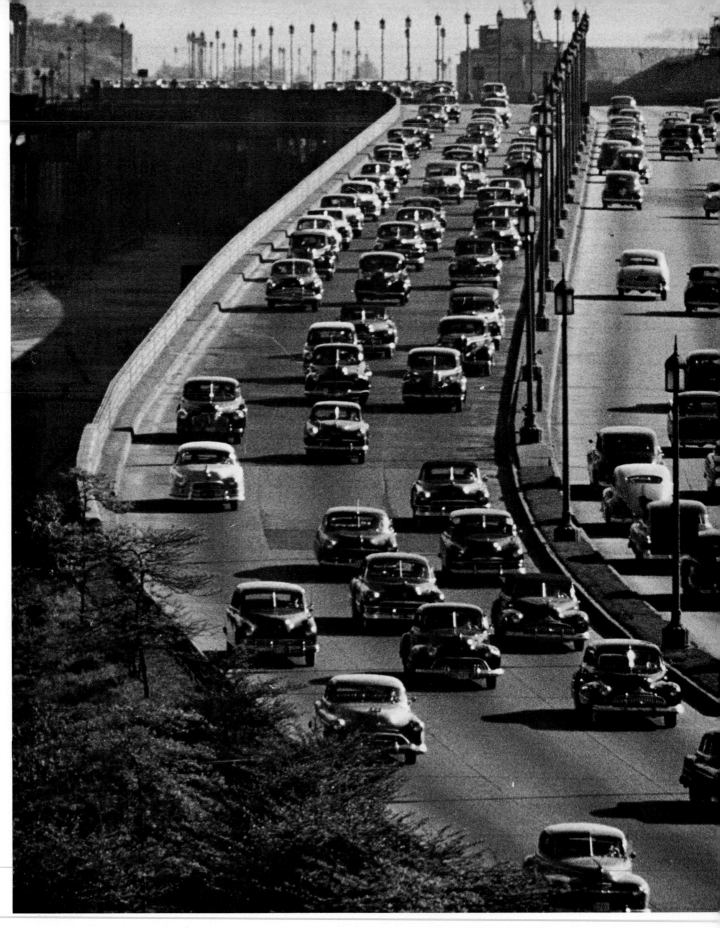

The West Side Highway looking south. The post-World War II era saw New York transformed into a city serviced—and clogged —by motor vehicles. New roads, like the West Side Highway

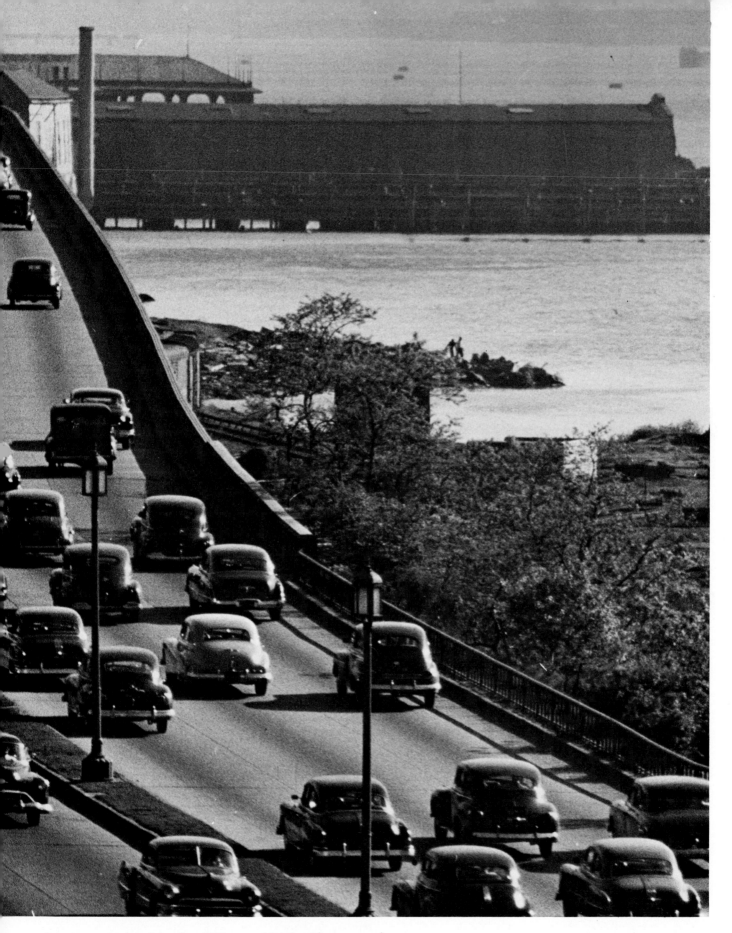

that was completed in the 1930s, combined with increased affluence and the growth of the suburbs to usher in the motor age.

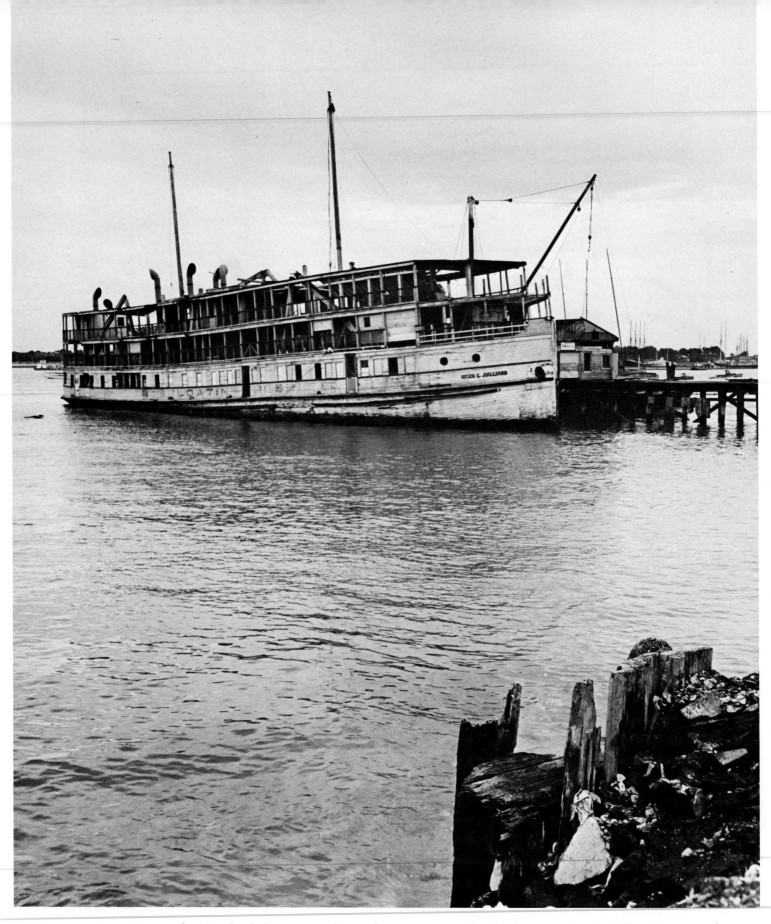

Two scenes at Gravesend Bay. The hulls are wooden and rotting. The remains of the docks are filled with mud. The water is gray and uninviting. The old paddlewheeler has taken its last excursion party around the waters of the city. A decade has ended. Yet the city survives, thriving unseen across the bay.

A cemetery in Queens [over]. Crowded cemeteries such as Calvary Cemetery in Queens remained a hallmark of New York, but the 1940s ended on a positive note—the building of United Nations Headquarters on the East River (a portion of the main building is seen in the upper right-hand corner).

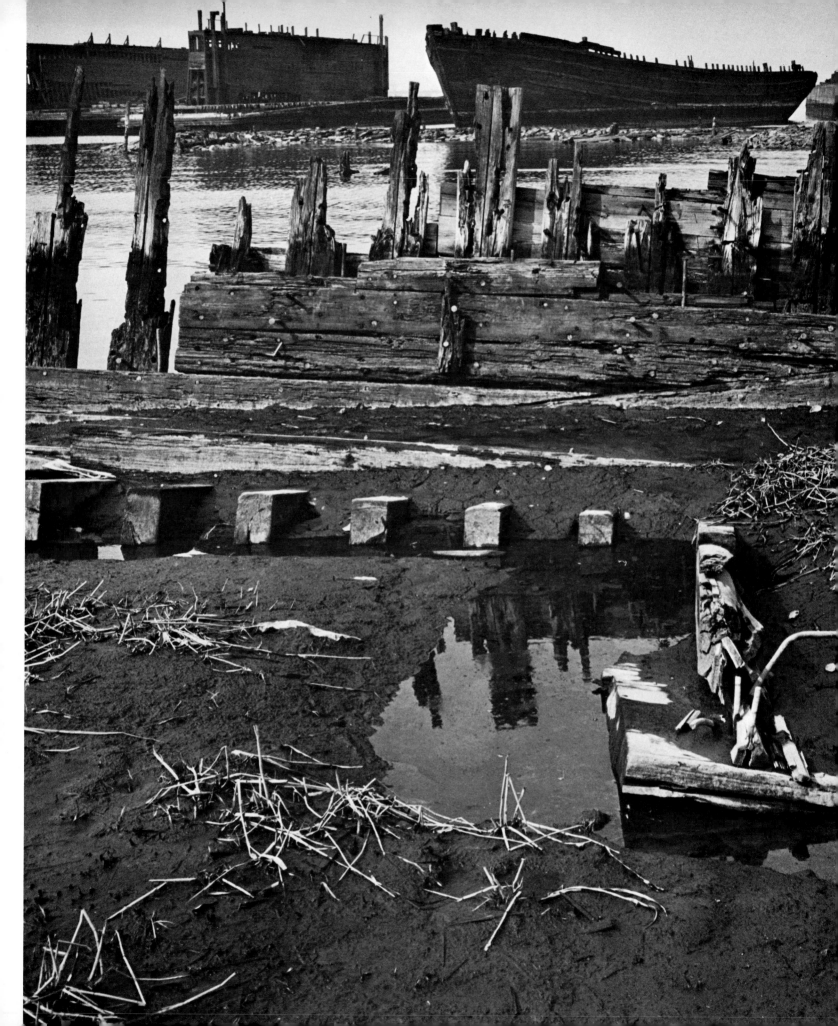

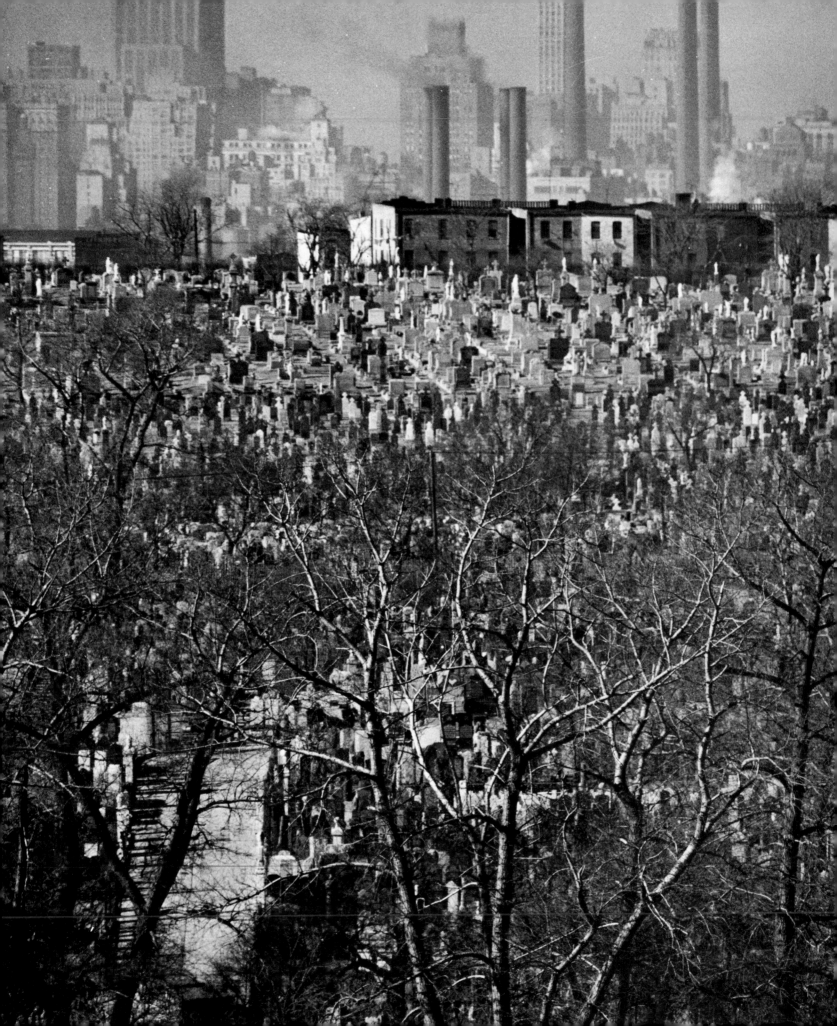

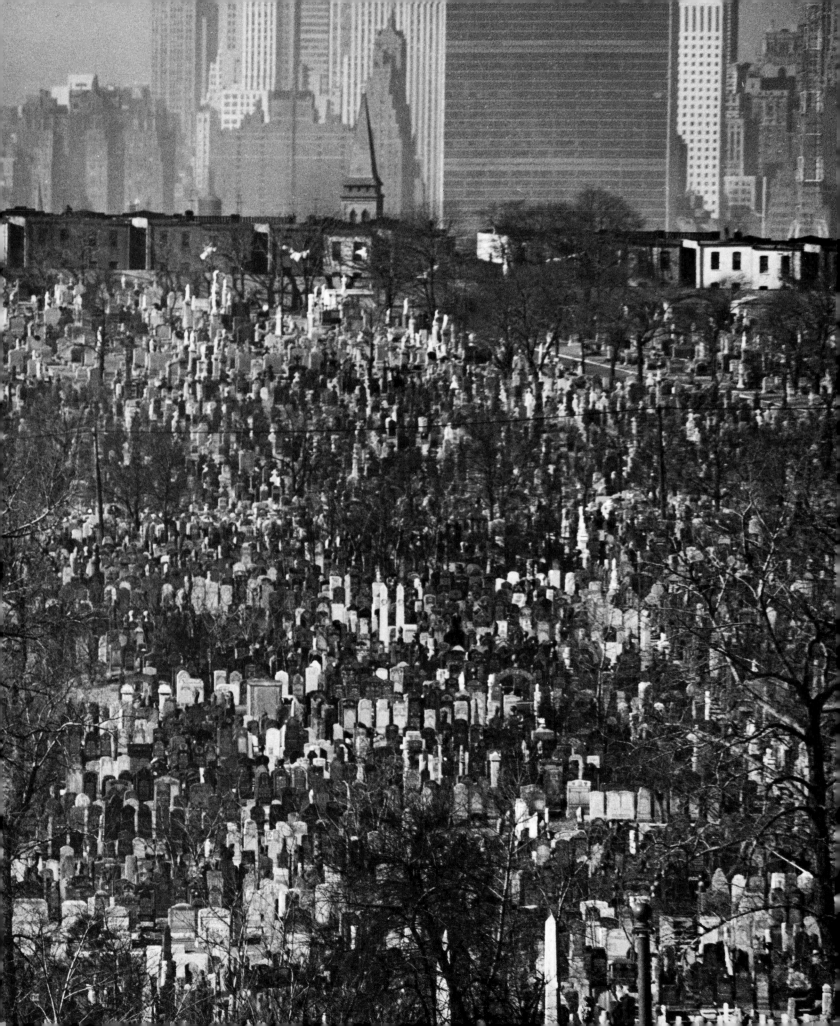